名家・創意系列

識別設計

REPUTED CREATIVE IDENTIFICATION DESIGN

定價／1200元

出 版 者／新形象出版事業有限公司
負 責 人／陳偉賢
地　　址／台北縣中和市中和路322號8 F 之1
電　　話／9207133 · 9278446
F A X／9290713
責任編輯／林東海 · 張麗琦
發 行 人／顏義勇
總 策 劃／陳偉昭
美術設計／張呂森、蕭秀慧、葉辰智
美術企劃／張麗琦、林東海
總 代 理／北星圖書事業股份有限公司
地　　址／台北縣永和市中正路391巷2號8樓
門　　市／北星圖書事業股份有限公司
　　　　　永和市中正路498號
電　　話／9229000 （代表）
F A X／9229041
郵　　撥／0544500 — 7北星圖書帳戶
印 刷 所／皇甫彩藝印刷股份有限公司
行政院新聞局出版事業登記證／局版台業字第3928 號
經濟部公司執／76 建三辛字第214743 號

Sub-element	Component	Unit	Measurement rules for components	Included	Excluded
3 Lighting installations **Definition:** Sub-circuit installations from sub-distribution boards to provide lighting.	1 Lighting installation: details to be stated.	m²	C1 The area measured is the area serviced by the system (i.e. the area of the rooms and circulation spaces that are served by the system, which is not necessarily the total gross internal floor area (GIFA) of the building). The area serviced is measured using the rules of measurement for ascertaining the GIFA. C2 Where more than one system is employed, the area measured for each system is the area serviced by the system. Areas to be measured using the rules of measurement for ascertaining the GIFA. C3 Installations to residential units, hotel rooms, student accommodation units and the like may be enumerated (nr). The type of residential unit or room and size (by number of bedrooms) of unit is to be stated. C4 Work to existing buildings is to be described and identified separately.	1 General internal lighting, including lighting fixed to the exterior of the building (e.g. bulkhead fittings and downlighters to soffits/external suspended ceilings). 2 Emergency lighting. 3 Lighting fixed to the exterior of the building supplied as part of the interior system. 4 Low voltage (LV) switchgear and distribution boards, where not included as part of the sub-mains distribution. 5 Cables and wiring, including support components from sub-distribution boards to lighting points, switches and the like. 6 Conduits and cable trunking, including all fittings and support components. 7 Earthing and bonding. 8 Fittings to lighting points, including roses, pendants and the like. 9 Switches, including pull cords. 10 Luminaires and lamps. 11 Lighting control equipment. 12 Sundry items. 13 Where works are to be carried out by a *subcontractor, subcontractor's preliminaries*, design fees, risk allowance, overheads and profit.	1 Specialist lighting systems (included in *sub-element* 5.8.4: Specialist lighting installations). 2 Security lights and lighting systems (included in *sub-element* 8.7.8: External security systems). 3 Street lighting, area lighting and flood lighting – included in *sub-element* 8.7.9: Site/street lighting systems). 4 Building management systems and other control systems (included in *sub-element* 5.12.3: Central control/building management systems (BMS)). 5 Builder's work in connection with services (included in *element* 5.14: Builder's work in connection with services). 6 Testing and commissioning of services (included in *element* 5.15: Testing and commissioning of services).

Sub-element	Component	Unit	Measurement rules for components	Included	Excluded
4 Specialist lighting installations **Definition:** Specialist or special effects internal illumination systems.	1 Specialist lighting installation: details to be stated.	nr/m²	C1 Where components are to be enumerated, the number of components is to be stated. C2 The area measured is the area serviced by the system (i.e. the area of the rooms and circulation spaces that are served by the system, which is not necessarily the total gross internal floor area (GIFA) of the building). The area serviced is measured using the rules of measurement for ascertaining the GIFA. C3 Where more than one system is employed, the area measured for each system is the area serviced by the system. Areas to be measured using the rules of measurement for ascertaining the GIFA. C4 Work to existing buildings is to be described and identified separately.	1 Illuminated display signs, lettering, emblems and symbols for information purposes, advertising and the like. 2 Studio lighting. 3 Auditorium lighting, theatre lighting, stage lighting and the like. 4 Arena lighting. 5 Operating theatres and other specialist lighting installations. 6 Low voltage (LV) switchgear and distribution boards, where not included as part of the sub-mains distribution. 7 Cables and wiring, including support components from sub-distribution boards to lighting points, switches and the like. 8 Conduits and cable trunking, including all fittings and support components. 9 Earthing and bonding. 10 Fittings to lighting points. 11 Switches, including pull cords. 12 Luminaires and lamps. 13 Lighting gantries and the like. 14 Lighting control equipment. 15 Sundry items. 16 Where works are to be carried out by a subcontractor, subcontractor's preliminaries, design fees, risk allowance, overheads and profit.	1 General lighting and emergency lighting installations (included in *sub-element 5.8.3: Lighting installations*). 2 Building management systems and other control systems (included in *sub-element 5.12.3: Central control/building management systems (BMS)*). 3 Builder's work in connection with services (included in *element 5.14: Builder's work in connection with services*). 4 Testing and commissioning of services (included in *element 5.15: Testing and commissioning of services*).

Sub-element	Component	Unit	Measurement rules for components	Included	Excluded
5 Local electricity generation systems **Definition:** Local generation equipment for the production of electrical energy, including emergency and or standby generator plant.	1 Electricity generation systems: details to be stated.	nr	C1 Where components are to be enumerated, the number of components is to be stated. C2 Work to existing buildings is to be described and identified separately.	1 Emergency/standby generator plant (gas, oil and dual fuel). 2 Ancillary cables and wiring, conduits and cable trunking, and controls required to connect local electricity generation systems to other systems. 3 Sundry items. 4 Where works are to be carried out by a *subcontractor, subcontractor's preliminaries,* design fees, risk allowance, overheads and profit.	1 Storage tanks and vessels, and fuel distribution pipelines (included in *sub-element* 5.9.2: Fuel storage and piped Distribution systems or *sub-element* 8.7.7: External fuel storage and piped distribution systems as appropriate). 2 Central heat and power (CHP) boiler plant (included in *element* 5.5: Heat source). 3 Solar collectors (included in *element* 5.5: Heat source). 4 Photovoltaic tiles, panels and the like (included in *sub-element* 5.8.6: Transformation devices in *sub-element* 8.7.3: External transformation devices, as appropriate). 5 Wind turbines and the like (included in *sub-element* 5.8.6: Transformation devices in *sub-element* 8.7.3: External transformation devices, as appropriate). 6 Uninterruptible power supply (UPS) installations and the like (included in *sub-element* 5.8.2: Power installations). 7 Building management systems and other control systems (included in *sub-element* 5.12.3: Central control/building management systems (BMS)). 8 Builder's work in connection with services (included in *element* 5.14: Builder's work in connection with services). 9 Testing and commissioning of services (included in *element* 5.15: Testing and commissioning of services).

Sub-element	Component	Unit	Measurement rules for components	Included	Excluded
6 Transformation devices **Definition:** Systems using the natural elements (i.e. wind and sun) to generate energy.	1 Wind turbines: details, including output (kW), to be stated. 2 Photovoltaic devices: details, including surface area of units (m²) and output (kW), to be stated. 3 Other transformation devices: details, including output (kW), to be stated.	nr nr nr	C1 Where components are to be enumerated, the number of components is to be stated. C2 Work to existing buildings is to be described and identified separately.	1 Wind turbines, including rooftop wind energy systems. 2 Photovoltaic devices, including cells, panels, modules and the like. 3 Solar collectors, including supporting framework (including fish plate collectors, evacuated tube collectors and the like). 4 Other transformation devices. 5 Generators in connection with transformation devices. 6 Ancillary cables and wiring, conduits and cable trunking, and controls required to connect transformation devices to other systems. 7 Sundry items. 8 Where works are to be carried out by a *subcontractor, subcontractor's preliminaries, design fees, risk allowance, overheads and profit.*	1 Horizontal solar systems providing protection to external walls (included in *sub-element* 2.5.3: Solar/rainscreen cladding). 2 Wind turbines external to the building envelope (included in *sub-element* 8.7.3: External transformation devices). 3 Photovoltaic devices external to the building envelope (included in *sub-element* 8.7.3: External transformation devices). 4 Heat pumps (included in *element* 5.5: Heat source). 5 Ground source heating (included in *element* 5.5: Heat source). 6 Solar collectors (included in *element* 5.5: Heat source). 7 Photovoltaic devices (e.g. tiles, slates, profiled sheets) where an integral part of a roof covering system (included in *sub-element* 2.3.2: Roof coverings). 8 Photovoltaic devices (e.g. profiled sheet cladding systems) where an integral part of an external wall system (included in *sub-element* 2.5.1: External walls above ground floor level or *sub-element* 2.5.2: External walls below ground floor level, as appropriate). 9 Photovoltaic glazing where an integral part of a curtain walling system, a structural glazing assembly or external windows (included in *sub-element* 2.5.1: External walls above ground floor level, *sub-element* 2.5.2: External walls below ground floor level or *sub-element* 2.6.1: External windows, as appropriate). 10 Building management systems and other control systems (included in *sub-element* 5.12.3: Central control/building management systems (BMS)).

Sub-element	Component	Unit	Measurement rules for components	Included	Excluded
					11 Builder's work in connection with services (included in *element* 5.14: Builder's work in connection with services). 12 Testing and commissioning of services (included in *element* 5.15: Testing and commissioning of services).
7 Earthing and bonding systems **Definition:** Systems for the transfer of electrical current to earth, to protect personnel, buildings, structure, plant and equipment in the case of electrical fault within the electricity supply system. Also to protect against interference from electromagnetic fields and electromagnetic forces.	1 Earthing and bonding systems: details to be stated.	m²	C1 The area measured is the area serviced by the system (i.e. the area of the rooms and circulation spaces that are served by the system, which is not necessarily the total gross internal floor area (GIFA) of the building). The area serviced is measured using the rules of measurement for ascertaining the GIFA. C2 Where more than one system is employed, the area measured for each system is the area serviced by the system. Areas to be measured using the rules of measurement for ascertaining the GIFA. C3 Installations to residential units, hotel rooms, student accommodation units and the like may be enumerated (nr). The type of residential unit or room and size (by number of bedrooms) of unit is to be stated. C4 Work to existing buildings is to be described and identified separately.	1 Earthing and bonding cables. 2 Earthing and bonding components, including protective conductors, earth clamps, earth tapes, clean earth bars, earth electrodes, earthing bus-bars, earth rod covers and boxed, equipotential bonding and all other ancillary components. 4 Sundry items. 5 Where works are to be carried out by a *subcontractor, subcontractor's preliminaries*, design fees, risk allowance, overheads and profit.	1 Earthing provided with individual systems (included in appropriate *sub-element*). 2 Builder's work in connection with services (included in *element* 5.14: Builder's work in connection with services). 3 Testing and commissioning of services (included in *element* 5.15: Testing and commissioning of services).

Element 5.9: Gas and other fuel installations

Sub-element	Component	Unit	Measurement rules for components	Included	Excluded
1 Gas distribution **Definition:** Piped gas supply systems taking gas from point of mains connection within building and distributing to user points.	1 Gas mains and sub-mains distribution: details to be stated.	m²	C1 The area measured is the total gross internal floor area (GIFA) of the building, measured using the rules of measurement for ascertaining the GIFA. C2 Installations to residential units, hotel rooms, student accommodation units and the like may be enumerated (nr). The type of residential unit or room and size (by number of bedrooms) of unit is to be stated. C3 Work to existing buildings is to be described and identified separately.	1 Distribution pipelines from point of mains connection within building to user points, including pipeline ancillaries and fittings. 2 Manifolds, local meters, gas governors, gas boosters, gas connection outlets. 3 Terminal control equipment. 4 Sundry items. 5 Where works are to be carried out by a *subcontractor, subcontractor's preliminaries*, design fees, risk allowance, overheads and profit.	1 Connection to the statutory undertaker's mains (included in *sub-element 8.7.5:* Gas mains supply). 2 Building management systems and other control systems (included in *sub-element 5.12.3:* Central control/building management systems (BMS)). 3 Builder's work in connection with services (included in *element 5.14:* Builder's work in connection with services). 4 Testing and commissioning of services (included in *element 5.15:* Testing and commissioning of services).
2 Fuel storage and piped distribution systems **Definition:** Storage tanks and vessels, and piped supply systems distributing oil, petrol, diesel or liquefied petroleum gas (LPG) from storage tanks or vessels to user points.	1 Fuel storage: details to be stated. 2 Piped distribution systems: details to be stated.	nr m²	C1 Where components are to be enumerated, the number of components is to be stated. C2 The area measured is the total gross internal floor area (GIFA) of the building, measured using the rules of measurement for ascertaining the GIFA. C3 Installations to residential units, hotel rooms, student accommodation units and the like may be enumerated (nr). The type of residential unit or room and size (by number of bedrooms) of unit is to be stated. C4 Work to existing buildings is to be described and identified separately.	1 Oil, petrol, diesel and liquefied petroleum gas (LPG) systems. 2 Storage tanks and vessels not supplied in connection with heat source installations. 3 Proprietary supports forming an integral part of the storage tank/vessel unit. 4 Off-site painting/anti-corrosion treatments. 5 Distribution pipelines, and pipeline fittings, from storage tank or vessel to plant or equipment being served. 6 Pipeline components/ancillaries (e.g. valves and pumps). 7 Thermal insulation. 8 Meters. 9 Monitoring equipment. 10 Sundry items. 11 Where works are to be carried out by a *subcontractor, subcontractor's preliminaries*, design fees, risk allowance, overheads and profit.	1 Storage tanks and vessels supplied as an integral part of heat source installations (included in *sub-element 5.5:* Heat source). 2 Storage tanks and vessels and distribution pipelines external to the building (included in *sub-element 8.7.7:* External fuel storage and piped distribution systems). 3 Supports not integral to the storage tank/vessel (included in *element 5.14:* Builder's work in connection with services). 4 Fuel bunds and the like to storage/retention tanks and vessel (included in *element 5.14:* Builder's work in connection with services). 5 On-site painting of storage tanks and vessels, supports and pipelines (included in *element 5.14:* Builder's work in connection with services). 6 Building management systems and other control systems (included in *sub-element 5.12.3:* Central control/building management systems (BMS)).

Sub-element	Component	Unit	Measurement rules for components	Included	Excluded
					7 Builder's work in connection with services (included in *element 5.14*: Builder's work in connection with services). 8 Testing and commissioning of services (included in *element 5.15*: Testing and commissioning of services).

Element 5.10: Lift and conveyor installations

Sub-element	Component	Unit	Measurement rules for components	Included	Excluded
1 Lifts **Definition:** Electro-mechanical or electro-hydraulic installations for the conveyance of persons, goods or equipment from one level to another in a vertical plane.	1 Passenger lifts: details, including capacity (i.e. number of persons), speed (in m/sec), number of doors (nr), door heights and number of levels serviced (nr), to be stated.	nr	C1 Where components are to be enumerated, the number of components is to be stated. C2 Work to existing buildings is to be described and identified separately.	1 Complete lift installation, including lift cars, doors and equipment, guides and counter balances, hydraulic and lifting equipment, emergency lighting, lift alarms and telephones. 2 Fire fighting lifts. 3 Wall climbing lifts. 4 Gantries, trolleys, blocks, hook and ropes, down-shop leads, pendant and the like. 5 Controls and electrical work from and including isolator where supplied with installation. 6 Sundry items. 7 Where works are to be carried out by a *subcontractor, subcontractor's preliminaries, design fees, risk allowance, overheads and profit.*	1 Lift shaft (included in *group elements* 1: Substructure and 2: Superstructure, as appropriate). 2 General purpose low voltage (LV) power supplies (included in *sub-element* 5.8.2: Power installations). 3 Building management systems and other control systems (included in *sub-element* 5.12.3: Central control/building management systems (BMS)). 4 Builder's work in connection with services (included in *element 5.14*: Builder's work in connection with services). 5 Testing and commissioning of services (included in *element 5.15*: Testing and commissioning of services).
	2 Wall climbing lifts: details, including capacity (in kg), number of persons), speed (in m/sec) and number of levels serviced (nr), to be stated.	nr			
	3 Goods lifts: details, including capacity (in kg), number of doors, door heights and number of levels serviced (nr), to be stated.	nr			

Sub-element	Component	Unit	Measurement rules for components	Included	Excluded
2 Enclosed hoists **Definition:** Permanently fixed lifting equipment, either electro-mechanical or hydraulically operated, for the raising or lowering of persons, goods or equipment.	1 Enclosed hoists: details, including capacity (in kg) and number of levels (nr) serviced, to be stated.	nr	C1 Number of hoists. C2 Work to existing buildings is to be described and identified separately.	1 Hoists, kitchen service hoists, dumb waiters and the like. 2 Complete hoist installation, including cages, doors and equipment, guides and counter balances, hydraulic and lifting equipment. 3 Controls and electrical work from and including isolator where supplied with installation. 4 Sundry items. 5 Where works are to be carried out by a subcontractor, subcontractor's preliminaries, design fees, risk allowance, overheads and profit.	1 Hoist enclosure or shaft (included in group elements 1: Substructure and 2: Superstructure, as appropriate). 2 General purpose low voltage (LV) power supplies (included in sub-element 5.8.2: Power installations). 3 Building management systems and other control systems (included in sub-element 5.12.3: Central control/building management systems (BMS)). 4 Builder's work in connection with services (included in element 5.14: Builder's work in connection with services). 5 Testing and commissioning of services (included in element 5.15: Testing and commissioning of services).
3 Escalators **Definition:** Electro-mechanical systems for the conveyance of persons from one level to another by means of a continually moving stairway.	1 Escalators: details, including, number of flights served (nr), angle of rise (in degrees). rise (m) and step width (mm), to be stated.	nr	C1 Where components are to be enumerated, the number of components is to be stated. C2 The rise is the distance between the finished floor level at the bottom of the escalator and the finished floor level at the top of the escalator. C3 Work to existing buildings is to be described and identified separately.	1 Escalators. 2 Ancillary components, including under step lighting, under handrail lighting, balustrades, cladding to sides and soffits, chairs. 3 Controls and electrical work from and including isolator where supplied with installation. 4 Sundry items. 5 Where works are to be carried out by a subcontractor, subcontractor's preliminaries, design fees, risk allowance, overheads and profit	1 General purpose low voltage (LV) power supplies (included in sub-element 5.8.2: Power installations). 2 Building management systems and other control systems (included in sub-element 5.12.3: Central control/building management systems (BMS)). 3 Builder's work in connection with services (included in element 5.14: Builder's work in connection with services). 4 Testing and commissioning of services (included in element 5.15: Testing and commissioning of services).

Sub-element	Component	Unit	Measurement rules for components	Included	Excluded
4 Moving pavements **Definition:** Electro-mechanical systems for the conveyance of persons from one place to another by means of a moving flat strip of pavement either level or inclined to elevate from one level to another.	1 Moving pavements: details, including, length (m) and width (mm), to be stated.	nr	C1 Where components are to be enumerated, the number of components is to be stated. C2 The linear length measured is the extreme length. C3 Work to existing buildings is to be described and identified separately.	1 Moving pavements. 2 Travelators. 3 Stairlifts. 4 Controls and electrical work from and including isolator where supplied with installation. 5 Sundry items. 6 Where works are to be carried out by a *subcontractor, subcontractor's preliminaries, design fees, risk allowance, overheads and profit.*	1 General purpose low voltage (LV) power supplies (included in *sub-element* 5.8.2: Power installations). 2 Building management systems and other control systems (included in *sub-element* 5.12.3: Central control/building management systems (BMS)). 3 Builder's work in connection with services (included in *element* 5.14: Builder's work in connection with services). 4 Testing and commissioning of services (included in *element* 5.15: Testing and commissioning of services).
5 Powered stairlifts **Definition:** Electro-mechanical systems, fixed to the wall or balustrade of a staircase, for the conveyance of persons with impaired mobility from one level to another.	1 Powered stairlifts: details to be stated.	nr	C1 Where components are to be enumerated, the number of components is to be stated. C2 Work to existing buildings is to be described and identified separately.	1 Complete stairlift installation, including rails, folding rails, carriages, hinged bridging platforms, guards, drive units and signage. 2 Controls and electrical work from and including isolator where supplied with installation 3 Sundry items. 4 Where works are to be carried out by a *subcontractor, subcontractor's preliminaries, design fees, risk allowance, overheads and profit.*	1 General purpose low voltage (LV) power supplies (included in *sub-element* 5.8.2: Power installations). 2 Building management systems and other control systems (included in *sub-element* 5.12.3: Central control/building management systems (BMS)). 3 Builder's work in connection with services (included in *element* 5.14: Builder's work in connection with services). 4 Testing and commissioning of services (included in *element* 5.15: Testing and commissioning of services).

Sub-element	Component	Unit	Measurement rules for components	Included	Excluded
6 Conveyors **Definition:** Systems for the mechanical conveyance of goods between two or more points.	1 People conveyors: details, including length (m) and width (mm), to be stated. 2 Goods conveyors: details, including length (m) and width (mm), to be stated.	nr nr	C1 Where components are to be enumerated, the number of components is to be stated. C2 The linear length measured is the extreme length. C3 Work to existing buildings is to be described and identified separately.	1 Complete conveyor systems. 2 Specialist systems (e.g. baggage handling systems and the like). 3 Controls and electrical work from and including isolator where supplied with installation. 4 Sundry items. 5 Where works are to be carried out by a *subcontractor, subcontractor's preliminaries*, design fees, risk allowance, overheads and profit.	1 General purpose low voltage (LV) power supplies (included in *sub-element* 5.8.2: Power installations). 2 Building management systems and other control systems (included in *sub-element* 5.12.3: Central control/Building management systems (BMS)). 3 Builder's work in connection with services (included in *element* 5.14: Builder's work in connection with services). 4 Testing and commissioning of services (included in *element* 5.15: Testing and commissioning of services).
7 Dock levellers and scissor lifts **Definition:** Localised lifting systems for goods and people.	1 Dock levellers and scissor lifts: details, including total rise (m), to be stated.	nr	C1 Where components are to be enumerated, the number of components is to be stated. C2 Work to existing buildings is to be described and identified separately.	1 Dock levellers, including canopy. 2 Scissor lifts. 3 Controls and electrical work from and including isolator where supplied with installation. 4 Sundry items. 5 Where works are to be carried out by a *subcontractor, subcontractor's preliminaries*, design fees, risk allowance, overheads and profit.	1 General purpose low voltage (LV) power supplies (included in *sub-element* 5.8.2: Power installations). 2 Building management systems and other control systems (included in *sub-element* 5.12.3: Central control/building management systems (BMS)). 3 Builder's work in connection with services (included in *element* 5.14: Builder's work in connection with services). 4 Testing and commissioning of services (included in *element* 5.15: Testing and commissioning of services).

Sub-element	Component	Unit	Measurement rules for components	Included	Excluded
8 Cranes and unenclosed hoists **Definition:** Cranes and unenclosed hoists for the lifting and movement of heavy goods and equipment.	1 Cranes: details including design load (kN) and total rise (m), to be stated.	nr	C1 Where components are to be enumerated, the number of components is to be stated. C2 Work to existing buildings is to be described and identified separately.	1 Cranes. 2 Travelling cranes. 3 Unenclosed hoists and other lifting systems for materials and goods. 4 Controls and electrical work from and including isolator where supplied with installation. 5 Sundry items. 6 Where works are to be carried out by a *subcontractor, subcontractor's preliminaries*, design fees, risk allowance, overheads and profit.	1 General purpose low voltage (LV) power supplies (included in *sub-element* 5.8.2: Power installations). 2 Building management systems and other control systems (included in *sub-element* 5.12.3: Central control/building management systems (BMS)). 3 Builder's work in connection with services (included in *element* 5.14: Builder's work in connection with services). 4 Testing and commissioning of services (included in *element* 5.15: Testing and commissioning of services).
	2 Travelling cranes: details, including design load (kN), to be stated.	nr			
	3 Unenclosed hoists: details, including total rise (m), to be stated.	nr			
9 Car lifts, car stacking systems, turntables and the like **Definition:** Vehicle lifting, storage and moving systems.	1 Car lifts: details, including number of floors served (nr), to be stated.	nr	C1 Where components are to be enumerated, the number of components is to be stated. C2 Work to existing buildings is to be described and identified separately.	1 Car lifts, car stacking systems and the like. 2 Vehicle turntables. 3 Controls and electrical work from and including isolator where supplied with installation. 4 Sundry items. 5 Where works are to be carried out by a *subcontractor, subcontractor's preliminaries*, design fees, risk allowance, overheads and profit.	1 General purpose low voltage (LV) power supplies (included in *sub-element* 5.8.2: Power installations). 2 Building management systems and other control systems (included in *sub-element* 5.12.3: Central control/building management systems (BMS)). 3 Builder's work in connection with services (included in *element* 5.14: Builder's work in connection with services). 4 Testing and commissioning of services (included in *element* 5.15: Testing and commissioning of services).
	2 Car stacking systems: details, including capacity (i.e. number of cars – nr), to be stated.	nr			
	3 Vehicle turntables: details to be stated.	nr			

Sub-element	Component	Unit	Measurement rules for components	Included	Excluded
10 Document handling systems **Definition:** Specialist document handling/delivery systems, warehouse picking systems and the like.	1 Document handling/delivery systems: details to be stated. 2 Warehouse picking systems: details to be stated. 3 Other systems: details to be stated.	nr nr nr	C1 Where components are to be enumerated, the number of components is to be stated. C2 Work to existing buildings is to be described and identified separately.	1 Document handling/delivery systems, warehouse picking systems and the like. 2 Controls and electrical work from and including isolator where supplied with installation. 3 Sundry items. 4 Where works are to be carried out by a *subcontractor, subcontractor's preliminaries, design fees, risk allowance, overheads and profit.*	1 General purpose low voltage (LV) power supplies (included in *sub-element 5.8.2: Power installations*). 2 Building management systems and other control systems (included in *sub-element 5.12.3: Central control/building management systems (BMS)*). 3 Builder's work in connection with services (included in *element 5.14: Builder's work in connection with services*). 4 Testing and commissioning of services (included in *element 5.15: Testing and commissioning of services*).
11 Other lift and conveyor installations **Definition:** Transport systems not covered by *sub-elements 5.10.1 to 5.10.10.*	1 Other lift and conveyor installations: details to be stated.	nr	C1 Where components are to be enumerated, the number of components is to be stated. C2 Work to existing buildings is to be described and identified separately.	1 Paternoster lifts. 2 Hoists for moving people with disability. 3 Other transport systems. 4 Controls and electrical work from and including isolator where supplied with installation. 5 Sundry items. 6 Where works are to be carried out by a *subcontractor, subcontractor's preliminaries, design fees, risk allowance, overheads and profit.*	1 Shafts and the like (included in *group elements 1: Substructure and elements 2: Superstructure, as appropriate*). 2 General purpose low voltage (LV) power supplies (included in *sub-element 5.8.2: Power installations*). 3 Building management systems and other control systems (included in *sub-element 5.12.3: Central control/building management systems (BMS)*). 4 Builder's work in connection with services (included in *element 5.14: Builder's work in connection with services*). 5 Testing and commissioning of services (included in *element 5.15: Testing and commissioning of services*).

Element 5.11: Fire and lightning protection

Sub-element	Component	Unit	Measurement rules for components	Included	Excluded
1 Fire fighting systems **Definition:** Piped distribution systems within the confines of the building for fire fighting purposes.	1 Sprinklers: details of each type of system to be stated.	m²	C1 Where components are to be enumerated, the number of components is to be stated. C2 The area measured is the area serviced by the system (i.e. the area of the rooms and circulation spaces that are served by the system, which is not necessarily the total gross internal floor area (GIFA) of the building). The area serviced is measured using the rules of measurement for ascertaining the GIFA. C3 Where more than one system is employed, the area measured for each system is the area serviced by the system. Areas to be measured using the rules of measurement for ascertaining the GIFA. C4 Work to existing buildings is to be described and identified separately.	1 Sprinklers, including reaction and control devices and sprinkler heads. 2 Fire hose reels, including hose reels and pressure booster sets. 3 Dry risers, including inlet breechings, inlet boxes, landing valves, outlet boxes and drain valves. 4 Wet risers, including landing valves, outlet boxes, pressure vessel within diaphragm and control panels. 5 Deluge systems, including water storage, reaction and control devices and deluge discharge nozzles. 6 Gas fire fighting systems, including gas storage cylinders and vessels, gas manifolds and equipment, discharge nozzles, detectors and activators. 7 Foam fire fighting systems, including foam generation equipment, storage vessels, detectors and activators, and foam discharge nozzles, etc. 8 Distribution pipelines, pipeline ancillaries and fittings. 9 Water tanks and cisterns for fire fighting installations. 10 Thermal insulation. 11 Control components. 12 Sundry items. 13 Where works are to be carried out by a *subcontractor, subcontractor's preliminaries,* design fees, risk allowance, overheads and profit.	1 Water supply (included in *element 5.4:* Water installations as appropriate). 2 General purpose low voltage (LV) power supplies (included in *sub-element 5.8.2:* Power installations). 3 Fire hydrants (included in *sub-element 5.4.1:* Mains water supply). 4 Hand held fire fighting equipment, including fire extinguishers, fire blankets and the like (included in *sub-element 4.1.1:* General fittings, furnishings and equipment). 5 Fire detection and alarm systems (included in *sub-element 5.12.1:* Communication systems). 6 Building management systems and other control systems (included in *sub-element 5.12.3:* Central control/building management systems (BMS)). 7 Builder's work in connection with services (included in *element 5.14:* Builder's work in connection with services). 8 Testing and commissioning of services (included in *element 5.15:* Testing and commissioning of services).
	2 Deluge systems: details of each type of system to be stated.	m²			
	3 Gas fire fighting systems: details of each type of system to be stated.	m²			
	4 Foam fire fighting systems: details of each type of system to be stated.	m²			
	5 Fire hose reels: details of each type of system to be stated.	nr			
	6 Dry risers: details to be stated.	nr			
	7 Wet risers: details to be stated.	nr			
	8 Other fire fighting systems: details of each type of system to be stated.	nr/m²			

Sub-element	Component	Unit	Measurement rules for components	Included	Excluded
2 Lightning protection **Definition:** Lightning protection installations.	1 Lightning protection installations (m²): details of each type of system to be stated.	m²	C1 The area measured is the area serviced by the system (i.e. the area of the rooms and circulation spaces that are served by the system, which is not necessarily the total gross internal floor area (GIFA) of the building). The area serviced is measured using the rules of measurement for ascertaining the GIFA. C2 Where more than one system is employed, the area measured for each system is the area serviced by the system. Areas to be measured using the rules of measurement for ascertaining the GIFA. C2 Work to existing buildings is to be described and identified separately.	1 Faraday cages and other tape based systems. 2 Finials. 3 Conductor tapes. 4 Grounding/earthing. 5 Sundry items. 6 Where works are to be carried out by a *subcontractor*, *subcontractor's preliminaries*, design fees, risk allowance, overheads and profit.	1 Earthing systems (included in *sub-element* 5.8.7: Earthing and bonding systems). 2 Builder's work in connection with services (included in *element* 5.14: Builder's work in connection with services). 3 Testing and commissioning of services (included in *element* 5.15: Testing and commissioning of services).

Element 5.12: Communication, security and control systems

Sub-element	Component	Unit	Measurement rules for components	Included	Excluded
1 Communication systems **Definition:** Systems for communicating, including visual, audio and data installations.	1 Telecommunication systems: details of each type of system to be stated.	m²	C1 Where components are to be enumerated, the number of components is to be stated. C2 The area measured is the area serviced by the system (i.e. the area of the rooms and circulation spaces that are served by the system, which is not necessarily the total gross internal floor area (GIFA) of the building). The area serviced is measured using the rules of measurement for ascertaining the GIFA. C3 Where more than one system is employed, the area measured for each system is the area serviced by the system. Areas to be measured using the rules of measurement for ascertaining the GIFA.	1 Telecommunication systems, including wiring, handsets and equipment, telex equipment, facsimile equipment, combined systems (e.g. PAX, PAXB and PNBX systems), and the like. 2 Data transmission, including wiring, computer networking, modems, multiplexers, data terminals and data-bus systems. 3 Paging and emergency call systems, including emergency call buttons, pull cords and the like (including aerials, radio paging equipment, microphones, amplifiers and speakers), induction loops, personal receivers and indicator boards).	1 Radio and television studio installations (included in *sub-element* 5.8.2: Power installations). 2 Illuminated display signs, lettering, emblems and symbols for information purposes, advertising and the like (included in *sub-element* 5.13.2: Radio and television studios). 3 General purpose low voltage (LV) power supplies (included in *sub-element* 5.8.2: Power installations). 4 Building management systems and other control systems (included in *sub-element* 5.12.3: Central control/building management systems (BMS)).
	2 Data transmission systems: details of each type of system to be stated.	m²			
	3 Paging and emergency call systems: details of each type of system to be stated.	m²			

Sub-element	Component	Unit	Measurement rules for components	Included	Excluded
	4 Public address and conference audio systems: details of each type of system to be stated.	m²	C4 Installations to residential units, hotel rooms, student accommodation units and the like may be enumerated (nr). The type of residential unit or room and size (by number of bedrooms) of unit is to be stated.	4 Public address and conference audio facilities, including public address systems, hospital radio, conference audio facilities, audio frequency induction loop systems, background noise systems (including microphones, amplifiers, and speakers).	5 Builder's work in connection with services (included in element 5.14: Builder's work in connection with services).
	5 Radio systems: details of each type of system to be stated.	m²	C5 Work to existing buildings is to be described and identified separately.	5 Radio systems, including cable and satellite systems (including receivers).	6 Testing and commissioning of services (included in element 5.15: Testing and commissioning of services).
	6 Projection systems: details of each type of system to be stated.	nr		6 Projection systems (e.g. cinematographic equipment, fixed or portable projection equipment, screens, back-projection equipment, sound equipment).	
	7 Fire detection and alarm systems: details of each type of system to be stated.	m²		7 Fire detection and alarm systems, including manual call points, automatic detection equipment, sounders, controls and indicator panels.	
	8 Liquid detection systems: details of each type of system to be stated.	m²		8 Liquid detection alarms (i.e. systems giving early warning of water/liquid leakage to prevent damage).	
	9 Burglar and security alarms: details of each type of system to be stated.	m²		9 Clocks, card clocks, flexitime installations.	
	10 Clocks, card clocks, flexitime installations: details of each type of system to be stated.	nr		10 Radio(s).	
	11 Door entry systems: details of each type of system to be stated	m²		11 Television systems, including cable and satellite systems.	
	12 Radio(s): details of each type of system to be stated.	m²		12 TV monitors.	
	13 Television systems: details of each type of system to be stated.	nr		13 Pneumatic or mechanical message systems.	
				14 Other communication system.	
				15 Sundry items.	
				16 Where works are to be carried out by a subcontractor, subcontractor's preliminaries, design fees, risk allowance, overheads and profit.	

Sub-element	Component	Unit	Measurement rules for components	Included	Excluded
	14 TV monitors: details of each type of system to be stated.	nr			
	15 Pneumatic or mechanical message systems: details of each type of system to be stated.	m²			
	16 Other communication systems: details of each type of system to be stated.	nr/m²			
2 Security systems **Definition:** Observation and access control installations and the like.	1 Surveillance equipment: details of each type of system to be stated.	nr/m²	C1 Where components are to be enumerated, the number of components is to be stated. C2 The area measured is the area serviced by the system (i.e. the area of the rooms and circulation spaces that are served by the system, which is not necessarily the total gross internal floor area (GIFA) of the building). The area serviced is measured using the rules of measurement for ascertaining the GIFA.	1 Surveillance equipment (e.g. CCTV). 2 Security detection equipment. 3 Security alarm equipment. 4 Access control systems. 5 Burglar and security alarms. 6 Door entry systems (audio and visual). 7 Security lights and lighting systems. 8 Other security systems. 9 Sundry items. 10 Where works are to be carried out by a *subcontractor, subcontractor's preliminaries, design fees, risk allowance, overheads and profit.*	1 General purpose low voltage (LV) power supplies (included in *sub-element 5.8.2: Power installations*). 2 External observation and access control installations and the like (unless stated otherwise, included in *sub-element 8.7.8: External security systems*). 3 Building management systems and other control systems (included in *sub-element 5.12.3: Central control/building management systems (BMS)*). 4 Builder's work in connection with services (included in *element 5.14: Builder's work in connection with services*). 5 Testing and commissioning of services (included in *element 5.15: Testing and commissioning of services*).
	2 Security detection equipment: details of each type of system to be stated.	nr/m²			
	3 Security alarm equipment: details of each type of system to be stated.	nr/m²	C3 Where more than one system is employed, the area measured for each system is the area serviced by the system. Areas to be measured using the rules of measurement for ascertaining the GIFA.		
	4 Access control systems: details of each type of system to be stated.	nr/m²	C4 Installations to residential units, hotel rooms, student accommodation units and the like may be enumerated (nr). The type of residential unit or room and size (by number of bedrooms) of unit is to be stated.		
	5 Burglar and security alarms: details of each type of system to be stated.	nr/m²	C5 Work to existing buildings is to be described and identified separately.		
	6 Door entry systems: details of each type of system to be stated.	nr	C6 State if external security systems included with building security systems (cross-reference to *sub-element 9.7.8: External security systems*).		

Sub-element	Component	Unit	Measurement rules for components	Included	Excluded
	7 Security lights and lighting systems); details of each type of system to be stated.	nr/m²			
	8 Other security systems: details of each type of system to be stated.	nr/m²			
3 Central control/building management systems **Definition:** Control systems which, from a central remote location, provide means for controlling and reporting on the performance of the operational systems of a building.	1 Central control/building management systems: details of each type of system to be stated.	m²	C1 The area measured is the area serviced by the system (i.e. the area of the rooms and circulation spaces that are served by the system, which is not necessarily the total gross internal floor area (GIFA) of the building). The area serviced is measured using the rules of measurement for ascertaining the GIFA. C2 Where more than one system is employed, the area measured for each system is the area serviced by the system. Areas to be measured using the rules of measurement for ascertaining the GIFA. C3 Work to existing buildings is to be described and identified separately.	1 Control panels for mechanical and electrical equipment. 2 Building management systems (BMS), including central and satellite computer terminal software. 3 Controlling terminal units and switches. 4 Control cabling and containment. 5 Compressed air and vacuum operated control systems. 6 Sundry items. 7 Where works are to be carried out by a *subcontractor, subcontractor's preliminaries,* design fees, risk allowance, overheads and profit.	1 Individual controls to heating, air conditioning installations, and the like (included with services installation or system as appropriate). 2 General purpose low voltage (LV) power supplies (included in *sub-element* 5.8.2: Power installations). 3 Builder's work in connection with services (included in *element* 5.14: Builder's work in connection with services). 4 Testing and commissioning of services (included in *element* 5.15: Testing and commissioning of services).

Element 5.13: Specialist installations

Sub-element	Component	Unit	Measurement rules for components	Included	Excluded
1 Specialist piped supply systems **Definition:** – Piped gas supply systems of high purity (e.g. oxygen or nitrous oxide) from storage source to distribution points in medical treatment, medical research or similar establishments. – Piped distribution systems providing suction for vacuum cleaning and collection facilities. – Piped water supply systems where the water is treated to obtain a high degree of purity for special use and application. – Systems for the treatment and circulation of water for swimming pools.	1 Medical and laboratory gas supply systems: details of each type of system to be stated. 2 Centralised vacuum cleaning systems: details of each type of system to be stated. 3 Treated water systems: details of each type of system to be stated. 4 Swimming pool water treatment systems: details of each type of system to be stated. 5 Compressed air systems: details of each type of system to be stated. 6 Vacuum systems: details of each type of system to be stated.	nr/m² nr/m² nr/m² nr/m² nr/m² nr/m²	C1 Where components are to be enumerated, the number of components is to be stated. C2 The area measured is the area serviced by the system (i.e. the area of the rooms and circulation spaces that are served by the system, which is not necessarily the total gross internal floor area (GIFA) of the building). The area serviced is measured using the rules of measurement for ascertaining the GIFA. C3 Where more than one system is employed, the area measured for each system is the area serviced by the system. Areas to be measured using the rules of measurement for ascertaining the GIFA. C4 Work to existing buildings is to be described and identified separately.	1 Medical and laboratory gas supply systems, including gas bottles and bulk storage vessels, manifold headers, gas governors, monitoring equipment, terminal control equipment, gas detection and alarm equipment, gas connection outlets and the like. 2 Centralised vacuum cleaning systems, including vacuum pumps, blowers and vacuum connection units. 3 Treated water systems, including de-alkalisation, de-ionisation, de-aeration, raw sewage storage tanks and vessels, chemical storage tanks and vessels, purified water tanks and vessels, distillation equipment, electrolytic chlorine ion generation equipment, demineralisation plant, reverse osmosis plant and the like. 4 Swimming pool water treatment, including filter vessels, chemical storage vessels, chemical dosing equipment, ozone generation and injection equipment, de-ozoning vessels, electrolytic chlorine ion generation equipment, pool inlet jets, scum channels, perimeter draw-off grilles and the like. 5 Compressed air systems, including compressors (including motors and starters), inter-coolers, after-coolers, air storage vessels and receivers, air separators, cooling water systems, lubrication systems, local water coolers, compressed air ancillaries, compressed air connection outlets, instrument air pipeline ancillaries (including manifolds), instrument air connection outlets, and the like.	1 General purpose low voltage (LV) power supplies (included in sub-element 5.8.2: Power installations). 2 Building management systems and other control systems (included in sub-element 5.12.3: Central control/building management systems (BMS)). 3 Builder's work in connection with services (included in element 5.14: Builder's work in connection with services). 4 Testing and commissioning of services (included in element 5.15: Testing and commissioning of services).

Sub-element	Component	Unit	Measurement rules for components	Included	Excluded
– Piped distribution systems providing compressed air for motive power and general purpose use. – Piped distribution systems providing compressed air of high quality (oil free) for purposes of operating pneumatic controls and other delicate instruments and equipment. – Piped distribution systems providing negative pressure at a number of points for particular user or process functions. – Other piped distributions of a specialist nature.	7 Other specialist piped supply systems: details of each type of system to be stated.	nr/m²		6 Vacuum systems, including vacuum pumps, intercoolers and driers, vacuum connection points and the like. 7 Other specialist piped supply systems. 8 Pipelines, pipeline ancillaries and fittings. 10 Air duct lines, duct line ancillaries and fittings. 11 Thermal insulation. 12 Silencers and acoustic treatment. 13 Control components. 14 Sundry items. 15 Where works are to be carried out by a *subcontractor, subcontractor's preliminaries,* design fees, risk allowance, overheads and profit.	
2 Radio and television studios **Definition:** Radio and television studios or the like.	1 Radio and television studios: details to be stated.	nr	C1 Where components are to be enumerated, the number of components is to be stated. C2 Work to existing buildings is to be described and identified separately.	1 Radio and television studio equipment.	1 General purpose low voltage (LV) power supplies (included in *sub-element 5.8.2:* Power installations). 2 Builder's work in connection with services (included in *element 5.14:* Builder's work in connection with services). 3 Testing and commissioning of services (included in *element 5.15:* Testing and commissioning of services).

Sub-element	Component	Unit	Measurement rules for components	Included	Excluded
3 Specialist refrigeration systems **Definition:** Specialist refrigeration systems.	1 Cold rooms: details of each type of system to be stated. 2 Ice pads: details to be stated. 3 Other specialist refrigeration systems: details of each type of system to be stated.	nr/m² nr/m² nr/m²	C1 Where components are to be enumerated, the number of components is to be stated. C2 The area measured is the area serviced by the system (i.e. the area of the rooms and circulation spaces that are served by the system, which is not necessarily the total gross internal floor area (GIFA) of the building). The area serviced is measured using the rules of measurement for ascertaining the GIFA. C3 Where more than one system is employed, the area measured for each system is the area serviced by the system. Areas to be measured using the rules of measurement for ascertaining the GIFA. C4 Work to existing buildings is to be described and identified separately.	1 Cold rooms, including packaged cold rooms, packaged walk-in freezers, wall panels and linings, ceiling panels and linings, flooring systems, doors and door mechanisms, jointing material, thermal cladding, refrigeration plant and equipment, evaporators, lighting and the like. 2 Ice pads, including waterproof layer, insulation layer, working screed, slip plane layer, bonded refrigeration pads (incorporating pipelines, reinforcement, etc.), floor drains and sealing plates, cooling towers, evaporative condensers, heat recovery systems and the like. 3 Other specialist refrigeration systems. 4 Sundry items. 5 Where works are to be carried out by a *subcontractor*, *subcontractor's preliminaries*, design fees, risk allowance, overheads and profit.	1 Central refrigeration plant and chillers (included in *sub-element* 5.6.3: Central cooling). 2 Cooling towers (included in *sub-element* 5.6.3: Central cooling). 3 External cooling towers (included in *sub-element* 8.8.2: Ancillary buildings and structures). 4 General purpose low voltage (LV) power supplies (included in *sub-element* 5.8.2: Power installations). 5 Building management systems and other control systems (included in *sub-element* 5.12.3: Central control/building management systems (BMS)). 6 Builder's work in connection with services (included in *element* 5.14: Builder's work in connection with services). 7 Testing and commissioning of services (included in *element* 5.15: Testing and commissioning of services).
4 Water features **Definition:** Water systems for display or decorative purposes involving the movement of water.	1 Water feature: details to be stated.	nr	C1 Number of water features. C2 Work to existing buildings is to be described and identified separately.	1 Water features, including fountains and waterfalls. 2 Water filtration equipment. 3 Nutrient treatment and equipment. 4 Final electrical connections. 5 Control components. 6 Sundry items. 7 Where works are to be carried out by a *subcontractor*, *subcontractor's preliminaries*, design fees, risk allowance, overheads and profit.	1 Cold water supply (included in *sub-element* 5.4.2: Cold water distribution). 2 General purpose low voltage (LV) power supplies (included in *sub-element* 5.8.2: Power installations). 3 Building management systems and other control systems (included in *sub-element* 5.12.3: Central control/building management systems (BMS)). 4 Builder's work in connection with services (included in *element* 5.14: Builder's work in connection with services). 5 Testing and commissioning of services (included in *element* 5.15: Testing and commissioning of services).

Sub-element	Component	Unit	Measurement rules for components	Included	Excluded
5 Other specialist installations **Definition:** Specialist installations not covered by *elements* 5.1 to 5.12 or *sub-elements* 5.13.1 to 5.13.4.	1 Other specialist installations: details of each type of system to be stated.	nr/m²	C1 Where components are to be enumerated, the number of components is to be stated. C2 The area measured is the area serviced by the system (i.e. the area of the rooms and circulation spaces that are served by the system, which is not necessarily the total gross internal floor area (GIFA) of the building). The area serviced is measured using the rules of measurement for ascertaining the GIFA. C3 Where more than one system is employed, the area measured for each system is the area serviced by the system. Areas to be measured using the rules of measurement for ascertaining the GIFA. C4 Work to existing buildings is to be described and identified separately.	1 Wave machines. 2 Sauna. 3 Jacuzzi. 4 Swimming pools. 5 Other specialist installations. 6 Sundry items. 7 Where works are to be carried out by a *subcontractor, subcontractor's preliminaries,* design fees, risk allowance, overheads and profit.	1 Water supply (included in *element* 5.4: Water installations as appropriate). 2 Gas supply (included in *sub-element* 5.9.1: Gas distribution) 3 General purpose low voltage (LV) power supplies (included in *sub-element* 5.8.2: Power installations). 4 Building management systems and other control systems (included in *sub-element* 5.12.3: Central control/building management systems (BMS)). 5 Builder's work in connection with services (included in *element* 5.14: Builder's work in connection with services). 6 Testing and commissioning of services (included in *element* 5.15: Testing and commissioning of services).

Element 5.14: Builder's work in connection with services

Sub-element	Component	Unit	Measurement rules for components	Included	Excluded
1 General builder's work **Definition:** Sundry builder's work associated with the installation of water, gas, electricity, heating, ventilation above ground drainage, telecommunications and other services.	1 Builder's work in general areas: details to be stated. 2 Builder's work to landlord areas: details to be stated. 3 Builder's work to plant rooms: details to be stated. 4 Fuel bunds: details to be stated.	m² m² m² nr	C1 Where components are to be enumerated, the number of components is to be stated. C2 The area measured is the floor area relating to each builder's work classification. The area is measured using the rules of measurement for ascertaining the gross internal floor area (GIFA). C3 Other cost significant items are to be measured by area (m²), linear measurement (m) or enumerated (nr) and identified separately. C4 Work to existing buildings is to be described and identified separately.	1 Builder's work in general areas. 2 Builder's work to landlord areas. 3 Builder's work to plant rooms. 4 Machine bases constructed on top of ground slabs and beds. 5 Fuel bunds and the like to storage/retention tanks and vessels. 6 Forming/cutting holes, mortices, sinkings, chases and the like, including making good. 7 Ducts, pipe sleeves and the like. 8 Trench covers, duct covers and frames. 9 Supports to storage tanks, vessels, cisterns and the like. 10 Stopping up and sealing holes. 11 Fire resistant stopping, including fire sleeves. 12 Fire breaks. 13 Painting/anti-corrosion treatments of mechanical services equipment, including fuel storage tanks and vessels, supports and pipelines. 14 Identification labelling and colour coding of services installations and systems. 15 Other builder's work items in connection with services. 16 Sundry items. 17 Where works are to be carried out by a *subcontractor, subcontractor's preliminaries, design fees, risk allowance, overheads and profit.*	

Element 5.15: Testing and commissioning of services

Sub-element	Component	Unit	Measurement rules for components	Included	Excluded
1 Testing and commissioning of services **Definition:** Testing and commissioning of mechanical and electrical services and installations.	1 Testing: details, including type of service installation, to be stated. 2 Commissioning: details, including type of service installation, to be stated.	% %	C1 The percentage addition is to be applied to the cost targets for elements 5.1 to 5.13 inclusive as appropriate. C2 Each system is to be identified separately.	1 Testing equipment and consumables. 2 Calibration. 3 Site installation tests. 4 Static testing, including testing records. 5 Performance testing, including performance test records. 6 Commissioning, including preliminary checks, setting systems and installations to work and regulation thereof, and commissioning records. 7 Temporary operation of equipment to employer's requirements. 8 Fuels required for testing and commissioning. 9 Sundry items. 10 Where works are to be carried out by a subcontractor or sub-consultant, subcontractor's or sub-consultant's preliminaries, design fees, risk allowance, overheads and profit.	

Group element 6: Complete buildings and building units

Group element 6 comprises the following elements:

6.1 Prefabricated buildings

Element 6.1: Prefabricated buildings

Sub-element	Component	Unit	Measurement rules for components	Included	Excluded
1 Complete buildings **Definition:** Complete or substantially complete building superstructures of proprietary construction, largely prefabricated.	1 Complete buildings: details to be stated.	m²	C1 The area measured is the gross internal floor area (GIFA) of the complete building unit. The area is measured using the rules of measurement for ascertaining GIFA.	1 Prefabricated buildings/building systems. 2 Where included as part of the building systems: – structure, roof and wall cladding – rainwater drainage – windows, external doors, stairs and the like – internal partitions, linings and finishes – internal doors – fixtures, furnishings and equipment – sanitary appliances – mechanical and electrical services – stopping up and sealing holes – fire resistant stopping, including fire sleeves – fire breaks around units.	1 Non-permanent prefabricated buildings/building systems (i.e. used as temporary accommodation for the duration or the building project (included in *sub-element* 10.1.1: Site accommodation (employer's requirements) or *sub-element* 10.2.2: Site establishment (main contractor's cost items) as appropriate). 2 Foundations and substructures (included In *group element* 1: Substructure). 3 Drainage below ground (included in *sub-element* 1.4.1: Ground floor slab/bed and suspended floor construction or *element* 8.6: External drainage, as appropriate). 4 Minor prefabricated buildings such as workshops, sheds, stores and the like (included in *sub-element* 8.8.2: Ancillary buildings and structures).

Sub-element	Component	Unit	Measurement rules for components	Included	Excluded
2 Building units **Definition:** Complete or substantially complete room units of proprietary construction, largely prefabricated, for incorporation into buildings.	1 Building units: details, including number (nr) of identical units, to be stated.	m²	C1 The area measured is the gross internal floor area (GIFA) for each type of unit. The area is measured using the rules of measurement for ascertaining GIFA.	1 Prefabricated room units, such as: – accommodation units/bedroom units – office units – toilet units/washroom units – soundproof rooms – computer rooms – cold rooms – spray booths – kiosks. 2 Where included as part of the building unit: – structure, roof and wall cladding – windows, external doors, stairs and the like – internal partitions, linings and finishes – internal doors – fixtures, furnishings and equipment – sanitary appliances – mechanical and electrical services – stopping up and sealing holes – fire resistant stopping, including fire sleeves – fire breaks around units.	1 Complete prefabricated buildings (included in sub-element 6.1.1: Complete buildings. 2 Bathroom, toilet and shower pods (included in sub-element 5.1.2: Pods).

Group element 7: Work to existing buildings

Group element 7 comprises the following elements:

7.1 Minor demolition works and alteration works

7.2 Repairs to existing services

7.3 Damp-proof courses/fungus and beetle eradication

7.4 Facade retention

7.5 Cleaning existing surfaces

7.6 Renovation works

Note: Fit-out works in connection with a new building (i.e. built to shell and core) do not constitute works to existing buildings. Such fit-out works are to be measured as new works in accordance with the measurement rules.

Element 7.1: Minor demolition works and alteration works

Sub-element	Component	Unit	Measurement rules for components	Included	Excluded
1 Minor demolition works and alteration works **Definition:** Individual items of work to existing buildings, involving one or more trade, in altering, adapting or repairing existing buildings, including cutting away and removing existing work and inserting new, and minor demolition works and soft strip.	1 Spot items: details to be stated. 2 Minor demolition works: details to be stated. 3 Removal: details to be stated. 4 Alteration works: details to be stated.	item nr/m/ m² item/ nr/m/ m² item/ nr/m/ m²	C1 Where components are to be enumerated, the number of components is to be stated. C2 Where the length of a component is to be measured, the length of linear components measured is their extreme length, over all obstructions. C3 Where the area of a component is to be measured, the area measured for items is the surface area of item. No deduction for voids. C4 Work arising out of party wall awards/agreements is to be described and identified separately.	1 Stripping out existing services installations, including pipe casings and the like. 2 Stripping out fixtures, fittings. 3 Stripping out skirtings, dado rails, picture rails, architraves and the like. 4 Taking out kitchen fittings and appliances. 5 Removing shelves, work benches and the like. 6 Removing sanitary appliances and fittings. 7 Removing parts of existing buildings. 8 Cutting openings in existing work. 9 Strutting and supports to openings in walls or after removal of walls. 10 Inserting tie beams, tie rods and the like. 11 Removing wall, floor and ceiling finishes. 12 Removing internal walls and partitions, including making good. 13 Removing floor construction. 14 Removing existing roof coverings. 15 Repairs to external wall cladding and covering systems. 16 Repairs to roof coverings (e.g. tiles, slates, sheet coverings, flexible sheet coverings and asphalt). 17 Repairs to existing rainwater installations. 18 Rebuilding chimney stacks. 19 Cutting back chimney breasts. 20 Rebuilding piers and columns. 21 Rebuilding walls and partitions (isolated – where not included in element 2.7: Internal walls and partitions).	1 Removal of toxic or hazardous material prior to alteration works, e.g. asbestos removal (included in sub-element 9.1.1: Toxic or hazardous material removal). 2 Decontaminating existing services systems prior to demolition, e.g. boilers and fuel storage tanks and vessels (included in sub-element 9.1.1: Toxic or hazardous material removal). 3 Underpinning to external walls which are an integral part of the new building (included in sub-element 1.1.3: Underpinning). 4 Underpinning to walls within existing buildings, which are to be rehabilitated, i.e. internal walls (included in sub-element 1.1.3: Underpinning). 5 Underpinning to external site boundary walls (included in sub-element 8.8.3: Underpinning to external site boundary walls). 6 Overhauling and repairs to existing mechanical and electrical installations, systems, plant and equipment (included in sub-element 7.2.1: Existing services). 7 Repairs to masonry, concrete, metal, timber and plastics components (included in element 7.6: Renovation works, as appropriate). 8 New building work and services within existing buildings to be included in the appropriate element/sub-element for building works. Work to existing buildings to be described and identified separately within each element/sub-element.

Sub-element	Component	Unit	Measurement rules for components	Included	Excluded
				22 Repairs to sheet linings (e.g. plasterboard and timber sheeting – to walls, floors and ceilings). 23 Taking out windows, doors, frames, linings, screens and the like preparatory to filling openings and/or taking down wall or partition. 24 Filling in or covering over existing openings. 25 Inserting new windows, doors, stairs, rooflights and the like into existing building fabric. 26 Re-glazing. 27 Repairs to screeds. 28 Repairs to toppings (e.g. granolithic). 29 Latex screeds (i.e. to existing floors). 30 Repairs to plastered, rendered and roughcast coatings (including lathing and baseboards). 31 Repairs to tiled finishes – walls and floors (e.g. quarry tiles, ceramic tiles). 32 Repairs to wood block flooring. 33 Repairs to floor coverings. 34 Degreasing old painted surfaces 35 Stripping previously decorated surfaces. 36 Removing paint from timber, metal and other similar surfaces (e.g. burning off paint and chemically stripping paint). 37 Repainting existing timber, metal and other similar surfaces (e.g. windows, doors, rooflights and the like). 38 Scrapping paint from plastered surfaces and the like. 39 Minor painting and redecoration (e.g. touch-up painting). 40 Overhauling ironmongery to windows, doors and the like.	9 Repairs to or replacement of structural members (e.g. roof members and structural beams) – (included in *sub-element 7.6.2*: Concrete repairs, *sub-element 7.6.3*: Metal repairs or *sub-element 7.6.4*: Timber repairs, as appropriate). 10 Repairs to existing windows, doors, hatches, rooflights, frames, linings and the like (included in *sub-element 7.6.3*: Metal repairs, *sub-element 7.6.4*: Timber repairs or *sub-element 7.6.5*: Plastics repairs, as appropriate). 11 Damp-proof courses (included in *sub-element 7.3.1*: Damp-proof courses). 12 Fungus/beetle eradication (included in *sub-element 7.2.2*: Fungus/beetle eradication).

Sub-element	Component	Unit	Measurement rules for components	Included	Excluded
				41 Applying sealants to existing window and door frames, rooflights and the like. 42 Other alteration works (spot items). 43 Temporary screens required for alteration works. 44 Sundry items. 45 Where works are to be carried out by a subcontractor, subcontractor's preliminaries, design fees, risk allowance, overheads and profit.	

Element 7.2: Repairs to existing services

Sub-element	Component	Unit	Measurement rules for components	Included	Excluded
1 Existing services **Definition:** Refurbishment of existing services installations, systems, equipment and plant.	1 Equipment/plant repairs: details to be stated. 2 Overhauling services installations/systems: details to be stated.	nr m²	C1 Where components are to be enumerated, the number of components is to be stated. C2 The area measured is the area serviced by the installation/system. The area serviced is measured using the rules of measurement for ascertaining the gross internal floor area (GIFA). C3 Where more than one installation/system is employed, the area measured for each system is the area serviced by the installation/system. Areas to be measured using the rules of measurement for ascertaining the GIFA.	1 Repairs to existing sanitary appliances (including clearing blockages). 2 Repairs to/overhauling of existing mechanical and electrical plant and equipment (e.g. boilers, water heaters, storage tanks and vessels, and extractor fans), including the replacement of components. 3 Fault finding. 4 Overhauling existing mechanical and electrical installations and systems (e.g. heating installation, ventilation systems, electrical systems and the like), including the replacement of components. 5 Repairs and upgrades to existing specialist services (e.g. lifts).	1 Decontaminating existing services systems prior to demolition, e.g. boilers and fuel storage tanks and vessels (included in sub-element 9.1.1: Toxic or hazardous material removal). 2 New services installations (included in group element 5: Services, as appropriate). 3 New services equipment and plant (included in group element 5: Services, as appropriate).

Sub-element	Component	Unit	Measurement rules for components	Included	Excluded
			C4 Where components are to be itemised, the number of key elements comprising the component are to be identified, described and enumerated within the description of the component. C5 Other cost significant items are to be measured by area (m²), linear measurement (m) or enumerated (nr) and identified separately. C6 Work arising out of party wall awards/agreements is to be described and identified separately.	6 Renewing flue pipes. 7 Sundry items. 8 Where works are to be carried out by a subcontractor, subcontractor's preliminaries, design fees, risk allowance, overheads and profit.	

Element 7.3: Damp-proof courses/fungus and beetle eradication

Sub-element	Component	Unit	Measurement rules for components	Included	Excluded
1 Damp-proof courses **Definition:** Preventing rising damp in existing masonry walls.	1 Damp-proof courses: details to be stated.	m	C1 The length of linear components measured is their extreme length, over all obstructions. C2 Work arising out of party wall awards/agreements is to be described and identified separately.	1 Chemical damp-proof courses, including drilling holes, injecting chemicals and making good holes. 2 Injection mortar damp-proof courses. 3 Inserted mechanical damp-proof courses. 4 Local making good to finishes. 5 Sundry items. 6 Where works are to be carried out by a subcontractor, subcontractor's preliminaries, design fees, risk allowance, overheads and profit.	1 Damp-proof courses inserted into new walls (included in group element 1: Substructure, as appropriate).
2 Fungus/beetle eradication	1 Eradication treatment: details to be stated.	m²	C1 The area measured is the surface area of the treatment. No deduction for voids. C2 Work arising out of party wall awards/agreements is to be described and identified separately.	1 Opening up existing work (e.g. lifting and replacing floor boards). 2 Cutting out fungus or beetle infested timber, plaster and the like, and disposing of cut out material.	

Sub-element	Component	Unit	Measurement rules for components	Included	Excluded
Definition: Treating existing timbers to eradicate fungus attacks such as dry and wet rot, and various types of wood boring infestation.				3 Applying preservative treatment (e.g. irrigation of walls by pressure injection, application of anti-fungicide solution and treating with insecticide). 4 Solid rod preservative inserts. 5 Preservative treatments. 6 Paste preservative treatment. 7 Insecticidal smoke treatment. 8 Sundry items. 9 Where works are to be carried out by a subcontractor, subcontractor's preliminaries, design fees, risk allowance, overheads and profit.	

Element 7.4: Facade retention

Sub-element	Component	Unit	Measurement rules for components	Included	Excluded
1 Facade retention **Definition:** Temporary or semi-permanent support for unstable structures or facades (i.e. structures not to be demolished).	1 Support structures: details to be stated.	nr	C1 Where components are to be enumerated, the number of components is to be stated. C2 Work arising out of party wall awards/agreements is to be described and identified separately.	1 Location surveys. 2 Commencement and completion condition surveys. 3 Dead, raking, flying or box shores; strutting (including bracing; sole plates and wall plates; needles, including holes; brackets, blockings and wedges; dog irons and similar metal work). 4 Foundations for shores. 5 Cutting holes in existing structures for needles and the like. 6 Sundry items. 7 Where works are to be carried out by a subcontractor, subcontractor's preliminaries, design fees, risk allowance, overheads and profit.	1 Temporary screens required for alteration works (included in sub-element 7.1.1: Minor demolition works and alteration works). 2 Supports to small openings cut into existing walls or after removal of internal walls or the like (included in sub-element 7.1.1: Minor demolition works and alteration works).

Element 7.5: Cleaning existing surfaces

Sub-element	Component	Unit	Measurement rules for components	Included	Excluded
1 Cleaning existing surfaces **Definition:** Cleaning and removing stains and deposits from existing surfaces.	1 Cleaning existing surfaces: details to be stated.	m²	C1 The area measured is the surface area of the surface to be cleaned. No deduction for voids. C2 Work arising out of party wall awards/agreements is to be described and identified separately.	1 Removing efflorescence, stains, soot, graffiti, vegetation, algae, bird droppings and the like. 2 Cleaning by washing, abrasive blasting, chemical treatment or other methods. 3 Artificial weathering. 4 Sundry items. 5 Where works are to be carried out by a subcontractor, subcontractor's preliminaries, design fees, risk allowance, overheads and profit.	1 Bird repellent coatings and the like (included in sub-element 4.4.1: Bird and vermin control).
2 Protective coatings to existing surfaces **Definition:** Coatings to protect existing surfaces, including bird/vermin repellent coatings.	1 Protective coatings to existing surfaces: details to be stated.	m²	C1 The area measured is the surface area of the surface to be coated. No deduction for voids. C2 Work arising out of party wall awards/agreements is to be described and identified separately.	1 Internal and external surfaces. 2 Specialist painting/coating systems (i.e. designed for use on concrete, masonry, steelwork or the like). 3 Lime washing, colourless waterproofers, anti-graffiti colourless coatings and the like. 4 Bird repellent coatings and the like. 5 Sundry items. 6 Where works are to be carried out by a subcontractor, subcontractor's preliminaries, design fees, risk allowance, overheads and profit.	1 Bird repellent coatings and the like (included in sub-element 4.4.1: Bird and vermin control).

Element 7.6: Renovation works

Sub-element	Component	Unit	Measurement rules for components	Included	Excluded
1 Masonry repairs **Definition:** Local cutting out and reinstatement of existing brick, block or stonework and repointing defective joints.	1 Masonry repairs; details to be stated.	nr/m/ m²	C1 Where components are to be enumerated, the number of components is to be stated. C2 Where the length of a repair is to be measured, the length of linear components measured is their extreme length, over all obstructions. C3 Where the area of a repair is to be measured, the area measured is the surface area of the repair. C4 Work arising out of party wall awards/agreements is to be described and identified separately.	1 Cutting out decayed, defective and cracked bricks, blocks or stones and inserting new (including isolated repairs, stitching and the like). 2 Plastic stone repairs. 3 Re-dressing stonework to new profiles. 4 Inserting new wall ties (without demolition). 5 Grouting. 6 Rejointing/repointing existing masonry. 7 Sundry items. 8 Where works are to be carried out by a *subcontractor, subcontractor's preliminaries,* design fees, risk allowance, overheads and profit.	1 Damp-proof courses inserted into new walls (included in *group element 1: Substructure* as appropriate).
2 Concrete repairs **Definition:** Cutting out, repairing, partially replacing, resurfacing and rehabilitating eroded and defective concrete.	1 Concrete repairs; details to be stated.	nr/m/ m²	C1 Where components are to be enumerated, the number of components is to be stated. C2 The length of linear components measured is their extreme length, over all obstructions. C3 The area measured is the surface area of the repair. C4 Work arising out of party wall awards/agreements is to be described and identified separately.	1 Cutting out defective concrete and replacing with new. 2 Cutting out defective reinforcement and replacing with new. 3 Cleaning and rust proofing existing rusted reinforcement. 4 Concrete and resin/cement mixes in repairs and resurfacing, including spray applied concrete. 5 Anchored mesh reinforcement. 6 Resin or cement impregnation/injection. 7 Sundry items. 8 Where works are to be carried out by a *subcontractor, subcontractor's preliminaries,* design fees, risk allowance, overheads and profit.	

Sub-element	Component	Unit	Measurement rules for components	Included	Excluded
3 Metal repairs **Definition:** Repairing, renovating and conserving existing architectural metalwork, metal components and finishes.	1 Metal repairs: details to be stated.	nr/m/ m²	C1 Where components are to be enumerated, the number of components is to be stated. C2 The length of linear components measured is their extreme length, over all obstructions. C3 The area measured is the surface area of the repair. C4 Work arising out of party wall awards/agreements is to be described and identified separately.	1 Taking down metalwork. 2 Cleaning and restoring surface finishes. 3 Straightening. 4 Rust proofing. 5 Metalwork repairs (e.g. welding, riveting and bolting), rejointing, reassembling and refixing. 6 Renewing surface finishes off-site. 7 Repairs to structural members (e.g. roof members and structural beams). 8 Repairs to existing windows, doors, hatches, rooflights, frames, linings and the like (including overhauling/renewing ironmongery, sash cords, opening gear and the like). 9 Repairs to staircases, including handrails and balustrades. 10 Sundry items. 11 Where works are to be carried out by a *subcontractor, subcontractor's preliminaries*, design fees, risk allowance, overheads and profit.	1 Renewing/replacing metal components in their entirety (e.g. roof structure, windows, doors, frames, rooflights and the like) – (included in *group element 2: Superstructure* or *sub-element 7.1.1: Minor demolition works and alteration works*, as appropriate).

Sub-element	Component	Unit	Measurement rules for components	Included	Excluded
4 Timber repairs **Definition:** Repairing, renovating and conserving existing timber structures, components and finishes.	1 Timber repairs: details to be stated.	nr/m/ m²	C1 Where components are to be enumerated, the number of components is to be stated. C2 The length of linear components measured is their extreme length, over all obstructions. C3 The area measured is the surface area of the repair. C4 Work arising out of party wall awards/agreements is to be described and identified separately.	1 Taking down existing work, cleaning and resurfacing, cutting out defective or decayed timber; piecing-in new timber; rejointing, refixing work. 2 Resin repairs to timbers. 3 Preservative/fire retardant treatments. 4 Repairs to structural members (e.g. roof members and structural beams). 5 Repairs to existing windows, doors, hatches, rooflights, frames, linings and the like (including overhauling/renewing ironmongery, sash cords, opening gear and the like). 9 Repairs to staircases, including handrails and balustrades. 10 Sundry items. 11 Where works are to be carried out by a subcontractor, subcontractor's preliminaries, design fees, risk allowance, overheads and profit.	1 Renewing/replacing timber components in their entirety (e.g. roof structure, windows, doors, frames, rooflights and the like) – (included in group element 2: Superstructure or sub-element 7.1.1: Minor demolition works and alteration works, as appropriate).
5 Plastics repairs **Definition:** Repairs to plastic windows, rooflights, doors, cladding and the like.	1 Plastics repairs: details to be stated.	nr/m/ m²	C1 Where components are to be enumerated, the number of components is to be stated. C2 The length of linear components measured is their extreme length, over all obstructions. C3 The area measured is the surface area of the repair. C4 Work arising out of party wall awards/agreements is to be described and identified separately.	1 Renewing domed rooflights. 2 Overhauling of windows, rooflights, doors and the like. 3 Repairs to rooflights, doors and the like. 4 Repairs to cladding and the like.	1 Renewing/replacing plastics components in their entirety (e.g. roof coverings, windows, doors (including frames), rooflights and the like) – (included in group element 2: Superstructure or sub-element 7.1.1: Minor demolition works and alteration works, as appropriate).

Group element 8: External works

Group element 8 comprises the following elements:

8.1 Site preparation works

8.2 Roads, paths and pavings

8.3 Planting

8.4 Fencing, railings and walls

8.5 Site/street furniture and equipment

8.6 External drainage

8.7 External services

8.8 Minor building works and ancillary buildings

Note: Works associated with toxic/hazardous material removal; major demolition works; specialist groundworks; temporary diversion works and extraordinary site investigation works are included in group element 9: Facilitating works.

Element 8.1: Site preparation works

Sub-element	Component	Unit	Measurement rules for components	Included	Excluded
1 Site clearance **Definition:** Preparatory work required to clear existing site vegetation, trees and the like, including the application of herbicides over the site before commencement of excavation works.	1 Clearing vegetation: details to be stated.	m²	C1 Where components are to be enumerated, the number of components is to be stated. C2 Where components are to be itemised, the number of key elements comprising the component are to be identified, described and enumerated within the description of the component. C3 The area measured is the surface area to which the work applies. C4 Other cost significant components are to be described and identified separately. Such components are to be measured by area (m²), linear measurement (m) or enumerated (nr) separately in accordance with the rules of measurement for this *sub-element*. C5 Work outside the curtilage of the site is to be described and identified separately.	1 Clearing existing site vegetation (e.g. shrubs and undergrowth), including disposing of arisings. 2 Taking down trees, including grubbing up tree stumps and roots and disposing of arisings. 3 Protection of protected trees. 4 Minor demolition works (e.g. outbuildings and the like). 5 Applying herbicides before commencement of excavation works. 6 Sundry items. 7 Where works are to be carried out by a *subcontractor, subcontractor's preliminaries, design fees, risk allowance, overheads and profit.*	1 Removal of toxic or hazardous materials (e.g. asbestos) – (included in *sub-element* 9.1.1: Toxic or hazardous material removal). 2 Major demolition works (included in *sub-element* 9.2.1: Demolition works). 3 Contaminated ground material removal (included in *sub-element* 9.1.2: Contaminated land). 4 Contaminated ground material treatment (included in *sub-element* 9.1.2: Contaminated land). 5 Eradication of Japanese knotweed, giant hogweed or other invasive plant (included in *sub-element* 9.1.3: Eradication of plant growth). 6 General site contouring and adjusting levels (included in *sub-element* 8.1.2: Preparatory groundworks).
	2 Taking down trees: details to be stated.	nr			
	3 Removing tree stumps and roots: details to be stated.	nr			
	4 Tree protection: details to be stated.	item			
	5 Minor demolition works: details to be stated.	item/nr			
	6 Applying herbicides: details to be stated.	m²			

Sub-element	Component	Unit	Measurement rules for components	Included	Excluded
2 Preparatory groundworks **Definition:** Preparatory earthworks to form new contours.	1 Forming new site contours and adjusting existing site levels: details to be stated.	m²	C1 Where components are to be enumerated, the number of components is to be stated. C2 The area measured is the surface area to which the work applies. C3 Other cost significant components are to be described and identified separately. Such components are to be measured by area (m²), linear measurement (m) or enumerated (nr) separately in accordance with the rules of measurement for this sub-element. C4 Work outside the curtilage of the site is to be described and identified separately.	1 Excavation and earthworks to form new site contours and adjust existing site levels. 2 Breaking out (or grubbing up) existing substructures, ground slabs, strip foundations, basement retaining walls and the like, including disposal. 3 Extracting old piles, including disposal. 4 Breaking out existing hard pavings, including concrete, bituminous bound material, brick, block and other hard materials, including disposal. 5 Removing existing underground storage tanks, including disposal and decontamination where not undertaken as facilitating works. 6 Grubbing up redundant foul and surface water drainage, including manholes, soakaways, catch pits, interceptors and the like, including disposal. Filling void. 7 Filling disused manholes, shafts and the like. 8 Sundry items. 9 Where works are to be carried out by a subcontractor, subcontractor's preliminaries, design fees, risk allowance, overheads and profit.	1 Ground investigation (included in group element 12: Project/design team fees). 2 Removing contaminated ground material (included in sub-element 9.1.2: Contaminated land). 3 Treatment of contaminated ground material (included in sub-element 9.1.2: Contaminated land). 4 Eradication of Japanese knotweed, giant hogweed or other invasive plant (included in sub-element 9.1.3: Eradication of plant growth). 5 Site dewatering and pumping (included in sub-element 9.1.3: Eradication of plant growth). 6 Soil stabilisation measures (included in sub-element 9.1.3: Eradication of plant growth). 7 Ground gas venting measures (included in sub-element 9.1.3: Eradication of plant growth). 8 Temporary diversion of existing drainage systems, existing services installations and systems, rivers, streams and the like (included in sub-element 9.4.1: Temporary diversion works). 9 Cultivating and final grading of soil for seeding, turfing or planting (included in element 8.3: Planting, as appropriate). 10 Excavation and earthworks associated with foundations, basements, ground slabs and beds (included in group element 1: Substructure, as appropriate).
	2 Breaking out existing substructures: details to be stated.	m²			
	3 Breaking out existing hard pavings: details to be stated.	m²			
	4 Grubbing up old drainage pipelines: details to be stated.	m			
	5 Grubbing up old manholes and the like: details to be stated.	nr			
	6 Filling disused manholes and the like: details to be stated.	nr			
	7 Removing existing underground storage tanks, including disposal: details to be stated.	nr			

Element 8.2: Roads, paths and pavings

Sub-element	Component	Unit	Measurement rules for components	Included	Excluded
1 Roads, paths and pavings **Definition:** Roads, paths and pavements, vehicular and pedestrian, including car parks and protection of grassed areas, and non-specialist surfacings and pavings used for sports and general amenities.	1 Roads: details, including width, to be stated.	m	C1 Where components are to be enumerated, the number of components is to be stated. C2 The length of linear components measured is their extreme length, over all obstructions. C3 The area measured for paved areas, hardstandings and the like is the surface area of the paving. No deduction is made for voids caused by tree grilles and the like. C4 Other cost significant components are to be described and identified separately. Such components are to be measured by area (m²), linear measurement (m) or enumerated (nr) separately in accordance with the rules of measurement for this sub-element. C5 Descriptions shall include the amount of any PC Sum included in the unit rates applied to the item. C6 Curved work is to be described and identified separately. C7 Work outside the curtilage of the site is to be described and identified separately.	1 Excavation and earthworks associated with the construction of roads, paths and pavings. 2 Disposal of excavated material, including tipping charges and landfill tax (including inert, non-hazardous and hazardous material where not to be carried out as facilitating works). **Note:** Where no contamination/remediation strategy report exists, an allowance is to be made within the construction *risk allowance* for the extra cost of disposing of contaminated material. 3 Disposal of surface water and ground water. 4 Preparation of sub-grades, including applying herbicides, levelling, grading, rolling, sub-grade improvement layers and geotextile membranes. 5 Sub-bases to roads, paths and pavings (e.g. granular and soil-cement) including laying, levelling, grading, and compacting. 6 Blinding (e.g. sand, cement bound sand and lean mix concrete). 7 In-situ concrete to roads, paths and pavings, including formwork, reinforcement, joints, worked finishes and the like. 8 Coated macadam and asphalt to roads, paths and pavings, including road bases, base course and wearing courses, application of binders, forming channels and the like. 9 Interlocking bricks and blocks to roads, paths and pavings, including sand beds, geotextile membranes, paving units, integral kerbs and edgings, and vibrating pavings.	1 Temporary roads, paths, pavings, hardstandings and the like (included in *sub-element* 10.2.2: Site establishment). 2 Special surfacings and pavings for sport and general amenity areas (included in *sub-element* 8.2.2: Special surfacings and pavings). 3 Bollards, including removable and collapsible (included in *sub-element* 8.5.1: Site/street furniture and equipment). 4 Surface water drainage, including road gullies (included in *sub-element* 8.6.1: Surface water and foul water drainage). 5 Prefabricated channels where not formed by using paving material (included in *sub-element* 8.6.1: Surface water and foul water drainage).
	2 Paths: details, including width, to be stated.	m			
	3 Paved areas, hardstandings and the like: details to be stated.	m²			
	3 Roundabouts: details to be stated.	nr			
	4 Road crossings: details to be stated.	nr			
	5 Steps: details to be stated.	nr			
	6 Ramps: details to be stated.	nr			
	7 Traffic calming accessories: details to be stated.	nr/m			
	8 Tree grilles: details to be stated.	nr			
	9 Vehicle protection barriers: details to be stated.	m			

Sub-element	Component	Unit	Measurement rules for components	Included	Excluded
	10 Bumpers: details to be stated.	m		10 Paving slabs to paths and pavings, including sand and mortar beds, separating layers, geotextile membranes, paving slabs, shallow channels and low edgings formed with standard paving units, movement joints and dividing strips (e.g. precast concrete, natural and artificial stone slab paving).	
	11 Pavement markings: details to be stated.	nr/m		11 Frangible smoke outlet paving panels to basements.	
	12 Repairs to existing roads, paths and pavings: details to be stated.	nr/m/m²		12 Paving slab cycle stands.	
				13 Brick paving to paths and pavings, including sand and mortar beds, separating layers, geotextile membranes, brick paving, shallow channels and low edgings formed with standard paving units, movement joints and dividing strips.	
				14 Sett and cobbled pavings to roads, paths and pavings, including sand and mortar beds, separating layers, geotextile membranes, brick paving, shallow channels and low edgings formed with standard paving units, movement joints and dividing strips (e.g. stone setts, concrete setts and cobbles).	
				15 Gravel surfacing to roads, paths and pavings (sealed and unsealed), including treating base with weedkiller, geotextile membranes, sealing surface with bituminous emulsion and the like.	
				16 Uncoated stone chipping surfacing to roads, paths and pavings, including treating base with weedkiller, binders and the like.	
				17 Hoggin and woodchip surfacing to roads, paths and pavings, including treating base with weedkiller, binders and the like.	
				18 Perforated units as protection to grassed areas (e.g. to form roads, paths and car parking areas).	

Sub-element	Component	Unit	Measurement rules for components	Included	Excluded
				19 Kerbs, kerb channels and the like, including concrete foundations, and haunchings, kerbs and kerb accessories (standard and purpose made kerbs).	
				20 Edgings, including concrete foundations and haunchings (standard and purpose made edgings).	
				21 Timber edgings and pegs.	
				22 Road crossings, zebra crossings and pelican crossings, including road markings, beacons, lights, signs, advance danger signs and the like and final connections to services.	
				23 Vehicle protection barriers	
				24 Vehicle bump rails and the like.	
				25 Paving accessories, including cat's eyes, tree grilles, traffic calming accessories and the like.	
				26 Pavement markings, including paint, thermoplastic and hot applied markings.	
				27 Steps, including structure, finishings, balustrades and handrails.	
				28 Ramps, including structure, finishings, balustrades and handrails.	
				29 Repairs to existing roads, paths and pavings.	
				30 Sundry items.	
				31 Where works are to be carried out by a *subcontractor*, *subcontractor's preliminaries*, design fees, risk allowance, overheads and profit.	

Sub-element	Component	Unit	Measurement rules for components	Included	Excluded
2 Special surfacings and pavings **Definition:** Surfacings and pavings specially and specifically for outdoor sporting activities and general amenities.	1 Surfacings and pavings: details to be stated.	m²	C1 Where components are to be enumerated, the number of components is to be stated. C2 The length of linear components measured is their extreme length, over all obstructions. C3 The area measured for surfacings and pavings is the surface area of the surfacing or paving. C4 Other cost significant components are to be described and identified separately. Such components are to be measured by area (m²), linear measurement (m) or enumerated (nr) separately in accordance with the rules of measurement for this sub-element. C5 Descriptions shall include the amount of any PC Sum included in the unit rates applied to the item. C6 Work outside the curtilage of the site is to be described and identified separately.	1 Surfacings and pavings designed specially and specifically for sports and general amenities, such as: – sheet and liquid applied surfacings (e.g. synthetic rubber, granulated rubber, plastics and fibre) – synthetic tufted surfacings for ski slopes – proprietary coloured no fines concrete and clay/shale surfacings and pavings. 2 Excavation and earthworks associated with the construction of surfacings and pavings for sporting activities and general amenities. 3 Disposal of excavated material, including tipping charges and landfill tax (including inert, non-hazardous and hazardous material where not to be carried out as facilitating works). **Note:** Where no contamination/remediation strategy report exists, an allowance is to be made within the construction *risk allowance* for the extra cost of disposing of contaminated material. 4 Disposal of surface water and ground water. 5 Preparation of sub-grades, including applying herbicides, levelling, grading, rolling, sub-grade improvement layers and geotextile membranes and the like. 6 Sub-bases to surfacings and pavings, including laying, levelling, grading, and compacting. 7 Accessories to surfacings and pavings. 8 Markings to surfacings and pavings. 9 Sundry items. 10 Where works are to be carried out by a *subcontractor*, *subcontractor's preliminaries*, design fees, risk allowance, overheads and profit.	1 Non-specialist surfacings and pavings used for sports and general amenities (included in *sub-element 8.2.1:* Roads, paths and pavings). 2 Natural grass surfaces used for sports (included in *sub-element 8.3.1:* Seeding and turfing). 3 Indoor surfaces used for sports (included in *sub-element 3.2.1:* Finishes to floors). 4 Surface water drainage, which is not an integral part of the surfacing or paving system (included in *sub-element 8.6.1:* Surface water and foul drainage or *sub-element 8.6.3:* Land drainage, as appropriate).

Element 8.3: Planting

Sub-element	Component	Unit	Measurement rules for components	Included	Excluded
1 Seeding and turfing **Definition:** Preparing soil and seeding or turfing to form lawns, parklands and other general grassed areas.	1 Grassed areas: details to be stated.	m²	C1 Where components are to be enumerated, the number of components is to be stated. C2 The length of linear components measured is their extreme length, over all obstructions. C3 The area measured for grassed areas is the surface area of the area to be grassed, measured over all obstructions. Areas of roads, paths, pavings, ponds and the like to be deducted. C4 Other cost significant components are to be described and identified separately. Such components are to be measured by area (m²), linear measurement (m) or enumerated (nr) separately in accordance with the rules of measurement for this *sub-element*. C5 Descriptions shall include the amount of any PC Sum included in the unit rates applied to the item. C6 Work outside the curtilage of the site is to be described and identified separately.	1 Applying herbicides. 2 Topsoil, including transporting from stockpiles or importing topsoil and spreading. 3 Cultivating topsoil, including removing stones and weeds. 4 Fine grading of topsoil. 5 Providing, spreading and working in manure, compost, mulch, fertilised, soil ameliorants and the like. 6 Light mesh reinforcement. 7 Seeding, including hydraulic seeding. 8 Turfing. 9 Reinforced grass proprietary systems, including sub-base, topsoil, reinforced root zone, seeding or turfing. 10 Seeding and turfing to retaining structures. 11 Initial grass cutting. 12 Initial marking out of grass sports pitches (e.g. football, rugby and cricket). 13 Watering, before end of defects liability period, period for rectifying defects or maintenance period. 14 Replacement seeding and turfing. 15 Maintenance work specified to be executed during the defects liability period, period for rectifying defects or maintenance period (i.e. as distinct from making good defects), including mowing and fertilising. 16 Work to existing grassed areas, including scarifying, forking, fertilising, applying weedkillers, local reseeding or returfing, etc. 17 Sundry items. 18 Where works are to be carried out by a *subcontractor*, *subcontractor's preliminaries*, design fees, risk allowance, overheads and profit.	1 Excavation and earthworks to forming new site contours and adjust existing site levels (included in *sub-element* 8.1.2: Preparatory groundworks). 2 Grass block pavings (included in *sub-element* 8.2.1: Roads, paths and pavings).
	2 Reinforced grass proprietary systems: details to be stated.	m²			
	3 Marking out of grass sports pitches: details to be stated.	nr			
	4 Work to existing grassed areas: details to be stated.	m²			
	5 Maintenance of grassed areas: details, including time period (weeks) to be stated.	m²			

Sub-element	Component	Unit	Measurement rules for components	Included	Excluded
2 External planting **Definition:** Preparing soil and planting bulbs, corms, tubers, hebacaceous plants, trees, hedges, shrubs and reed beds.	1 Planting: details to be stated.	m²	C1 Where components are to be enumerated, the number of components is to be stated.	1 Applying herbicides.	1 Clearing existing site vegetation (e.g. shrubs and undergrowth), including disposing of arisings (included in *sub-element* 8.1.1: Site clearance).
	2 Planting reed beds: details to be stated.	m²	C2 The length of linear components measured is their extreme length, over all obstructions.	2 Topsoil, including transporting from stockpiles or importing topsoil and spreading.	2 Taking down trees, including grubbing up tree stumps and roots and disposing of arisings (included in *sub-element* 8.1.1: Site clearance).
	3 Hedges: details to be stated.	m	C3 The area measured is the surface area of external planting, measured over all obstructions. Areas of roads, paths, pavings, ponds and the like to be deducted.	3 Cultivating topsoil, including removing stones and weeds.	3 General site contouring and adjusting levels (included in *sub-element* 8.1.2: Preparatory groundworks).
	4 Trees: details to be stated.	nr	C4 Other cost significant components are to be described and identified separately. Such components are to be measured by area (m²), linear measurement (m) or enumerated (nr) separately in accordance with the rules of measurement for this *sub-element*.	4 Fine grading of topsoil.	4 Internal planting (included in *sub-element* 4.3.1: Internal planting).
	5 Woodland planting: details to be stated.	m²		5 Forming raised and sunken beds, borders and the like.	5 Tree grilles (included in *sub-element* 8.2.1: Roads, paths and pavings).
	6 Tree surgery, thinning and pruning: details to be stated.	nr	C5 Descriptions shall include the amount of any PC Sum included in the unit rates applied to the item.	6 Providing, spreading and working in manure, compost, mulch, fertilised, soil ameliorants and the like.	6 Seeding and turfing (included in *sub-element* 8.3.1: Seeding and turfing).
	7 Maintenance work to plants and shrubs and planting beds: details, including time period (weeks), to be stated.	m²	C6 Work outside the curtilage of the site is to be described and identified separately.	7 Overlays, including mulch matting, and gravel, bark or other materials.	7 Green roofs and roof gardens (included in *sub-element* 2.3.2: Roof coverings).
	8 Maintenance work to trees: details, including number of occasions and time period (weeks), to be stated.	nr		8 Planting bulbs, corms, tubers and the like.	8 Planting to green roofs/roof gardens (included in *sub-element* 2.3.2: Roof coverings).
	9 Maintenance work to hedges: details, including time period (weeks), to be stated.	m		9 Planting container grown plants.	
				10 Planting to retaining structures.	
				11 Planting shrubs and hedges.	
				12 Fence support for hedges.	
				13 Planting trees, including nursery stock and semi-mature trees.	
				14 Excavating and back filling tree pits.	
				15 External prefabricated plant/tree containers.	
				16 Support wires for climbers, tree stakes, tree guards, wrapping, labelling, and other protection of trees, shrubs and plants.	
				17 Planting reed beds and the like.	
				18 Woodland planting.	
				19 Tree surgery, thinning and pruning.	
				20 Roof gardens.	
				21 Applying anti-desiccants.	
				21 Watering, before end of defects liability period, period for rectifying defects or maintenance period.	
				22 Protecting new planted areas with temporary fencing, boards, tarpaulins, and the like.	

Sub-element	Component	Unit	Measurement rules for components	Included	Excluded
				23 Maintenance work specified to be executed during the defects liability period, period for rectifying defects or maintenance period (i.e. as distinct from making good defects), including weeding and pruning. 24 Replacement planting. 25 Sundry items. 26 Where works are to be carried out by a *subcontractor, subcontractor's preliminaries*, design fees, risk allowance, overheads and profit.	

Element 8.4: Fencing, railings and walls

Sub-element	Component	Unit	Measurement rules for components	Included	Excluded
1 Fencing and railings **Definition:** Fencing and railings and the like to prevent access to or from an area, or to provide light or noise screening, with associated gates.	1 Fencing: details, including height (m), to be stated. 2 Railings: details, including height (m), to be stated. 3 Gates: details to be stated.	m m nr	C1 Where components are to be enumerated, the number of components is to be stated. C2 The length of linear components measured is their extreme length, over all obstructions. C3 Other cost significant components are to be described and identified separately. Such components are to be measured by area (m²), linear measurement (m) or enumerated (nr) separately in accordance with the rules of measurement for this *sub-element*. C4 Descriptions shall include the amount of any PC Sum included in the unit rates applied to the item. C5 Curved work is to be described and identified separately. C6 Work outside the curtilage of the site is to be described and identified separately.	1 Timber, metal and concrete fencing systems, including all system components. 2 Railings. 3 Noise/light screening, including systems applied to fencing. 4 Gates and gate posts associated with fencing, and railings. 5 Security gates and gate posts associated with fencing, and railings, including mechanical and electrical operating equipment, guide rails and the like. 6 Ironmongery for gates. 7 Fencing to provide light or noise screening, including systems attached to fencing. 8 Excavating, concreting and backfilling holes for posts and the like. 9 Fixing railings to concrete and masonry. 10 Painting, coating and preservative treatments.	1 Balustrades and handrails to external steps (included in *sub-element* 8.2.1: Roads, paths and pavings). 2 Balustrades and handrails to external ramps (included in *sub-element* 8.2.1: Roads, paths and pavings). 3 Hedges (included in *sub-element* 8.3.2: External planting). 4 Masonry walls and screens (included in *sub-element* 8.4.2: Walls and screens). 5 Masonry walls and screens with timber infill panels (included in *sub-element* 8.4.2: Walls and screens). 6 Retaining walls (included in *sub-element* 8.4.3: Retaining walls). 7 General low voltage (LV) power installations to security gates (included in *sub-element* 8.7.4: Electricity distribution to external plant and equipment).

Sub-element	Component	Unit	Measurement rules for components	Included	Excluded
				11 Sundry items. 12 Where works are to be carried out by a subcontractor, subcontractor's preliminaries, design fees, risk allowance, overheads and profit.	
2 Walls and screens **Definition:** Non-retaining walls and screens and the like to or prevent access to or from an area, or to provide light or noise screening, with associated gates.	1 Walls: details, including height (m), to be stated.	m	C1 Where components are to be enumerated, the number of components is to be stated. C2 The length of linear components measured is their extreme length, over all obstructions.	1 Masonry walls and screens (e.g. brickwork, blockwork and stonework) including foundations, reinforcement and design joints. 2 Masonry walls and screens with timber infill panels, including foundations. 3 Trench and pit excavations.	1 Retaining walls (included in sub-element 8.4.3: Retaining walls). 2 General low voltage (LV) power installations to security gates (included in sub-element 8.7.4: Electricity distribution to external plant and equipment).
	2 Screens: details, including height (m), to be stated.	m	C3 Other cost significant components are to be described and identified separately. Such components are to be measured by area (m²), linear measurement (m) or enumerated (nr) separately in accordance with the rules of measurement for this sub-element.	4 Disposal of excavated material, including tipping charges and landfill tax (including inert, non-hazardous and hazardous material where not to be carried out as facilitating works). Note: Where no contamination/remediation strategy report exists, an allowance is to be made within the construction risk allowance for the extra cost of disposing of contaminated material. 5 Disposal of surface water and ground water. 6 Consolidating and compacting formation level to receive foundations. 7 Blinding. 8 Piers, including reinforcement. 9 Pier caps. 10 Copings and the like.	
	3 Gates: details to be stated.	nr	C4 Descriptions shall include the amount of any PC Sum included in the unit rates applied to the item. C5 Work outside the curtilage of the site is to be described and identified separately.	11 Gates and gate posts associated with walls and screens. 12 Security gates and gate posts associated with walls and screens, including mechanical and electrical operating equipment, guide rails and the like. 13 Ironmongery for gates. 14 Sundry items. 15 Where works are to be carried out by a subcontractor, subcontractor's preliminaries, design fees, risk allowance, overheads and profit.	

Sub-element	Component	Unit	Measurement rules for components	Included	Excluded
3 Retaining walls **Definition:** Retaining walls which are not an integral part of the building.	1 Retaining walls: details, including height (m) above ground, to be stated.	m	C1 Where components are to be enumerated, the number of components is to be stated. C2 The length of linear components measured is their extreme length, over all obstructions. C3 Ground bearing piles in connection with retaining walls shall be measured under sub-element 8.4.3 in accordance with the rules of measurement for piled foundations (refer to sub-element 1.1.2: Piled foundations).	1 Concrete retaining walls, including reinforcement, formwork and design joints. 2 Fixings cast into or fixed to concrete retaining walls to retain masonry walls (e.g. brickwork, blockwork and stonework) facing wall. 3 Masonry facing walls to concrete retaining walls (e.g. brickwork, blockwork and stonework), including reinforcement and design joints.	1 Retaining walls which form an integral part of the building (included in sub-element 1.3.1: Basement retaining walls or sub-element 1.3.2: Embedded basement retaining walls, as appropriate). 2 Soft landscape work associated with retaining structures, including provision of topsoil, preparation of topsoil, seeding and turfing and planting (included in sub-elements 8.3.1: Seeding and turfing and 8.3.2: External planting, as appropriate).
	2 Temporary works: details to be stated.	item	C4 Other cost significant components are to be described and identified separately. Such components are to be measured by area (m²), linear measurement (m) or enumerated (nr) separately in accordance with the rules of measurement for this sub-element. C5 Descriptions shall include the amount of any PC Sum included in the unit rates applied to the item. C6 Work outside the curtilage of the site is to be described and identified separately.	4 Masonry retaining walls (e.g. brickwork, blockwork and stonework) including reinforcement and design joints. 5 Crib walls, including timber (including preservative treatment) and precast concrete headers and stretchers, and combined units; and sand and gravel filling. 6 Gabions, including steel mesh cages/mattresses and wiring together; graded stone filling and filter membranes. 7 Reinforced earth, including reinforcement layers (e.g. steel, polymeric and geotextile), selected fill material, anchors and soil nails, mesh to support soft landscape facing, concrete, timber facing and the like. 8 Other types of retaining structure. 9 Piles associated with external retaining walls (individual, continuous and steel sheet), including piling mats and platforms (installing and removing), piling rigs, cutting off excess lengths of piles or steel sheet piles, cutting out concrete to tops of piles and preparing pile heads and reinforcement, and pile tests. 10 Trench and pit excavations, including earthwork support (including insertion and extraction of steel sheet piling if used). 11 Excavating below ground water level.	

Sub-element	Component	Unit	Measurement rules for components	Included	Excluded
				12 Disposal of excavated material, including tipping charges and landfill tax (including inert, non-hazardous and hazardous material where not to be carried out as facilitating works). **Note:** Where no contamination/remediation strategy report exists, an allowance is to be made within the construction *risk allowance* for the extra cost of disposing of contaminated material.	
				13 Disposal of surface water and ground water.	
				14 Consolidating and compacting formation level to receive foundations.	
				15 Blinding.	
				16 Weep holes.	
				17 Land drainage forming an integral part of the retaining wall.	
				18 Copings and the like.	
				19 Temporary works (e.g. props and wallings to support contiguous bored pile walls and the like).	
				20 Sundry items.	
				21 Where works are to be carried out by a *subcontractor, subcontractor's preliminaries*, design fees, risk allowance, overheads and profit.	

Sub-element	Component	Unit	Measurement rules for components	Included	Excluded
4 Barriers and guardrails **Definition:** External vehicle and pedestrian barriers and guardrail systems with associated gates.	1 Vehicle restraint systems: details to be stated. 2 Pedestrian restraint systems: details to be stated. 3 Vehicle and pedestrian control barriers and gates: details to be stated.	m m nr	C1 Where components are to be enumerated, the number of components is to be stated. C2 The length of linear components measured is their extreme length, over all obstructions. C3 Other cost significant components are to be described and identified separately. Such components are to be measured by area (m²), linear measurement (m) or enumerated (nr) separately in accordance with the rules of measurement for this *sub-element*. C4 Work outside the curtilage of the site is to be described and identified separately.	1 Vehicle restraint systems, including parapets. 2 Pedestrian restraint systems, including parapets. 3 Vehicle and pedestrian control barriers and gates not associated with fencing. 4 Excavating, disposal of excavated material, concreting and backfilling holes for posts and the like. 5 Fixing barriers and guardrails to concrete and masonry. 6 Painting, coatings and the like. 7 Sundry items associated with the provision of barriers and guardrails. 8 Where works are to be carried out by a *subcontractor, subcontractor's preliminaries,* design fees, risk allowance, overheads and profit.	1 Vehicle protection barriers (included in *sub-element* 8.2.1: Roads, paths and pavings). 2 Vehicle bump rails and the like (included in *sub-element* 8.2.1: Roads, paths and pavings).

Element 8.5: Site/street furniture and equipment

Sub-element	Component	Unit	Measurement rules for components	Included	Excluded
1 Site/street furniture and equipment **Definition:** Furniture and equipment designed for use externally, but excluding items provided by a statutory undertaker.	1 Component: details to be stated.	nr	C1 Where components are to be enumerated, the number of components is to be stated. C2 Work outside the curtilage of the site is to be described and identified separately.	1 Gates, where not part of fencing, railings, walls, screens barriers or guardrails. 2 Turnstiles. 3 Bollards, including removable and collapsible. 4 Seats, benches, tables. 5 Litter bins, grit bins, dustbins (including continental bins). 6 Poster display units, notice boards. 7 Cycle stands. 8 Directional signs, including reflective traffic signs.	1 Road crossings, including associated warning signs (included in *sub-element* 8.2.1: Roads, paths and pavings). 2 Cycle stands which are an integral part of pavings (included in *sub-element* 8.2.1: Roads, paths and pavings). 3 Tree grilles (included in *sub-element* 8.2.1: Roads, paths and pavings). 4 External prefabricated plant/tree containers (included in *sub-element* 8.3.2: External planting).

Sub-element	Component	Unit	Measurement rules for components	Included	Excluded
				9 Flagpoles. 10 Sports and play-ground equipment, including safety mats. 11 Other furniture and equipment to be used externally. 12 Minor footbridges. 13 Clothes drying fittings. 14 Bus stops, bus shelters, telephone boxes/booths, post boxes and road signs where not the responsibility of a statutory undertaker. 15 Sculptures and other works of art external to the building envelope. 16 Site/street furniture and equipment which act as transformation devices (i.e. generate energy). 17 Other site and street furniture and equipment. 18 All builder's work in connection with installing site/street furniture and equipment, including excavating, disposal of excavated material, concreting and backfilling holes for posts and the like, fixing devices, and fixing furniture and equipment in place. 19 Painting, coating and preservative treatments. 20 Sundry items. 21 Where works are to be carried out by a *subcontractor, subcontractor's preliminaries*, design fees, risk allowance, overheads and profit.	5 Gates where an integral part of fencing, railings, walls, screens, barriers or guardrails (included in *element 8.4*: Fencing, railings and walls, as appropriate). 6 Items which are the responsibility of a statutory undertaker (e.g. street lighting, bus stops and shelters, telephone boxes/booths, post boxes and road signs). 7 Illuminated traffic signs (included in *sub-element 8.7.9*: Site/street lighting systems). 8 External illumination/lighting systems (included in *sub-element 8.7.9*: Site/street lighting systems).

Sub-element	Component	Unit	Measurement rules for components	Included	Excluded
2 Ornamental features **Definition:** Ornamental water features or the like.	1 Water features: details to be stated. 2 Other features: details to be stated.	nr nr	C1 Where components are to be enumerated, the number of components is to be stated. C2 Work outside the curtilage of the site is to be described and identified separately.	1 Water features and the like. 2 Mains water supply. 3 General low voltage (LV) power installations to water features, waterfalls and the like, including cables, excavating and backfilling trenches and the like. 4 Builder's work in connection with installing water features or the like. 5 Sundry items. 6 Where works are to be carried out by a *subcontractor, subcontractor's preliminaries,* design fees, risk allowance, overheads and profit.	1 Drainage installations (included in *sub-element* 8.6.1: Surface water and foul water drainage). 2 Testing and commissioning of external services (included in *sub-element* 8.7.13: Testing and commissioning of external services).

Element 8.6: External drainage

Sub-element	Component	Unit	Measurement rules for components	Included	Excluded
1 Surface water and foul water drainage **Definition:** Foul water and surface water drainage systems, below ground and above ground, from first manhole beyond the enclosing walls of the building, the sewer connection, or other outfall (e.g. on-site sewage treatment facility).	1 Connections to statutory undertaker's sewers: details to be stated. 2 Drainage runs; below ground: details, including depth of trench (m) and nominal size of pipe (mm), to be stated. 3 Drainage runs; above ground: details, including height above ground (m), nominal size of pipe (mm), to be stated.	nr m m	C1 Where components are to be enumerated, the number of components is to be stated. C2 The length of linear components measured is their extreme length, over all branches, fittings and the like. C3 Other cost significant components are to be described and identified separately. Such components are to be measured by area (m²), linear measurement (m) or enumerated (nr) separately. C4 Work outside the curtilage of the site is to be described and identified separately.	1 Connection to statutory undertaker's sewer or sewers. 1 Trenches for pipework, including excavation, earthwork support, backfilling and disposal of surplus material. 2 Pipeline and pipeline fittings. 3 Granular beds and surround, concrete beds, cradles, haunchings and surrounds, and foamed concrete backfill. 4 Supports for above ground drainage, including earth embankments. 5 Connections to manholes and the like. 6 Connections to above ground soil stacks, sanitary appliances and wastes. 7 Connections to ancillary equipment and systems (e.g. pumping stations and sewage treatment vessels).	1 Above ground soil stacks, wastes and the like (included in *sub-element* 5.3.1: Foul drainage above ground). 2 Groundwater pressure relief drains to basement retaining walls connected to the drainage system, i.e. fin drains, filter drains and blanket drains (included in *element* 1.3: Basement retaining walls). 3 Sustainable urban drainage schemes (SUD) (included in *sub-element* 8.6.2: Ancillary drainage systems). 4 External on-site waste water or sewage treatment facilities (included in *sub-element* 8.6.2: Ancillary drainage systems).

Sub-element	Component	Unit	Measurement rules for components	Included	Excluded
	4 Prefabricated channels: details, including nominal size, to be stated.	m		8 Gullies and gratings, including road gullies and gratings.	5 Laboratory/industrial waste drainage (included in sub-element 8.6.3: External laboratory and industrial liquid waste drainage).
				9 Rodding and access points.	
	5 Manholes and the like: details, including depth (m), to be stated.	nr		10 Prefabricated channels (i.e. in roads, paths and pavements).	6 Testing and commissioning of external surface water and foul water drainage (included in sub-element 8.6.5: Testing and commissioning of external drainage installations).
				11 Interceptor traps and fresh air inlets, and air release and wash out valves to pressure pipelines.	
	6 Alterations to existing external drainage systems: details to be stated.	nr		12 Inspection chambers, manholes and catch pits, including channels benchings, step irons, access covers and other accessories.	
				13 Soakaways.	
	7 Work to existing manholes or the like: details to be stated.	nr		14 Retention/storage tanks and vessels.	
				15 Cesspools and septic tanks.	
				16 Petrol interceptor units.	
				17 Packaged pumping stations.	
	8 Clearing existing drains: details to be stated.	nr/m		18 Outfalls/outlet headwalls.	
				19 Connections to sewers, where not statutory undertaker's sewers.	
	9 Sealing redundant drains: details to be stated.	nr/m		20 Connections to ancillary drainage systems.	
				21 Painting, anti-corrosion treatments and coating systems to drainage above ground.	
	10 Filling disused manholes or the like: details to be stated.	nr		22 Builder's work in connection with external surface water and foul water drainage.	
				23 Alterations to existing external drainage systems.	
				24 Work to existing manholes or the like.	
				25 Clearing existing drains.	
				26 Sealing redundant drains, including filling entire length of drain with foam concrete or the like.	
				27 Filling disused manholes.	
				28 Testing and commissioning of external surface water and foul water drainage.	
				29 Sundry items.	
				30 Where works are to be carried out by a subcontractor, subcontractor's preliminaries, design fees, risk allowance, overheads and profit.	

Sub-element	Component	Unit	Measurement rules for components	Included	Excluded
2 Ancillary drainage systems **Definition:** Systems with a storage tank or vessel for the reception of foul water and sewage at one level, for transfer by pump to drains or sewers at a higher level; sewage treatment systems to meet local special needs where it is necessary to treat human or animal sewage to render it safe for discharge into the statutory undertaker's drainage system; and sustainable urban drainage schemes.	1 Pumping stations: details to be stated.	nr	C1 Where components are to be enumerated, the number of components is to be stated. C2 The length of linear components measured is their extreme length, over all obstructions. C3 The area measured for sustainable urban drainage schemes is the surface area of land served by the scheme. C4 Other cost significant components are to be described and identified separately. Such components are to be measured by area (m²), linear measurement (m) or enumerated (nr) separately in accordance with the rules of measurement for this *sub-element*. C5 Work outside the curtilage of the site is to be described and identified separately.	1 Pumping stations. 2 Ejector stations. 3 Storage/retention tanks and vessels (e.g. concrete and proprietary), including supports, forming protective bunds and the like. 4 Sewage treatment systems, including receivers or storage vessels and treatment vessels (e.g. concrete and proprietary), control components and monitoring equipment. 5 Sustainable urban drainage schemes (SUDS). 6 Control components located externally. 7 Monitoring equipment located externally. 8 Painting, anti-corrosion treatments and coating systems to ancillary drainage equipment and systems. 9 Builder's work in connection with the provision of ancillary drainage equipment and systems. 10 Sundry items associated with the provision ancillary drainage equipment and systems. 11 Where works are to be carried out by a *subcontractor*, *subcontractor's preliminaries*, design fees, risk allowance, overheads and profit.	1 Packaged pumping stations (included in *sub-element* 8.6.1: Surface water and foul water drainage). 2 General low voltage (LV) power installations to ancillary drainage systems, including cables, excavating and backfilling trenches and the like (included in *sub-element* 8.7.4: Electricity distribution to external plant and equipment). 3 Connections from drainage pipeline to system (included in *sub-element* 8.6.1: Surface water and foul water drainage). 4 Building management systems and other control systems (included in *sub-element* 5.12.3: Central control/building management systems (BMS)). 5 Testing and commissioning of ancillary drainage system (included in *sub-element* 8.6.5: Commissioning of external drainage installations).
	2 Ejector stations: details to be stated.	nr			
	3 Storage/retention tanks and vessels: details to be stated.	nr			
	4 Sewage treatment systems: details to be stated.	nr			
	5 Sustainable urban drainage schemes: details to be stated.	m²			

Sub-element	Component	Unit	Measurement rules for components	Included	Excluded
3 External laboratory and industrial liquid waste drainage **Definition:** Laboratory/industrial waste drainage, from the external face of the external wall to point of disposal.	1 Drainage runs; below ground: details, including depth of trench (m) and nominal size of pipe (mm), to be stated.	m	C1 Where components are to be enumerated, the number of components is to be stated. C2 The length of linear components measured is their extreme length, over all branches, fittings and the like. C3 Other cost significant components are to be described and identified separately. Such components are to be measured by area (m²), linear measurement (m) or enumerated (nr) separately in accordance with the rules of measurement for this *sub-element*. C4 Descriptions shall include the amount of any PC Sum included in the unit rates applied to the item. C5 Work outside the curtilage of the site is to be described and identified separately.	1 Trenches for pipework, including excavation, earthwork support, backfilling and disposal of surplus material. 2 Pipework and pipework fittings. 3 Granular beds and surround, concrete beds, cradles, haunchings and surrounds, and foamed concrete backfill. 4 Supports for above ground drainage, including earth embankments. 5 Connections tanks and the like. 6 Storage tanks and vessels. 7 Settlement tanks. 8 Effluent treatment plant. 9 Dosing equipment. 10 Sterilisation equipment. 11 Connections to equipment. 12 Control components located externally. 13 Monitoring equipment located externally. 14 Painting, anti-corrosion treatments and coating systems to drainage pipelines. 15 Builder's work in connection with external laboratory and industrial liquid waste drainage. 16 Sundry items. 17 Where works are to be carried out by a subcontractor, subcontractor's preliminaries, design fees, risk allowance, overheads and profit.	1 Laboratory and industrial liquid waste drainage from external face of the external wall to the building to appliance or equipment (included in *sub-element* 5.3.2: Laboratory and industrial liquid waste drainage). 2 Testing and commissioning of external laboratory and industrial liquid waste drainage (included in *sub-element* 8.6.5: Testing and commissioning of external drainage installations).
	2 Drainage runs; above ground: details, including height above ground (m) and nominal size of pipe (mm), to be stated.	m			
	3 Equipment and plant: details to be stated.	nr			

Sub-element	Component	Unit	Measurement rules for components	Included	Excluded
4 Land drainage **Definition:** Disposal systems for the drainage of waterlogged ground.	1 Drainage runs; below ground: details, including depth of trench (m) and nominal size of pipe (mm), to be stated.	m	C1 Where components are to be enumerated, the number of components is to be stated. C2 The length of linear components measured is their extreme length, over all branches, fittings and the like.	1 Filter drains, with or without pipes. 2 Fin drains, with or without pipes. 3 Mole drains. 4 Trenchless drains. 5 Pipe drains, including fittings. 6 Drainage blankets (e.g. comprising layer of aggregate, porous pipes and upper/lower geotextile pipes).	1 Groundwater pressure relief drains to basement retaining walls connected to the main underground drainage systems to point of disposal (included in *element 1.3*: Basement retaining walls). 2 Testing and commissioning of land drainage (included in *sub-element 8.6.5*: Testing and commissioning of external drainage installations).
	2 Manholes and the like: details, including depth (m), to be stated.	nr	C3 The area measured for drainage blankets is the surface area of land serviced by the blanket. C4 The area measured for land drainage to parklands is the surface area of parkland.	7 Trenches for pipework, including excavation, earthwork support, backfilling and disposal of surplus material. 8 Pipework and pipework fittings (to point of disposal). 9 Granular fill and surrounds.	
	3 Drainage blankets: details to be stated.	m²	C5 Other cost significant components are to be described and identified separately. Such components are to be measured by area (m²), linear measurement (m) or enumerated (nr) separately in accordance with the rules of measurement for this *sub-element*.	10 Geotextile filters and trench linings. 11 Silt traps, silt trap manholes and the like. 12 Soakaways. 13 Storage tanks and vessels. 14 Outfalls/outlet head walls. 15 Builder's work in connection with land drainage.	
	4 Land drainage to parkland: details, including centres of main runs (m) and laterals (m), to be stated.	ha	C6 Descriptions shall include the amount of any PC Sum included in the unit rates applied to the item. C7 Work outside the curtilage of the site is to be described and identified separately.	16 Clearing existing ditches, channels and the like. 17 Sundry items. 18 Where works are to be carried out by a *subcontractor*, *subcontractor's preliminaries*, design fees, risk allowance, overheads and profit.	

Sub-element	Component	Unit	Measurement rules for components	Included	Excluded
5 Testing and commissioning of external drainage installations **Definition:** Testing and commissioning of external drainage installations.	1 Testing; details to be stated. 2 Commissioning; details to be stated.	% %	C1 The percentage addition is to be applied to the *cost targets* for *sub-elements* 8.6.1 to 8.6.5 inclusive, as appropriate. C2 Each system is to be identified separately. **Note:** Clearly state if costs associated with testing and commissioning of external drainage installations are included with costs for testing and commissioning of services within building (cross-reference to *element* 5.15: Testing and commissioning services).	1 Testing equipment and consumables 2 Calibration. 3 Site installation tests. 4 Static testing, including testing records. 5 Performance testing, including performance test records. 6 Commissioning, including preliminary checks, setting systems and installations to work and regulation thereof, and commissioning records. 7 Temporary operation of plant and equipment to *employer's* requirements. 8 Fuels required for testing and commissioning. 9 Sundry items. 10 Where works are to be carried out by a *subcontractor* or sub-consultant, *subcontractor's* or sub-consultant's preliminaries, design fees, risk allowance, overheads and profit.	1 Testing and commissioning of internal services (included in *sub-element* 5.15.1: Testing and commissioning of services).

Element 8.7: External services

Sub-element	Component	Unit	Measurement rules for components	Included	Excluded
1 Water mains supply **Definition:** Piped water supply systems bringing water from the statutory undertaker's mains to point of entry into building. Including distribution to external user points (e.g. to external plant and equipment) and fire hydrants.	1 Connections to statutory undertaker's water main: details to be stated. 2 Connections to external plant and equipment: details to be stated. 3 Service runs: details to be stated.	nr nr m	C1 Where components are to be enumerated, the number of components is to be stated. C2 For connections to external plant and equipment, the number of draw-off points is to be stated. C3 The length of linear components measured is their extreme length, over all branches, fittings and the like.	1 Connections to statutory undertaker's water main. 2 Water main from statutory undertaker's mains to water meter, including pipelines and pipeline fittings, excavation and backfilling trenches, ground anchor blocks, and the like. 3 Connections to external plant and equipment.	1 Piped water supply systems from point of entry into building to appliances and equipment within the building (included in *sub-element* 5.4.1: Mains water supply). 2 Piped water supply systems to distribute cold water from point of storage to user points within the building (included in *sub-element* 5.4.2: Cold water distribution). 3 Rainwater harvesting systems internal to the building (included in *sub-element* 5.4.2: Cold water distribution).

Sub-element	Component	Unit	Measurement rules for components	Included	Excluded
	4 Rainwater harvesting systems: details, including the number of collection points (nr), to be stated. 5 Grey water systems: details, including the number of collection points (nr), to be stated.	nr nr	C4 Other cost significant components are to be described and identified separately. Such components are to be measured by area (m²), linear measurement (m) or enumerated (nr) separately in accordance with the rules of measurement for this sub-element. C5 Descriptions shall include the amount of any PC Sum included in the unit rates applied to the item. C6 Work outside the curtilage of the site is to be described and identified separately.	4 Mains water supply and distribution of water supply to external plant and equipment), including pipelines and pipeline fittings, excavation and backfilling trenches, ground anchor blocks and the like. 5 Water meters, where not provided by the statutory undertaker, including chambers and enclosures. 6 Fire hydrants. 7 Trace heating. 8 Thermal insulation. 9 Constructing stop valve surface boxes. 10 Rainwater harvesting systems external to the building, including collection pipelines. 11 Grey water systems external to the building, including collection pipelines. 12 Sundry items. 13 Where works are to be carried out by a subcontractor, subcontractor's preliminaries, design fees, risk allowance, overheads and profit.	4 Grey water systems internal to the building (included in sub-element 5.4.2: Cold water distribution). 5 Irrigation (included in sub-element 8.7.10: Irrigation systems). 6 Builder's work in connection with external services (included in sub-element 8.7.12: Builder's work in connection with external services). 7 Testing and commissioning of services (included in sub-element 8.7.13: Testing and commissioning of external services).

Sub-element	Component	Unit	Measurement rules for components	Included	Excluded
2 Electricity mains supply **Definition:** The distribution of high voltage (HV) electricity from statutory undertaker's supply to an on-site transformer station; the distribution of low voltage (LV) electricity from the on-site transformer (or other supply intake) to the main switchgear panel within the building; and external installations for providing electricity, including emergency or standby generation plant.	1 Connections to statutory undertaker's electricity main: details to be stated. 2 Service runs: details to be stated. 3 Transformer sub-stations: details to be stated. 4 External electricity generation installation/plant: details to be stated.	nr m nr nr	C1 Where components are to be enumerated, the number of components is to be stated. C2 The length of linear components measured is their extreme length, over all obstructions. C3 Other cost significant components are to be described and identified separately. Such components are to be measured by area (m²), linear measurement (m) or enumerated (nr) separately in accordance with the rules of measurement for this *sub-element*. C4 Work outside the curtilage of the site is to be described and identified separately.	1 Connections to statutory undertaker's electricity main. 2 Distribution of HV electricity to on-site transformer, including cables, excavating and backfilling trenches and the like. 3 Transformer sub-stations, including packaged sub-stations. 4 Distribution of LV electricity to main switchgear panel within the building, excavating and backfilling trenches and the like. 5 Constructing draw pits, including access covers. 6 Marker tape, cover tiles and other special protection for electrical cables. 7 External electricity generation plant, including emergency or standby generation plant. 8 Sundry items. 9 Where works are to be carried out by a *subcontractor, subcontractor's preliminaries,* design fees, risk allowance, overheads and profit.	1 LV distribution from, and including, main switchgear panel to area distribution boards and/or sub-distribution boards (included in *sub-element* 5.8.1: Electrical mains and sub-mains distribution). 2 Protective compounds, connected with transformer substations and the like (included in *sub-element* 8.7.12: Builder's work in connection with external services). 3 Electric generation installations within the building (included in *sub-element* 5.8.5: Local electricity generation systems). 4 Fuel storage and distribution in connection with external electricity generation plant (included in *sub-element* 8.7.7: External fuel storage and piped distribution systems). 5 Building management systems and other control systems (included in *sub-element* 5.12.3: Central control/building management systems (BMS)). 6 Builder's work in connection with external services (included in *sub-element* 8.7.12: Builder's work in connection with external services). 7 Testing and commissioning of services (included in *sub-element* 8.7.13: Testing and commissioning of external services).

Sub-element	Component	Unit	Measurement rules for components	Included	Excluded
3 External transformation devices **Definition:** Systems using the natural elements (i.e. wind and sun) to generate energy.	1 Wind turbines: details to be stated. 2 Photovoltaic devices: details, including surface area of units (m²), to be stated. 3 Other transformation devices: details to be stated.	nr nr nr	C1 Where components are to be enumerated, the number of components is to be stated.	1 Wind turbines, where external to the building. 2 Photovoltaic devices, where external to the building. 3 Solar collectors, where external to the building. 4 Other transformation devices. 5 Generators in connection with transformation devices. 6 Distribution of LV electricity to main switchgear panel within the building, excavating and backfilling trenches and the like. 7 Constructing draw pits, including access covers. 8 Marker tape, cover tiles and other special protection for electrical cables. 9 Sundry items. 10 Where works are to be carried out by a subcontractor, subcontractor's preliminaries, design fees, risk allowance, overheads and profit.	1 Wind turbines, photovoltaic devices and other transformation devices which are an integral part of the building (included in sub-element 5.8.6: Transformation devices). 2 Heat pumps (included in element 5.5: Heat source). 3 Ground source heating (included in element 5.5: Heat source). 4 Solar collectors which are an integral part of the building (included in sub-element 5.8.6: Transformation devices). 5 Site/street furniture and equipment (e.g. playground equipment and sculptures) which act as transformation devices (included in sub-element 8.5.1: Site/street furniture and equipment). 6 Building management systems and other control systems (included in sub-element 5.12.3: Central control/building management systems (BMS)). 7 Builder's work in connection with external transformation devices, including bases (included in sub-element 8.7.12: Builder's work in connection with external services). 8 Testing and commissioning of services (included in sub-element 8.7.13: Testing and commissioning of external services).

Sub-element	Component	Unit	Measurement rules for components	Included	Excluded
4 Electricity distribution to external plant and equipment **Definition:** Sub-circuit power installations from sub-distribution boards to external equipment terminating at socket outlets, fuse connection units and other accessories, including final connections to permanent mechanical and electrical plant and equipment, external features (e.g. water features) and the like.	1 Connections to external plant or equipment: details to be stated. 2 Service runs: details to be stated.	nr m	C1 Where components are to be enumerated, the number of components is to be stated. C2 The length of linear components measured is their extreme length, over all obstructions. C3 Other cost significant components are to be described and identified separately. Such components are to be measured by area (m²), linear measurement (m) or enumerated (nr) separately in accordance with the rules of measurement for this *sub-element*. C4 Work outside the curtilage of the site is to be described and identified separately.	1 General low voltage (LV) power installations to external plant and equipment, including cables, excavating and backfilling trenches and the like. 2 LV switchgear and distribution boards, where not included as part of the sub-mains distribution. 3 Uninterruptible power supply (UPS) installations and the like, specific to external plant and equipment. 4 Cables and wiring, including support components from sub-distribution boards to fuse connection units and the like. 5 Conduits and cable trunking, including all fittings and support components. 6 Earthing and bonding components. 7 Constructing draw pits, including access covers. 8 Marker tape, cover tiles and other special protection for electrical cables. 9 Fuse connection units and other outlet accessories. 10 Final connections to equipment (e.g. to pumping stations and ejector stations). 11 Separate power installations to specialist mechanical and electrical equipment (e.g. to sewage treatment plant). 12 Final connections to specialist mechanical and electrical equipment where not carried out by the equipment installer. 13 Sundry items. 14 Where works are to be carried out by a *subcontractor, subcontractor's preliminaries*, design fees, risk allowance, overheads and profit.	1 General power installations within building (included in *sub-element* 5.8.2: Power installations). 2 General power installations to external water features and the like (included in *sub-element* 8.5.2: Ornamental features). 3 General power installations to external security systems (included in *sub-element* 8.7.8: External security systems). 4 General power installations to external illumination systems (included in *sub-element* 8.7.9: Site/street lighting systems). 5 Final connections to specialist mechanical and electrical equipment where carried out by the equipment installer. 6 Building management systems and other control systems (included in *sub-element* 5.12.3: Central control/building management systems (BMS)). 7 Builder's work in connection with external services (included in *sub-element* 8.7.12: Builder's work in connection with external services). 8 Testing and commissioning of services (included in *sub-element* 8.7.13: Testing and commissioning of external services).

Sub-element	Component	Unit	Measurement rules for components	Included	Excluded
5 Gas mains supply **Definition:** Piped natural gas supply systems taking gas from the statutory undertaker's mains to gas meter; and taking liquefied petroleum gas (LPG) from external storage vessels to distribution point, including mains gas supply and distribution of gas supply to external user points (e.g. to external plant and equipment).	1 Connections to statutory undertaker's gas main: details to be stated. 2 Service runs: details to be stated. 3 Governing stations: details to be stated.	nr m nr	C1 Where components are to be enumerated, the number of components is to be stated. C2 The length of linear components measured is their extreme length, over all obstructions. C3 Other cost significant components are to be described and identified separately. Such components are to be measured by area (m²), linear measurement (m) or enumerated (nr) separately in accordance with the rules of measurement for this *sub-element*. C4 Work outside the curtilage of the site is to be described and identified separately.	1 Connections to statutory undertaker's gas main. 2 Gas main from statutory undertaker's mains to point of mains connection within building, including pipelines and fittings, excavating and backfilling trenches and the like. 3 Connections to external plant and equipment. 4 Mains gas supply and distribution of gas supply to external plant and equipment, including, pipelines and fittings, excavation and backfilling trenches. 5 Governing stations. 4 LPG installations, including storage bottles and containers, pipelines and fittings to gas distribution point in building. 5 Sundry items associated with the provision of mains gas supplies. 6 Where works are to be carried out by a *subcontractor, subcontractor's preliminaries*, design fees, risk allowance, overheads and profit.	1 Gas distribution pipelines from point of mains connection within building to user points within building (included in *sub-element* 5.9.1: Gas distribution). 2 Protective compounds, fencing, storage racks associated with LPG installations (included in *sub-element* 8.7.12: Builder's work in connection with external services). 3 Builder's work in connection with external services (included in *sub-element* 8.7.12: Builder's work in connection with external services). 4 Testing and commissioning of services (included in *sub-element* 8.7.13: Testing and commissioning of external services).
6 Telecommunications and other communication system connections **Definition:** Connection of telecommunications systems, cable television, and other communication systems from statutory undertaker's or other service provider's supply to the main distribution point within the building.	1 Telecommunication connections: details to be stated. 2 Cable television connections: details to be stated. 3 Other communication connections: details to be stated. 4 Service runs: details to be stated.	nr nr nr m	C1 Where components are to be enumerated, the number of components is to be stated. C2 The length of linear components measured is their extreme length, over all obstructions. C3 Other cost significant components are to be described and identified separately. Such components are to be measured by area (m²), linear measurement (m) or enumerated (nr) separately in accordance with the rules of measurement for this *sub-element*. C4 Work outside the curtilage of the site is to be described and identified separately.	1 Connections to statutory undertaker's or service provider's supply. 2 Distribution of telecommunications, cable television, and other communication systems, including wiring to main distribution point within building, including cables, excavating and backfilling trenches and the like. 3 Constructing draw pits, including access covers. 4 Marker tape, cover tiles and other special protection for electrical cables. 5 Sundry items. 6 Where works are to be carried out by a *subcontractor, subcontractor's preliminaries*, design fees, risk allowance, overheads and profit.	1 Telecommunications systems, cable television, and other communication systems distribution from main distribution point within the building to user points within building (included in *sub-element* 5.12.1: Communication systems). 2 Builder's work in connection with external services (included in *sub-element* 8.7.12: Builder's work in connection with external services). 3 Testing and commissioning of services (included in *sub-element* 8.7.13: Testing and commissioning of external services).

Sub-element	Component	Unit	Measurement rules for components	Included	Excluded
7 External fuel storage and piped distribution systems **Definition:** Storage tanks and vessels external to building, and piped supply systems distributing oil, petrol, diesel or liquefied petroleum gas (LPG) from storage tanks or vessels to entry point within building or to external plant and equipment.	1 Fuel storage and piped distribution systems: details to be stated. 2 Service runs: details to be stated.	nr m	C1 Where components are to be enumerated, the number of components is to be stated. C2 The length of linear components measured is their extreme length, over all obstructions. C3 Other cost significant components are to be described and identified separately. Such components are to be measured by area (m²), linear measurement (m) or enumerated (nr) separately in accordance with the rules of measurement for this sub-element. C4 Work outside the curtilage of the site is to be described and identified separately.	1 Oil, petrol, diesel and liquefied petroleum gas (LPG) systems. 2 Storage tanks and vessels not supplied in connection with heat source installations. 3 Proprietary supports forming an integral part of the storage tank/vessel unit. 4 Off-site painting/anti-corrosion treatments. 5 Connections to external plant and equipment. 6 Distribution pipelines, and pipeline fittings, from storage tank or vessel to plant or equipment being served, above ground and below ground, including excavating and backfilling trenches and the like. 7 Pipeline components/ancillaries (e.g. valves and pumps). 8 Thermal insulation. 9 Off-site painting/anti-corrosion treatments. 10 Meters. 11 Monitoring equipment. 12 Sundry items. 13 Where works are to be carried out by a subcontractor, subcontractor's preliminaries, design fees, risk allowance, overheads and profit.	1 Storage tanks and vessels and distribution pipelines within the building (included in sub-element 5.9.2: Fuel storage and piped distribution systems). 2 Supports not integral to the storage tank/vessel (included in sub-element 8.7.12: Builder's work in connection with external services). 3 Bunds and the like to fuel storage/tanks and vessels (included in sub-element 8.7.12: Builder's work in connection with external services). 4 On-site painting of storage tanks and vessels, supports and pipelines (included in element 5.14: Builder's work in connection with services). 5 Building management systems and other control systems (included in sub-element 5.12.3: Central control/building management systems (BMS)). 6 Builder's work in connection with external services (included in sub-element 8.7.12: Builder's work in connection with external services). 7 Testing and commissioning of services (included in sub-element 8.7.13: Testing and commissioning of external services).

Sub-element	Component	Unit	Measurement rules for components	Included	Excluded
8 External security systems **Definition:** External observation and access control installations and the like.	1 Surveillance equipment: details of each type of system to be stated.	item/nr	C1 Where components are to be enumerated, the number of components is to be stated. C2 Where components are to be itemised, the number of key elements comprising the component are to be identified, described and enumerated within the description of the component. C3 The length of linear components measured is their extreme length, over all obstructions. C4 Other cost significant components are to be described and identified separately. Such components are to be measured by area (m²), linear measurement (m) or enumerated (nr) separately in accordance with the rules of measurement for this sub-element. C5 Work outside the curtilage of the site is to be described and identified separately. C6 State if external security systems included with building security systems (cross-reference to sub-element 5.13.2: Security systems).	1 Surveillance equipment (e.g. CCTV). 2 Security detection equipment. 3 Security alarm equipment. 4 Gate access control systems. 5 Gate entry systems (audio and visual). 6 Security lights and lighting systems. 7 Other security systems. 8 Cables/wiring interlinking components of external security systems, including excavating and backfilling trenches, protection and the like. 9 Camera poles and the like, including excavating, concreting and backfilling holes for poles and the like. 10 General power installations to external security systems, including cables, excavating and backfilling trenches and the like. 11 Constructing draw pits, including access covers. 12 Marker tape, cover tiles and other special protection for electrical cables. 13 Sundry items. 14 Where works are to be carried out by a subcontractor, subcontractor's preliminaries, design fees, risk allowance, overheads and profit.	1 Internal observation and access control installations and the like (included in sub-element 5.12.2: Security systems). 2 Security gates, including mechanical and electrical operating equipment, guide rails and the like (included in element 8.4: Fencing, railings and walls, as appropriate). 3 Building management systems and other control systems (included in sub-element 5.12.3: Central control/building management systems (BMS)). 4 Builder's work in connection with external services (included in sub-element 8.7.12: Builder's work in connection with external services). 5 Testing and commissioning of services (included in sub-element 8.7.13: Testing and commissioning of external services).
	2 Security detection equipment: details of each type of system to be stated.	item/nr			
	3 Security alarm equipment: details of each type of system to be stated.	item/nr			
	4 Gate access control systems: details of each type of system to be stated.	nr			
	5 Gate entry systems: details of each type of system to be stated.	nr			
	6 Security lights and lighting systems: details of each type of system to be stated.	item/nr			
	7 Other security systems: details of each type of system to be stated.	item/nr			
	8 Service runs: details to be stated.	m			

Sub-element	Component	Unit	Measurement rules for components	Included	Excluded
9 Site/street lighting systems **Definition:** External illumination systems, including lighting to pedestrian areas, paths and roads, and illuminated traffic signs.	1 External lighting to pedestrian areas: details to be stated.	nr	C1 Where components are to be enumerated, the number of components is to be stated. C2 Other cost significant components are to be described and identified separately. Such components are to be measured by area (m²), linear measurement (m) or enumerated (nr) separately in accordance with the rules of measurement for this sub-element. C3 Work outside the curtilage of the site is to be described and identified separately.	1 External lighting, columns, poles, bollards, and masts, luminaires and lamps, cables, lighting to external surfaces/areas. 2 Fixing luminaires and lamps to building fabric. 3 Illuminated traffic signs. 4 General power installations to external illumination systems, including cables, excavating and backfilling trenches and the like. 5 Constructing draw pits, including access covers. 6 Marker tape, cover tiles and other special protection for electrical cables. 7 Luminaires and lamps. 8 Lighting control points. 9 Painting and anti-corrosion treatments to poles, bollards, masts and the like. 10 Sundry items. 11 Where works are to be carried out by a subcontractor, subcontractor's preliminaries, design fees, risk allowance, overheads and profit.	1 Lighting fixed to the exterior of the building supplied as part of the interior lighting system (included in sub-element 5.8.3: Lighting installations). 2 Security lights and lighting systems (included in sub-element 8.7.8: External security systems). 3 Builder's work in connection with external services (included in sub-element 8.7.12: Builder's work in connection with external services). 4 Testing and commissioning of services (included in sub-element 8.7.13: Testing and commissioning of external services).
	2 External lighting to paths: details to be stated.	nr			
	3 External lighting to roads: details to be stated.	nr			
	4 Illuminated traffic signs: details to be stated.	nr			

Sub-element	Component	Unit	Measurement rules for components	Included	Excluded
10 Irrigation systems **Definition:** Piped water supply systems to landscape planted areas or crop planted areas providing a water supply for growing purposes.	1 Irrigation systems: details to be stated.	m²	C1 The area measured for irrigation systems is the surface area of land serviced by the system. C2 Other cost significant components are to be described and identified separately. Such components are to be measured by area (m²), linear measurement (m) or enumerated (nr) separately in accordance with the rules of measurement for this *sub-element*. C3 Work outside the curtilage of the site is to be described and identified separately.	1 Pipelines, including pipeline fittings and ancillaries. 2 Storage tanks and vessels. 3 Chemical storage vessels. 4 Chemical dosing equipment. 5 Nutrient treatment and equipment. 6 Outlet pipes and nozzles. 7 Painting, anti-corrosion treatments and coating systems to storage tanks and vessels, pipelines and the like. 8 Builder's work in connection with land drainage. 9 Sundry items. 10 Where works are to be carried out by a *subcontractor, subcontractor's preliminaries*, design fees, risk allowance, overheads and profit.	1 Mains water supply (included in *sub-element* 8.7.1: Water mains supply). 2 General power installations to external plant and equipment (included in *sub-element* 8.7.4: Electricity distribution to external plant and equipment). 3 Builder's work in connection with external services (included in *sub-element* 8.7.12: Builder's work in connection with external services). 4 Testing and commissioning of services (included in *sub-element* 8.7.13: Testing and commissioning of external services).
11 Local/district heating installations **Definition:** Local/district heating installations, including heat source.	1 Heat source associated plant and equipment: details to be stated. 2 Service runs: details to be stated. 3 External heating ducts and duct access covers: details to be stated.	item/nr m m	C1 Where components are to be enumerated, the number of components is to be stated. C2 Where components are to be itemised, the number of key elements comprising the component are to be identified, described and enumerated within the description of the component. C3 The length of linear components measured is their extreme length, over all obstructions. C4 Other cost significant components are to be described and identified separately. Such components are to be measured by area (m²), linear measurement (m) or enumerated (nr) separately in accordance with the rules of measurement for this *sub-element*. C5 Work outside the curtilage of the site is to be described and identified separately.	1 Externally located heat source (e.g. boiler plant), including ancillary plant and equipment. 2 Instrumentation and control components to heat source. 3 Heat distribution pipelines from heat source to point of entry into building, including pipelines, pipeline fittings and ancillaries (e.g. valves and pumps). 4 Heating ducts and access covers to local/district heating pipelines. 5 Instrumentation and control components to heating systems. 6 Thermal insulation. 7 Sundry items. 8 Where works are to be carried out by a *subcontractor, subcontractor's preliminaries*, design fees, risk allowance, overheads and profit.	1 Internally located heat source (e.g. boiler plant), including ancillary plant and equipment (included in *element* 5.5: Heat source). 2 Heat distribution pipelines from point of entry into building to heat emitter or other equipment (included in *element* 5.6: Space heating and air conditioning, as appropriate). 3 Fuel supply (included in *sub-element* 8.7.5: Gas mains supply or *sub-element* 8.7.7: External fuel storage and piped distribution systems, as appropriate). 4 Boiler houses and the like (included in *sub-element* 8.8.2: Ancillary buildings and structures). 5 Builder's work in connection with external services (included in *sub-element* 8.7.12: Builder's work in connection with external services). 6 Testing and commissioning of services (included in *sub-element* 8.7.13: Testing and commissioning of external services).

Sub-element	Component	Unit	Measurement rules for components	Included	Excluded
12 Builder's work in connection with external services **Definition:** Sundry builder's work associated with the installation of water, gas, electricity, heating, ventilation above ground drainage, telecommunications and other services.	1 Ducts and the like: details to be stated. 2 Supports to external storage tanks, vessels and the like: details to be stated. 3 Fuel bunds and the like to storage/retention tanks and vessels: details to be stated. 4 Protective compounds, fencing, storage racks associated with LPG installations and the like: details to be stated. 5 Protective compounds, connected with transformer sub-stations and the like: details to be stated. 6 Bases for services equipment: details, including size, to be stated. 7 Other builder's work in connection with external services: details to be stated.	nr/m item/nr item/nr item/nr item/nr nr %	C1 Where components are to be enumerated, the number of components is to be stated. C2 Where components are to be itemised, the number of key elements comprising the component are to be identified, described and enumerated within the description of the component. C3 Where the linear length of a component is to be measured, the length measured is their extreme length, over all fittings and the like. C4 Where a percentage addition is to be applied, the percentage addition is to be applied to the cost targets for sub-elements 8.7.1 to 8.7.11 inclusive as appropriate. Each system is to be identified separately. C5 Other cost significant components are to be described and identified separately. Such components are to be measured by area (m²), linear measurement (m) or enumerated (nr) separately in accordance with the rules of measurement for this sub-element. C6 Work to existing buildings is to be described and identified separately. C7 Work outside the curtilage of the site is to be described and identified separately.	1 Ducts and the like for external mains services. 2 Supports to external storage tanks, vessels and the like. 3 Fuel bunds and the like to storage/retention tanks and vessels. 4 Protective compounds, fencing, storage racks associated with LPG installations and the like. 5 Protective compounds, connected with transformer substations and the like. 6 Bases for services equipment, including for transformation devices (i.e. wind turbines, photovoltaic devices and the like). 7 On-site painting or anti-corrosion treatments of mechanical services equipment, including fuel storage tanks and vessels, pipelines and the like. 8 Forming/cutting holes, mortices, sinkings, chases and the like, including making good. 9 Pipe ducts, sleeves and the like. 10 Trench covers, duct covers and frames. 11 Stopping up and sealing holes. 12 Fire resistant stopping, including fire sleeves. 13 Identification labelling and colour coding of services installations and systems. 14 Other builder's work items in connection with external services. 15 Sundry items. 16 Where works are to be carried out by a subcontractor, subcontractor's preliminaries, design fees, risk allowance, overheads and profit.	1 Trenches for buried pipelines, cables and ducts, including excavation, earthwork support, backfilling, beds and surrounds (included in element 8.6: External drainage or element 8.7: External services, as appropriate). 2 Cover tiles, identification tapes and other special protection for services (included in element 8.7: External services as appropriate). 3 Constructing draw pits, including access covers (included in sub-element 8.7.2: Electricity mains supply, sub-element 8.7.3: External transformation devices, sub-element 8.7.4: Electricity distribution to external plant and equipment, sub-element 8.7.6: Telecommunications and other communication system connections, sub-element 8.7.8: External security systems, sub-element 8.7.9: Site/street lighting systems, as appropriate). 4 Heating ducts and access covers to local/district heating pipelines (included in sub-element 8.7.11: Local/district heating installations).

Sub-element	Component	Unit	Measurement rules for components	Included	Excluded
13 Testing and commissioning of external services **Definition:** Testing and commissioning of external mechanical and electrical services and installations.	1 Testing: details to be stated. 2 Commissioning: details to be stated.	% %	C1 The percentage addition is to be applied to the *cost targets* for *sub-elements* 8.7.1 to 8.7.11 inclusive as appropriate. C2 Each system is to be identified separately. **Note:** Clearly state if costs associated with testing and commissioning of external services are included with costs for testing and commissioning of services within building (cross-reference to *element* 5.15: Testing and commissioning of services).	1 Testing equipment and consumables. 2 Calibration. 3 Site installation tests. 4 Static testing, including testing records. 5 Performance testing, including performance test records. 6 Commissioning, including preliminary checks, setting systems and installations to work and regulation thereof, and commissioning records. 7 Temporary operation of plant and equipment to *employer's* requirements. 8 Fuels required for testing and commissioning. 9 Sundry items. 10 Where works are to be carried out by a *subcontractor* or sub-consultant, *subcontractor's* or sub-consultant's preliminaries, design fees, risk allowance, overheads and profit.	1 Testing and commissioning of services within building (included in *element* 5.15: Testing and commissioning of services).

Element 8.8: Minor building works and ancillary buildings

Sub-element	Component	Unit	Measurement rules for components	Included	Excluded
1 Minor building works **Definition:** Refurbishment of, and alterations to, existing separate external small ancillary buildings, including overhauling existing mechanical and electrical plant and equipment.	1 Refurbishment of existing ancillary buildings: details, including GIFA (m²), to be stated. 2 Overhauling existing mechanical and electrical plant and equipment: details to be stated. 3 Repairs to existing fences, railings, walls and screen walls: details to be stated.	item/nr item/nr nr/m	C1 Where components are to be enumerated, the number of components is to be stated. C2 Where components are to be itemised, the number of key elements comprising the component are to be identified, described and enumerated within the description of the component. C3 The area measured is the gross internal floor area (GIFA), measured using the rules of measurement for ascertaining GIFA. C4 Other cost significant components are to be described and identified separately. Such components are to be measured by area (m²), linear measurement (m) or enumerated (nr) separately in accordance with the rules of measurement for this *sub-element*. C5 Work outside the curtilage of the site is to be described and identified separately.	1 Refurbishment (including alterations) of existing separate external small ancillary buildings (e.g. boiler houses). 2 Overhauling existing mechanical and electrical plant and equipment (externally located). 3 Repairs to existing fences, railings, walls, screen walls and retaining walls. 4 Works arising out of party wall awards/agreements. 5 Other minor building works to ancillary buildings.	1 Repairs to existing roads, paths and pavings (included in *element* 8.2: Roads, paths and pavings). 2 Repairs to existing grassed areas (included in *sub-element* 8.3.1: Seeding and turfing). 3 Alterations to existing external drainage systems (included in *sub-element* 8.6.1: Surface water and foul water drainage). 4 Work to existing manholes or the like (included in *sub-element* 8.6.1: Surface water and foul water drainage). 5 Clearing existing drains (included in *sub-element* 8.6.1: Surface water and foul water drainage). 6 Sealing redundant drains, including filling entire length of drain with foam concrete or the like (included in *sub-element* 8.6.1: Surface water and foul water drainage). 7 Filling disused manholes (included in *sub-element* 8.6.1: Surface water and foul water drainage).

Sub-element	Component	Unit	Measurement rules for components	Included	Excluded
2 Ancillary buildings and structures **Definition:** Separate external small ancillary buildings and structures, including specialist structures.	1 Minor ancillary building – built: details, including GIFA (m²), to be stated. 2 Minor ancillary building – prefabricated/proprietary: details to be stated.	nr nr	C1 Where components are to be enumerated, the number of components is to be stated. C2 The area measured is the gross internal floor area (GIFA), measured using the rules of measurement for ascertaining GIFA. C3 Other cost significant components are to be described and identified separately. Such components are to be measured by area (m²), linear measurement (m) or enumerated (nr) separately in accordance with the rules of measurement for this sub-element. C4 Work outside the curtilage of the site is to be described and identified separately. C5 Work arising out of party wall awards/agreements is to be described and identified separately.	1 Boiler houses. 2 Substation buildings or housings, where not supplied and installed by the statutory undertaker. 3 Fuel storage buildings and the like. 4 Specialist structures (e.g. external cooling towers). 5 Bicycle stores. 6 Prefabricated/timber workshops, sheds, stores and the like. 7 Guard huts and the like. 8 Canopies to external areas. 9 Other ancillary buildings.	1 Fuel bunds and the like to storage/retention tanks and vessels (included in sub-element 8.7.12: Builder's work in connection with external services). 2 Protective compounds, fencing, storage racks associated with LPG installations and the like (included in sub-element 8.7.12: Builder's work in connection with external services). 3 Protective compounds, connected with transformer substations and the like (included in sub-element 8.7.12: Builder's work in connection with external services).
3 Underpinning to external site boundary walls **Definition:** Inserting additional foundation support under and around existing foundations within existing buildings, including boundary walls.	1 Underpinning to external site boundary walls and the like: details to be stated.	m	C1 The length of underpinning measured is the extreme length. C2 Other cost significant components are to be described and identified separately. Such components are to be measured by area (m²), linear measurement (m) or enumerated (nr) separately in accordance with the rules of measurement for this sub-element. C3 Curved work is to be described and identified separately. C4 Work arising out of party wall awards/agreements is to be described and identified separately.	1 Underpinning to external site boundary walls. 2 Preliminary trenches and underpinning pits, excavation and earthwork support. 3 Temporary supports. 4 Disposal of excavated material. 5 Cutting away existing projecting foundations and the like. 6 Preparing existing work to receive pinning up of new work. 7 Concrete, including reinforcement and formwork. 8 Masonry (brickwork, blockwork and the like). 9 Sundry items. 10 Where works are to be carried out by a subcontractor, subcontractor's preliminaries, design fees, risk allowance, overheads and profit.	1 Underpinning to walls which are an integral part of the new building or rehabilitated building (included in sub-element 1.1.3: Underpinning).

Group element 9: Facilitating works

Group element 9 comprises the following elements:

9.1 Toxic/hazardous material removal

9.2 Major demolition works

9.3 Specialist groundworks

9.4 Temporary diversion works

9.5 Extraordinary site investigation works

Note: Works associated with general site preparation and groundworks, minor demolition works, and permanent roads, paths and pavings are included in *group element 8: External works*. The provision of temporary roads and services is included in *group element 10: Main contractor's* preliminaries.

Element 9.1: Toxic/hazardous material removal

Sub-element	Component	Unit	Measurement rules for components	Included	Excluded
1 Toxic or hazardous material removal **Definition:** Removal, employing special safety measures, of toxic or hazardous material prior to demolition or refurbishment works.	1 Toxic or hazardous material removal: details to be stated. 2 Toxic or hazardous chemical removal: details to be stated.	item item	C1 Cost significant components are to be described and identified separately. Such components are to be measured by area (m²), linear measurement (m) or enumerated (nr) separately.	1 Removal of toxic or hazardous parts of building fabric (e.g. asbestos). 2 Removal of toxic or hazardous insulating materials or components from existing services installations, including storage tanks and vessels.	1 Contaminated ground material removal or treatment (included in *sub-element 9.1.2: Contaminated land*). 2 Asbestos survey fees and the like (included in *group element 12: Project/design team* fees).

EFFECTIVE FROM 1 MAY 2009

Sub-element	Component	Unit	Measurement rules for components	Included	Excluded
				3 Removal of toxic or hazardous chemicals from existing services installations, including storage tanks and vessels. 4 Safe disposal. Note: Where no asbestos survey records exist, an allowance is to be made within the construction risk allowance. 5 Sundry items. 6 Where works are to be carried out by a subcontractor, subcontractor's preliminaries, design fees, risk allowance, overheads and profit.	
2 Contaminated land Definition: Removal and/or treatment of contaminated ground material.	1 Contaminated ground material removal: details to be stated. 2 Contaminated ground material treatment: details to be stated.	m²/m³ m²	C1 The area measured is the area of contaminated land. C2 Where the volume of excavation and disposal of contaminated ground material is measured, the volume measured is the surface area of the contaminated material multiplied by the average depth of the contaminated material. C3 Quantities given for disposal of contaminated ground material are the bulk before excavating and no allowance is made for subsequent variations to bulk or for extra space to accommodate earthwork support. C4 Other cost significant components are to be described and identified separately. Such components are to be measured by area (m²), linear measurement (m) or enumerated (nr) separately.	1 Contaminated ground material removal using dig and dump strategy, including safe disposal of excavated material to licensed tip (i.e. non-hazardous and hazardous material), tipping charges and landfill tax. 2 Contaminated ground material treatment using in-situ methods, such as: – dilution – clean cover – on-site encapsulation – bio-remediation – soil washing – soil flushing – thermal treatment – vacuum extraction – stabilisation. 3 Where works are to be carried out by a subcontractor, subcontractor's preliminaries, design fees, risk allowance, overheads and profit.	1 Environmental audits and intrusive ground investigations/surveys (included in group element 12: Project/design team fees). 2 Remediation strategy/plan (included in group element 12: Project/design team fees). 3 Supervision to ensure compliance with remediation strategy/plan (included in group element 12: Project/design team fees) 4 Reinstatement works required by alleviation strategy (included in group element 1: Substructure or group element 8: External works, as appropriate).

ORDER OF COST ESTIMATING AND ELEMENTAL COST PLANNING

Sub-element	Component	Unit	Measurement rules for components	Included	Excluded
3 Eradication of plant growth **Definition:** Eradication of Japanese knotweed, giant hogweed or other invasive plant.	1 Eradication by dig and dump strategy: details to be stated. 2 Eradication by chemical treatment: details to be stated.	m²/m³ nr/m²	C1 Where components are to be enumerated, the number of components is to be stated. C2 The area measured is the area designated as infected by the plant growth. C3 Where the volume of excavation and disposal of contaminated ground material is measured, the volume measured is the surface area of the contaminated material multiplied by the average depth of the contaminated material. C4 Quantities given for disposal of contaminated ground material are the bulk before excavating and no allowance is made for subsequent variations to bulk or for extra space to accommodate earthwork support. C5 Other cost significant components are to be described and identified separately. Such components are to be measured by area (m²), linear measurement (m) or enumerated (nr) separately.	1 Eradication by dig and dump strategy (including inserting rootbarrier® membrane system or the like), including excavation and safe disposal of excavated material to licensed tip, tipping charges, landfill tax and backfilling voids with inert material. 2 Eradication by chemical treatment. 3 Where works are to be carried out by a *subcontractor*, *subcontractor's preliminaries*, design fees, risk allowance, overheads and profit.	1 Site investigation surveys for Japanese knotweed, giant hogweed or other invasive plant (included in *element* 12.1: Consultants' fees). 2 Supervision of removal of Japanese knotweed, giant hogweed or other invasive plant by specialist consultant (included in *element* 12.1: Consultants' fees). **Note:** Removal undertaken by a works contractor, but is to be carried out under strict supervision of a specialist consultant.

Element 9.2: Major demolition works

Sub-element	Component	Unit	Measurement rules for components	Included	Excluded
1 Demolition works **Definition:** Taking down to ground level and removing complete buildings/ structures or parts of buildings/structures, including services, fittings and finishes thereto.	1 Demolition of entire buildings: details to be stated. 2 Demolition of major parts of existing buildings: details to be stated.	m² m²	C1 The area measured is the gross internal floor area (GIFA), measured using the rules of measurement for ascertaining the GIFA. C2 Cost significant components are to be described and identified separately. Such components are to be measured by area (m²), linear measurement (m) or enumerated (nr) separately.	1 Demolition of entire buildings and structures, including removing service installations (i.e. significant buildings and structures). 2 Demolition of major parts of existing buildings and structures (including removing service installations) ready to receive new construction.	1 Removing parts of existing buildings (included in *group element* 7: Work to existing buildings). 2 Alterations to existing buildings (included in *group element* 7: Work to existing buildings). 3 Stripping out services in conjunction with alteration works to existing buildings (included in *sub-element* 7.1.1: Minor demolition works and alteration works).

210 | RICS NEW RULES OF MEASUREMENT EFFECTIVE FROM 1 MAY 2009

Sub-element	Component	Unit	Measurement rules for components	Included	Excluded
				3 Disposal of materials arising from demolition, including materials classified as inert, non-hazardous and hazardous. 4 Disconnecting existing mains services, including water, gas, electricity, drainage, district heating, telecommunication systems, data systems and the like). 6 Statutory undertaker's fees and charges for disconnecting main services. 7 Sundry items. 8 Where works are to be carried out by a *subcontractor, subcontractor's preliminaries*, design fees, risk allowance, overheads and profit.	4 Decontaminating existing services systems prior to demolition (e.g. boilers and fuel storage tanks and vessels – included in *sub-element 9.1.1*: Toxic or hazardous material removal). 5 Temporary or semi-permanent support to structures or façades (included in *element 7.4*: Facade retention). 6 Minor demolitions carried out as part of the site clearance (included in *sub-element 8.1.1*: Site clearance).

Element 9.3: Specialist groundworks

Sub-element	Component	Unit	Measurement rules for components	Included	Excluded
1 Site dewatering and pumping **Definition:** Temporarily lowering the ground water level over the whole of the site to facilitate construction.	1 Site dewatering: details to be stated.	item/m²	C1 Where components are to be itemised, the number of key elements comprising the component are to be identified, described and enumerated within the description of the component. C2 The area measured is the area affected by the dewatering system employed. C3 Other cost significant components are to be described and identified separately. Such components are to be measured by area (m²), linear measurement (m) or enumerated (nr) separately.	1 Forming well points, including well pointing equipment and well point installation. 2 Filling (gravel or other filling). 3 Drain tubes and ring mains (installing and removing). 4 Sumps. 5 Pumps and pumping, including standby pumps. 6 Off-site disposal of water. 7 Running costs. 8 Attendance, including out of hours. 9 Sundry items associated with site dewatering. 10 Where works are to be carried out by a *subcontractor, subcontractor's preliminaries*, design fees, risk allowance, overheads and profit.	1 Permanent land drainage (included in *sub-element 8.6.4*: Land drainage).

Sub-element	Component	Unit	Measurement rules for components	Included	Excluded
2 Soil stabilisation measures **Definition:** Stabilisation or improvement of bearing capacity or slip resistance of existing ground to facilitate construction by injecting or otherwise introducing stabilising materials, by power vibrating, by soil nailing or by ground anchors.	1 Soil stabilisation measures: details to be stated.	m²	C1 The area measured is the area affected by the soil stabilisation measure. C2 Other cost significant components are to be described and identified separately. Such components are to be measured by area (m²), linear measurement (m) or enumerated (nr) separately.	1 Soil stabilisation measures, including: – cement or chemical grouting – electrochemical stabilisation – sand stowing – forming regular pattern of holes, compacting surrounding soil, and filling with aggregates or hard fill, all by means of power vibrators – soil nailing – ground anchors – pressure grouting – compacting – freezing of ground water and subsoil – stabilising soil in situ by incorporating cement with a rotovator. 2 Sundry items. 3 Where works are to be carried out by a *subcontractor, subcontractor's preliminaries*, design fees, risk allowance, overheads and profit.	1 Consolidating and compacting formation level to receive construction (included in *sub-element* 1.1.1: Standard foundations; *sub-element* 1.2.1: Basement excavation; *element* 1.3: Basement retaining walls; or *sub-element* 1.4.1: Ground floor slab/bed and suspended floor construction, as appropriate).
3 Ground gas venting measures **Definition:** Systems to prevent accumulation of radon or landfill gases.	1 Ground gas venting: details to be stated.	m²	C1 The area measured is the area affected by the gas venting measure. C2 Other cost significant components are to be described and identified separately. Such components are to be measured by area (m²), linear measurement (m) or enumerated (nr) separately.	1 Ground gas venting measures, including: – gas proof membranes – perforated collection pipes – proprietary gas dispersal fin layers – radon sumps – vent pipes, including vertical risers to vent at high level. 2 Sundry items associated with ground gas venting measures. 3 Where works are to be carried out by a *subcontractor, subcontractor's preliminaries*, design fees, risk allowance, overheads and profit.	1 Gas proof membranes used to also serve as a damp-proof membrane (included in *sub-element* 1.4.1: Ground floor slab/bed and suspended floor construction). 2 Radon sumps under ground slab of building (included in *sub-element* 1.4.1: Ground floor slab/bed and suspended floor construction). 3 Granular venting layers (included in *sub-element* 1.4.1: Ground floor slab/bed and suspended floor construction).

Element 9.4: Temporary diversion works

Sub-element	Component	Unit	Measurement rules for components	Included	Excluded
1 Temporary diversion works **Definition:** Temporary diversion of existing drainage systems, existing services installations and systems, rivers, streams and the like.	1 Temporary diversion of drains: details to be stated. 2 Temporary diversion of services: details to be stated. 3 Temporary diversion of waterways: details to be stated.	item item item	C1 Works are to be itemised and described. C2 Where insufficient information is available, such works are to be included in group *element 14: Risks*, as appropriate.	1 All works in connection with temporary diversion of drains. 2 All works in connection with temporary diversion of services (e.g. water, electricity, gas and communications). 3 All works in connection with temporary diversion of rivers, streams and the like. 4 Statutory undertaker's fees and charges in connection with diversion works. 5 Sundry items. 6 Where works are to be carried out by a *subcontractor, subcontractor's preliminaries, design fees, risk allowance, overheads and profit.*	

Element 9.5: Extraordinary site investigation works

Sub-element	Component	Unit	Measurement rules for components	Included	Excluded
1 Archaeological investigation **Definition:** Site based archaeological investigation.	1 Archaeological investigation: details to be stated.	item	C1 Works are to be itemised and described. C2 Where insufficient information is available, such works are to be included in group *element 14: Risks*, as appropriate.	1 Physical archaeological investigation works (i.e. site based excavation works in search of artefacts and the like). 2 Attendance on archaeologists.	1 Desktop studies (included in *group element* 12: Project/design team fees). 2 Archaeological excavations (included in *group element* 13: Other development/project costs).
2 Reptile/wildlife mitigation measures **Definition:** Relocation of reptiles/wildlife and provision of fences/barriers to cordon off the working area.	1 Reptile/wildlife mitigation measures: details to be stated.	item	C1 Works are to be itemised and described. C2 Where insufficient information is available, such works are to be included in group *element 14: Risks*, as appropriate.	1 Trapping and relocation of reptiles/wildlife and the like. 2 Provision of temporary fences, barriers and the like to cordon off working area. 3 Attendance.	1 Desktop studies (included in *group element* 12: Project/design team fees).

Sub-element	Component	Unit	Measurement rules for components	Included	Excluded
3 Other extraordinary site investigation works	1 Other extraordinary site investigation works: details to be stated.	item	C1 Works are to be itemised and described. C2 Where insufficient information is available, such works are to be included in group element 14: Risks, as appropriate.		1 Desktop studies (included in group element 12: Project/design team fees).

Group element 10: Main contractor's preliminaries

Group element 10 comprises the following elements:

10.1 Employer's requirements:

 10.1.1 Site accommodation

 10.1.2 Site records

 10.1.3 Completion and post-completion requirements.

10.2 Main contractor's cost items:

 10.2.1 Management and staff

 10.2.2 Site establishment

 10.2.3 Temporary services

 10.2.4 Security

 10.2.5 Safety and environmental protection

 10.2.6 Control and protection

 10.2.7 Mechanical plant

 10.2.8 Temporary works

 10.2.9 Site records

 10.2.10 Completion and post-completion requirements

 10.2.11 Cleaning

 10.2.12 Fees and charges

 10.2.13 Site services

 10.2.14 Insurance, bonds, guarantees and warranties.

Note: Where the unit of measurement for a component or a sub-component has been given as 'per week', a week shall mean a period of 7 calendar days irrespective of public holidays.

Element 10.1: Employer's requirements

Sub-element 10.1.1: Site accommodation

Component	Included	Unit	Excluded
1 Site accommodation	Site accommodation for the employer and the employer's representatives where separate from main contractor's site accommodation, including:		Site accommodation, furniture and equipment, telecommunication and IT systems for the employer and the employer representatives where an integral part of the main contractor's site accommodation (included in element 10.2: Main contractor's cost items, as appropriate).
	1 Site offices.	per week	
	2 Sanitary accommodation.	per week	
	3 Welfare facilities.	per week	
	4 Foundations to site accommodation.	per week	
	5 Temporary drainage to accommodation.	per week	
	6 Temporary services.	per week	
	7 Intruder alarms.	per week	
	8 Adaptations/alterations during works.	per week	
	9 Cleaning.	per week	
	10 Charges.	per week	
	11 Temporary offices (off site – rent).	per week	
2 Furniture and equipment	Furniture and equipment for the employer and the employer's representatives where separate from main contractor's site accommodation. For example, desks, chairs, meeting table and chairs, cupboards, kettles, coffee maker, photocopier and consumables.	item	
3 Telecommunication and IT systems	Telecommunication and IT systems for the employer and the employer's representatives where separate from main contractor's site accommodation, including telephones, fax machines, photocopier, computers, printers and consumables.	per person (nr)	

Sub-element 10.1.2: Site records

Component	Included	Unit	Excluded
1 Site records	1 Operation and maintenance manuals. 2 Compilation of health and safety file (if required). 3 Home Information Packs.	sum sum sum	

Sub-element 10.1.3: Completion and post-completion requirements

Component	Included	Unit	Excluded
1 Handover requirements	1 Training of building user's staff in the operation and maintenance of the building engineering services systems. 2 Provision of spare parts for maintenance of building engineering services. 3 Provision of tools and portable indicating instruments for the operation and maintenance of building engineering services systems.	sum sum sum	
2 Operation and maintenance services	1 Operation and maintenance of building engineering services installations, mechanical plant and equipment and the like during the defects liability period, period for rectifying defects, maintenance period or other specified period (i.e. additional services to that normally required by the contract).	per week	1 Ongoing maintenance of internal and external planting (included in sub-element 4.3.1: Internal planting and sub-element 8.3.2: External planting, as appropriate).

Element 10.2: Main contractor's cost items

Sub-element 10.2.1: Management and staff

Component	Included	Unit	Excluded
1 Project specific management and staff	*Main contractor's project specific management and staff such as:*		1 External design consultants (included in *group element* 12: Project/design team design fees).
	1 Project manager/director.	man hours per week	2 Security staff (included in *sub-element* 10.2.4: Security).
	2 Construction manager.	man hours per week	
	3 Supervisors, including works/trade package managers, building services engineering managers/co-ordinators and off-site production managers.	man hours per week	
	4 Health and safety manager/officers.	man hours per week	
	5 Commissioning manager – building engineering services.	man hours per week	
	6 Planning/programming manager and staff.	man hours per week	
	7 Commercial manager.	man hours per week	
	8 Quantity surveyors.	man hours per week	
	9 Procurement manager.	man hours per week	
	10 Design manager and staff (where contract strategy is design and build).	man hours per week	
	11 Project engineers.	man hours per week	
	12 Environmental manager.	man hours per week	
	13 Temporary works design engineers.	man hours per week	
	14 Materials management staff (e.g. storeman).	man hours per week	

Component	Included	Unit	Excluded
	15 Administrative staff, including secretary, document controllers, finance clerks and the like.	man hours per week	
	16 Other management and staff.	man hours per week	
2 Visiting management and staff	Main contractor's visiting management and staff such as:		1 Visiting management and staff for which an allowance has been made within the main contractor's overheads (included in element 11.1: Main contractor's overheads).
	1 Managing director; regional director; operations director; commercial director and the like.	man hours per week	
	2 Quality assurance manager.	man hours per week	
	3 Contract manager.	man hours per week	
	4 Health and safety manager.	man hours per week	
	5 Environmental manager/consultant.	man hours per week	
	6 Other visiting management and staff.	man hours per week	
3 Extraordinary support costs	1 Legal advice costs (i.e. solicitors).	sum	1 Extraordinary support costs for which an allowance has been made within the main contractor's overheads (included in element 11.1: Main contractor's overheads).
	2 Recruitment costs.	sum	
	3 Team building costs.	sum	
	4 Other extraordinary support costs.	sum	
	5 Day transport.	per week	
	6 Personnel transport (i.e. transportation of work operatives to site).	per week	
	7 Temporary living accommodation (e.g. long/medium term accommodation costs).	per week	
	8 Subsistence payments.	per week	
	9 Out-of-hours working.	per week	

Component	Included	Unit	Excluded
4 Staff travel	Costs associated with off-site visits such as:		
	1 Visits to employer's and consultants' offices.	sum	
	2 Visits to subcontractors' offices/works.	sum	
	3 Overseas visits.	sum	
	4 Accommodation charges and overnight expenses.	sum	

Sub-element 10.2.2: Site establishment

Component	Included	Unit	Excluded
1 Site accommodation	Main contractor's and common user temporary site accommodation such as: – offices – conference/meeting rooms – canteens and kitchens – drying rooms – toilets and washrooms – first aid room – laboratories – workshops – secure stores – compounds, including containers for material storage – security control room – stairs and office staging. 1 Hire and purchase charges.	per week	1 Employer's accommodation, where not an integral part of the main contractor's site accommodation (included in sub-element 10.1.1: Site accommodation). 2 Temporary bases, foundations and provision of drainage and services to temporary site accommodation (included in component 10.2.2.3: Builder's work and temporary services connections to site accommodation). 3 Service provider's charges for temporary services (included in sub-element 10.2.12: Fees and charges). 4 Rates for temporary services (included in sub-element 10.2.12: Fees and charges).

Component	Included	Unit	Excluded
	2 *Employer's* accommodation, where an integral part of the *main contractor's* site accommodation.	per week	
	3 Delivery of temporary site accommodation to site, erection, construction and removal.	sum	
	4 Temporary accommodation made available by the *employer*.	per week	
	5 Intruder alarms.	sum	
	6 Land/property rental where site accommodation located off-site.	per week	
	7 Alterations and adaptations to site accommodation, including partitioning, doors, painting and decorating, and the like.	sum	
	8 Relocation and alterations of temporary accommodation during construction stage.	sum	
	9 Reinstating temporary site accommodation to original condition prior to removal from site.	sum	
	10 Removal of site accommodation and temporary works in connection with site accommodation.	sum	
2 Temporary works in connection with site establishment	1 Temporary bases and foundations for site accommodation.	m²	1 Provision of temporary services to site establishment (included in *sub-element* 10.2.3: Temporary services).
	2 Connections to temporary service.	nr	2 Provision of temporary drainage to site establishment (included in *sub-element* 10.2.3: Temporary services).
	3 Connections to temporary drainage.	nr	3 Hoardings, fans, fencing and the like to site boundaries and to form site compounds (included in *sub-element* 10.2.4: Security (Hoardings, fences and gates).
	4 Temporary site roads, paths and pavings (including on-site car parking).	m²	
	5 Temporary surface water drainage to temporary site roads, paths and pavements.	m	

Component	Included	Unit	Excluded
3 Furniture and equipment	1 Workstations for staff, including maintenance.	per person (nr)	1 Telephone and fax installations (included in *sub-element* 10.2.3: Temporary services).
	2 General office furniture, including maintenance.	sum	2 Computers and IT associated equipment (included in *component* 10.2.2.4: IT systems).
	3 Conference/meeting room furniture, including maintenance.	sum	
	4 Photocopiers, including purchase/rental, maintenance and other running costs.	nr	
	5 Canteen furniture, including maintenance.	sum/per week	
	6 Canteen equipment, including purchase/rental, maintenance and other running costs.	sum	
	7 Floor coverings, including maintenance.	sum	
	8 Water dispensers, including purchase/rental, maintenance and other running costs.	sum	
	9 Heaters, including maintenance of heaters.	sum	
	10 Other office equipment, including maintenance.	sum	
	11 Removal of furniture and equipment.	sum	
	12 Maintenance furniture and floor covering.	sum	

Component	Included	Unit	Excluded
4 IT systems	1 Computer hardware, including purchase/rental, installation, initial set up, maintenance and running costs, such as: – desktop computers and laptop computers – CAD stations – server and network equipment – printers and plotters – other computer system hardware.	per person (nr)	1 Computer and printer consumables (included in *component* 10.2.2.5: Consumables and services). 2 Document management, including electronic data management systems (EDMS) (included in *component* 10.2.2.6: Brought in services).
	2 Software and software licences.	per person (nr)	
	3 Modem lines, modems and connections (i.e. email and internet capability).	per person (nr)	
	4 WAN lines and connections (if on WAN).	per person (nr)	
	5 Line rental charges.	per week	
	6 Internet/website addresses.	per person (nr)	
	7 Internet service provider (ISP) charges.	per person (nr)	
	8 Line calls charges.	per week	
	9 IT support and maintenance.	per person (nr)	
5 Consumables and services	1 Stationery.	per week	
	2 Computer and printer consumables (e.g. ink cartridges).	per week	
	3 Postage.	per week	
	4 Courier charges.	per week	
	5 Tea, coffee, water bottles and the like.	per week	
	6 First aid consumables.	per week	
	7 Photocopier consumables (e.g. paper and toners).	per week	
	8 Fax consumables (e.g. paper and toners).	per week	
	9 Drawing printer consumables (e.g. ink cartridges).	per week	

Component	Included	Unit	Excluded
6 Brought in services	Services outsourced by the *main contractor* such as:		
	1 Catering.	per week	
	2 Equipment maintenance.	per week	
	3 Document management, including electronic data management systems (EDMS).	per week	
	4 Printing (purchasing), including reports and drawings.	per week	
	5 Staff transport.	per week	
	6 Off-site parking charges.	per week	
	7 Meeting room facilities.	per week	
	8 Photographic services.	per week	
7 Sundries	1 *Main contractor's* signboards.	sum	
	2 Safety and information notice boards.	sum	
	3 Fire points.	sum	
	4 Shelters.	sum	
	5 Tool stores.	sum	
	6 Crane signage.	sum	
	7 *Employer's* composite signboards.	sum	

Sub-element 10.2.3: Temporary services

Component	Included	Unit	Excluded
1 Temporary water supply	1 Temporary connections.	sum	
	2 Distribution equipment, installation and adaptations.	sum	
	3 Meter charges.	sum/per week	
2 Temporary gas supply	1 Gas connection.	sum	
	2 Distribution equipment, installation and adaptations.	sum	
	3 Charges.	per week	
	4 Bottled gas.	sum/per week	
3 Temporary electricity supply	1 Temporary connections.	sum	
	2 Temporary electrical supply for tower cranes.	sum	
	3 Charges – power consumption for site establishment.	per week	
	4 Charges – power consumption for the works.	per week	
	5 Distribution equipment, installation and adaptations.	sum	
	6 Attendance.	per week	
	7 Uninterrupted power supply (UPS).	sum	
	8 Temporary substation modifications.	sum	

Component	Included	Unit	Excluded
4 Temporary telecommunication systems	1 Landlines (including connection and rental charges), including: – telephone and fax lines – ISDN lines.	sum/per week	1 Fax consumables (included in component 10.2.2.5: Consumables and services).
	2 Telephone and facsimile equipment (including connection and rental charges), including: – PABX equipment – handsets, including purchase or rental – fax machines, including purchase or rental – installation of equipment – maintenance of equipment.	sum/per week	
	3 Mobile (cellular) phones, including: – mobile phones, including purchase or rental and connection charges – spare batteries – mobile phone charges.	sum/per week	
	4 Telephone charges, including: – telephone call charges – fax charges – fax and telephone consumables.	per week	
	5 Radios (including purchase or rental charges), including: – base set – handsets and chargers – repairs and maintenance – licences – spare batteries.	per week	

Component	Included	Unit	Excluded
5 Temporary drainage	1 Temporary mains.	sum	
	2 Septic tanks.	sum	
	3 On-site treatment plant.	sum	
	4 Holding tanks.	sum	
	5 Sewage pumping.	sum	
	6 Distribution pipework, etc.	sum	
	7 Drainage installation and adaptations.	sum	
	8 Disposal charges (i.e. rates).	per week	
	9 Disposal costs (i.e. tanker charges).	per week	

Sub-element 10.2.4: Security

Component	Included	Unit	Excluded
1 Security staff	1 Security guards (day and night).	man hours per week	1 Security staff accommodation (included in sub-element 10.2.2: Site establishment).
	2 Watchmen (day and night).	man hours per week	
2 Security equipment	1 Site pass issue equipment.	sum	
	2 Site pass consumables.	per week	
	3 CCTV surveillance installation.	sum	
	4 Temporary vehicle control barriers.	nr	
3 Hoardings, fences and gates	1 Perimeter hoardings and fencing and the like to site boundaries and to form site compounds.	m	
	2 Access gates, including frames and ironmongery.	nr	
	3 Painting of hoardings, fencing, gates, and the like.	m	
	4 Temporary doors.	nr	
	5 Modification to line of hoarding and fencing during construction.	sum	
	6 Dismantling and removal of hoarding, fencing, gates, and the like.	m	

Sub-element 10.2.5: Safety and environmental protection

Works required to satisfy requirements of CDM Regulations.

Component	Included	Unit	Excluded
1 Safety programme	1 Health and safety manager/officers.	man hours per week	1 Health and safety manager/officers (included in *sub-element* 10.2.1: Management and staff).
	2 Safety audits, including safety audits carried out by external consultant.	man hours per week	2 Welfare facilities (included in *sub-element* 10.2.2: Site establishment).
	3 Staff safety training.	per person (nr)/ per week	
	4 Site safety incentive scheme	per week	
	5 Notices and information to neighbours.	sum	
	6 Personal protective equipment (PPE), including for *employer* and *consultants*.	per set	
	7 PPE for multi-service gangs.	per set	
	8 Fire points.	nr	
	9 Temporary fire alarms.	nr	
	10 Fire extinguishers.	nr	
	11 Statutory safety signage.	sum	
	12 Nurse.	man hours per week	
	13 Traffic marshals.	man hours per week	
	14 Temporary traffic lights.	sets per week	

Component	Included	Unit	Excluded
2 Barriers and safety scaffolding	1 Guard rails and edge protection (e.g. to edges of suspended slabs and roofs).	sum	1 Debris netting/plastic sheeting provided as part of access scaffolding (included in *sub-element* 10.2.8: Temporary works).
	2 Temporary staircase balustrades (i.e. to new staircases during construction).	sum	2 Fan protection provided as part of access scaffolding (included in *sub-element* 10.2.8: Temporary works).
	3 Lift shaft protection.	nr	
	4 Protection to holes and openings in ground floor slabs, suspended slabs and the like.	sum	
	5 Debris netting/plastic sheeting.	sum	
	6 Fan protection.	sum	
	7 Scaffold inspections.	per week	
	8 Hoist run-offs.	sum	
	9 Protective walkways.	sum	
	10 Other safety measures.	sum	
3 Environmental protection measures	1 Control of pollution.	sum	1 Environmental manager/consultant (included in *sub-element* 10.2.1: Management and staff).
	2 Residual control of noise.	sum	
	3 Environmental monitoring.	man hours per week	
	4 Environmental manager/consultant.	man hours per week	
	5 Environmental audits, including safety audits carried out by external consultant.	man hours per week	

Sub-element 10.2.6: Control and protection

Component	Included	Unit	Excluded
1 Surveys, inspections and monitoring	1 Surveys.	sum	1 Environmental monitoring (included in *sub-element* 10.2.5: Safety and environmental protection).
	2 Topographical survey.	sum	
	3 Non-*employer* dilapidation survey.	sum	
	4 Structural/dilapidations survey adjoining buildings.	sum	
	5 Environmental surveys.	sum	
	6 Movement monitoring.	sum	
	7 Maintenance and inspection costs.	sum	
2 Setting out	1 Setting out primary grids.	sum	
	2 Grid transfers and level checks.	sum	
	3 Maintenance of grids.	sum	
	4 Take over control and independent checks (i.e. on change of subcontractors).	sum	
	5 Instruments for setting out.	sum	
3 Protection of works	1 Protection of finished works to project handover.	sum	
	2 Protection of stairs, balustrades and the like works to project handover.	sum	
	3 Protection of fittings and furnishings works to project handover.	sum	
	4 Protection of entrance doors and frames works to project handover.	sum	
	5 Protection of lift cars and doors works to project handover.	sum	
	6 Protection of specifically vulnerable products to project handover.	sum	
	7 Protection of all sundry items.	sum	

Component	Included	Unit	Excluded
4 Samples	1 Provision of samples.	sum	
	2 Provision of sample room.	sum	
	3 Mock ups and sample panels.	sum	
	4 Testing of samples/mock ups, including testing fees.	sum	
	5 On site laboratory equipment.	sum	
	6 Mock ups of complete units (e.g. residential units, student accommodation units, hotel accommodation and the like).	sum	
5 Environmental control of building	1 Dry out building.	sum	
	2 Temporary heating/cooling.	sum	
	3 Temporary waterproofing, including over roofs.	sum	
	4 Temporary enclosures.	sum	

Sub-element 10.2.7: Mechanical plant

Component	Included	Unit	Excluded
1 Generally	Common user mechanical plant and equipment used in construction operations.		Plant and equipment used for specific construction operations, such as: 1 Earthmoving plant (included in group element 1: Substructure, group element 8: External works, or group element 9: Facilitating works, as appropriate). 2 Piling plant (included in group element 1: Substructure or group element 8: External works as appropriate). 3 Paving and surfacing plant (included in or group element 8: External works). 4 Wheel spinners, and road sweepers (included in component 10.2.11.2: Maintenance of roads, paths and pavings). 5 Access scaffolding (included in sub-element 10.2.8: Temporary works).

Component	Included	Unit	Excluded
2 Tower cranes	1 Hire charges.	per week	1 Temporary electrical supply to tower crane (included in *sub-element* 10.2.3: Temporary services).
	2 Crane operator.	per week	
	3 Overtime for crane and operator.	per week	
	4 Piles for tower crane bases.	sum	
	5 Temporary bases for tower cranes, including anchors.	sum	
	6 Ties.	per week	
	7 Connections to temporary electrical supply.	sum	
	8 Bring to site, erection, test and commission.	sum	
	9 Periodic safety checks/inspections.	per week	
	10 Dismantling and removing from site.	sum	
	11 Other costs specific to tower crane such as: – chain pack and sundries – relief operator – banksman – man cage.	sum/per week	
	12 Temporary voids in building structure for craneage, hoists and the like, including filling voids after removal.	sum	
3 Mobile cranes	1 Mobile crane hire charges, including driver/operator charges.	per week	
	2 Attendance.	per week	
	3 Other costs specific to mobile crane hire.	sum/per week	

Component	Included	Unit	Excluded
4 Hoists	1 Goods and passenger hoists, including protection cages and embedment frames.	per week	1 Temporary services to hoist installations (included in sub-element 10.2.3: Temporary services).
	2 Hoist bases.	sum	
	3 Bringing to site, erecting, testing and commissioning.	sum	
	4 Dismantling and removing from site.	sum	
	5 Protection systems.	per week	
	6 Hoist operator, including overtime.	per week	
	7 Beam hoists.	per week	
	8 Periodic safety checks/inspections.	per week	
	9 Other costs specific to temporary hoist installations.	per week	
5 Access plant	1 Folk lifts.	per week	
	2 Scissor lifts.	per week	
	3 Loading platforms.	per week	
	4 Maintenance of mechanical access equipment.	per week	
	5 Other costs specific to mechanical access equipment.	per week/sum	
6 Concrete plant	1 Concrete plant.	per week	1 Temporary services to concrete plant (included in sub-element 10.2.3: Temporary services).
	2 Plant operator.	per week	
	3 Overtime for plant and operator.	per week	
	4 Bases for concrete plant.	sum	
	5 Power connections, including cabling and statutory undertaker's charges for temporary connection to their supply.	sum	
	6 Bring to site, erection, test and commission.	sum	
	7 Maintenance of concrete plant.	per week	
	8 Dismantling and removing from site.	sum	
7 Other plant	1 Small plant and tools.	per week	

Sub-element 10.2.8: Temporary works

Component	Included	Unit	Excluded
1 Access scaffolding	Common user access scaffolding (type of access scaffolding to be specified): – access scaffolding to elevations, lift shafts and the like, including fans, mesh screens – structural scaffolding (e.g. to party walls) – birdcage scaffolding – cantilever access scaffolding – staircase platforms – primary loading platforms – travelling access platforms. 1 Bringing to site, erecting and initial safety checks. 2 Hire charges. 3 Altering and adapting during construction. 4 Dismantling and removing from site.	 sum per week sum/per week sum	1 Scaffolding specific to works packages (included in appropriate *element* or *sub-element*). 2 Scaffold inspections (included in *sub-element* 10.2.5: Safety and environmental protection)
2 Temporary works	Common user temporary works: – support scaffolding and propping – crash decks – temporary protection to existing trees and/or vegetation – floodlights. 1 Bringing to site, erecting and initial safety checks. 2 Hire charges. 3 Altering and adapting during construction. 4 Dismantling and removing from site.	 sum per week sum/per week sum	1 Temporary works design (included in *sub-element* 10.1.1: Management and staff). 2 Temporary bases, drainage and services to site accommodation (included in *sub-element* 10.2.2: Site establishment). 3 Temporary roads, paths and pavement, including on-site car parking (included in *sub-element* 10.2.2: Site establishment (Builder's work in connection with site accommodation)). 4 Hoardings, fans, fencing and the like to site boundaries and to form site compounds (included in *sub-element* 10.2.4: Security (hoardings, fences and gates). 5 Temporary earthwork support basement excavations (included in *sub-element* 1.2.1: Basement excavation). 6 Temporary props and wallings to support contiguous bored pile wall of basement excavations (included in *sub-element* 1.3.2: Embedded basement retaining walls or *sub-element* 8.4.3: Retaining walls, as applicable). 7 Traffic management, including traffic marshals and temporary traffic lights (included in *sub-element* 10.2.5: Safety and environmental protection).

Sub-element 10.2.9: Site records

Component	Included	Unit	Excluded
1 Site records	Unless otherwise indicated, costs associated with the following shall be deemed to be included in management and staff costs:		
	1 Photography:		
	– camera purchase	nr	
	– consumables	sum	
	– printing and presentation	sum	
	2 Works records:		
	– progress reporting		
	– site setting out drawings		
	– condition surveys and reports	sum	
	– operation and maintenance manuals	sum	
	– as-built/installed drawings and schedules	sum	
	– co-ordinating, gathering and compiling health and safety information and presentation to CDM co-ordinator	sum	
	– compilation of health and safety file (if required)	sum	
	– Home Information Packs (HIPS).	sum	

Sub-element 10.2.10: Completion and post-completion requirements

Component	Included	Unit	Excluded
1 Testing and commissioning plan	Costs associated with the following shall be deemed to be included in sub-element 10.2.1: Management and staff costs: 1 Preparation of Commissioning Plan.		1 Testing and commissioning of services (included in element 5.15: Testing and commissioning services or sub-elements 8.6.5: Testing and commissioning of external drainage installations; and 8.7.13: Testing and commissioning of external services).
2 Handover	Unless otherwise indicated, costs associated with the following shall be deemed to be included in sub-element 10.2.1: Management and staff costs: 1 Preparation of Handover Plan. 2 Training of building user's staff in the operation and maintenance of the building engineering services systems. 3 Provision of spare parts for maintenance of building engineering services. 4 Provision of tools and portable indicating instruments for the operation and maintenance of building engineering services systems. 5 Pre-completion inspections. 6 Final inspections.	 sum sum sum	
3 Post-completion services	1 Supervisory staff (employer/tenant care). 2 Handyman. 3 Minor materials and sundry items. 4 Insurances. 5 Other post-construction staff.	man hours per week man hours per week sum/week sum man hours per week	

Sub-element 10.2.11: Cleaning

Component	Included	Unit	Excluded
1 Site tidy	1 Cleaning site accommodation – internal, including cleaning telephone handsets, other office furniture and equipment and window cleaning.	per week	
	2 Periodic maintenance of site accommodation, including redecoration (internal and external).	nr	
	3 Waste management, including rubbish disposal (including compactor visits; skips and waste bins; roll-off, roll-on waste bins) and other disposal.	per week	
	4 Pest control.	per week	
2 Maintenance of roads, paths and pavings	1 Maintenance of temporary site roads, paths, and pavements.	per week	
	2 Maintenance of public and private roads, including wheel spinners and road sweepers.	per week	
3 Building clean	1 Final builder's clean.	sum	

Sub-element 10.2.12: Fees and charges

Component	Included	Unit	Excluded
1 Fees	1 Building control fees, where not paid by the employer.	sum	1 Building control fees, where paid by the employer (included in group element 12: Project/design team fees).
	2 Oversailing fees, where not paid by the employer.	sum	2 Oversailing fees, where paid by the employer (included in group element 12: Project/design team fees).
	3 Considerate Constructors' Scheme fees (or alternative scheme operated by local authority).	sum	3 Zurich and NHBC Buildmark registration fees or similar fees, where paid by the employer (included in group element 12: Project/design team fees).
	4 Zurich and NHBC Buildmark registration fees or similar fees, where not paid by the employer.	per unit	
2 Charges	1 Rates on temporary accommodation.	sum	1 Statutory undertaker's charges in connection with permanent services to the building (included in element 8.7: External services, as appropriate).
	2 Licences in connection with hoardings, scaffolding, gantries and the like.	sum	2 Statutory undertaker's charges in connection with temporary services (included in sub-element 10.2.3: Temporary services).
	3 Licences in connection with crossovers, parking permits, parking bay suspensions and the like.	sum	

Sub-element 10.2.13: Site services

Component	Included	Unit	Excluded
1 Temporary works	1 Temporary works which are not specific to an *element*.	sum	1 Temporary screens (included in *sub-element* 7.1.1: Minor demolition works and alteration works). 2 Supports to small openings cut into existing walls or after removal of internal walls or the like (included in *sub-element* 7.1.1: Minor demolition works and alteration works). 3 Temporary or semi-permanent support for unstable structures or facades, i.e. structures not to be demolished (included in *sub-element* 7.4.1: Facade retention).
2 Multi-service gang	1 Ganger. 2 Labour. 3 Fork lift driver. 4 Service gang plant and transport.	man hours per week man hours per week man hours per week sum	

Sub-element 10.2.14: Insurance, bonds, guarantees and warranties

Component	Included	Unit	Excluded
1 Works insurances	1 Contractors 'all risks' (CAR) insurance. 2 Contractor's plant and equipment insurance. 3 Temporary buildings insurance. 4 Terrorism insurance. 5 Other insurances in connection with the works. 6 Insurance premium tax (IPT). 7 Allowance for recovery of all or part of insurance premium excess.	sum sum sum sum sum sum sum	

Component	Included	Unit	Excluded
2 Public liability insurances	1 Non-negligence insurance.	sum	
	2 Professional indemnity insurance.	sum	
	3 Insurance premium tax (IPT).	sum	
	4 Allowance for recovery of all or part of insurance premium excess.	sum	
3 Employer's (main contractor's) liability insurances	1 Management and staff, including administrative staff.	sum	
	2 Works operatives.	sum	
	3 Insurance premium tax (IPT).	sum	
	4 Allowance for recovery of all or part of insurance premium excess.	sum	
4 Other insurances	1 Employer's loss of liquidated damages.	sum	
	2 Latent defects cover.	sum	
	3 Motor vehicles.	sum	
	4 Other insurances.	sum	
	5 Insurance premium tax (IPT).	sum	
	6 Allowance for recovery of all or part of insurance premium excess.	sum	
5 Bonds	1 Tender bonds (if applicable).	sum	
	2 Performance bonds.	sum	
6 Guarantees	1 Parent company guarantees.	sum	
	2 Product guarantees, insurance backed.	sum	
7 Warranties	1 Collateral warranties.	sum	
	2 Funder's warranties.	sum	
	3 Purchaser's and tenant's warranties.	sum	
	4 Other warranties.	sum	

Group element 11: Main contractor's overheads and profit

Group element 11 comprises the following elements:

11.1 Main contractor's overheads

11.2 Main contractor's profit

Element	Included	Excluded
1 Main contractor's overheads	1 Generally, the costs of head office set up and administration proportioned to each contract by the *main contractor*.	1 Visiting management and staff for which an allowance has been made within the *main contractor's preliminaries* (included in *component* 10.2.1.2: Visiting management and staff). 2 Extraordinary support costs for which an allowance has been made within the *main contractor's preliminaries* (included in *component* 10.2.1.3: Extraordinary support costs).
2 Main contractor's profit	1 The amount of net profit that the *main contractor* needs to achieve.	

Group element 12: Project/design team fees

Group element 12 comprises the following elements:

12.1 Consultants' fees

12.2 Main contractor's pre-construction fees

12.3 Main contractor's design fees (Note: Only applicable where a main contractor-led design and build contract strategy is to be used.)

Note: Where the unit of measurement for a component or a sub-component has been given as 'per week', a week shall mean a period of 7 calendar days irrespective of public holidays.

Element 12.1: Consultants' fees

Component	Included	Unit	Excluded
1 Project team and design team consultants' fees **Note:** Where design liability is to be transferred to the *main contractor* (i.e. where a design and build or other contractor-led design strategy is to be used) and all, or some, of the consultants within the *design team* are to be novated, the balance of the consultants' fees due after novation has occurred are to be transferred from *element 12.1: Consultants' fees to element 12.3: Main contractor's design fees. See element 12.3: Main contractor's design fees.*	1 Professional adviser. 2 Project manager. 3 Contract administrator. 4 *Employer's* agent. 5 Architect. 6 Quantity surveyor/cost manager. 7 Building services engineer(s). 8 Structural engineer. 9 CDM co-ordinator. 10 Interior designer. 11 Landscape architect. 12 Infrastructure engineer. 13 Drainage engineer.	%/sum	

Component	Included	Unit	Excluded
2 Other consultants' fees	1 Measuring surveyor (i.e. to carry out topographical survey of site; to verify ground levels/contours, physical features, existing boundaries, adjacent properties and site access). 2 Drainage and utilities surveyor (i.e. to trace and locate existing drainage and other services, both underground and above ground, on or near the site, including, water; electricity, telecommunications, data lines and oil/fuel pipelines; advising on extent of existing utilities). 3 Geotechnical engineer (e.g. trial pits, boreholes and borehole logs, geology of site, including underground workings, laboratory and soil tests, groundwater observation and pumping tests and geophysical surveys). 4 Environmental consultant (e.g. environmental audits, contamination surveys for asbestos, methane, toxic waste, chemical waste and radioactive substances; and preparation and management of remediation strategy/action plan). 5 Ecologist. 6 Arboriculturist (i.e. to survey and provide advice on trees and the like). 7 Party wall surveyor (i.e. to prepare party wall notices and awards/agreements). 8 Rights of light surveyor (e.g. rights of light agreements). 9 Asbestos consultant. 10 Acoustics consultant. 11 Facade consultant. 12 Lift consultant. 13 Fire consultant. 14 Building control consultant. 15 Traffic consultant (e.g. to examine traffic records, take traffic count, advise on traffic patterns, carry out computer simulation of existing traffic flows, delay analysis and advise on noise levels). 16 Japanese knotweed (invasive weeds) specialist (e.g. to survey the site for invasive weeds).	%/sum	1 Physical archaeological investigation works, i.e. excavation works in search of artefacts and the like (included in *sub-element* 9.5.1: Archaeological investigation). 2 Relocation of reptiles/wildlife and the like (included in *sub-element* 9.5.2: Reptiles/wildlife mitigation measures). 3 Physical investigation works in search of unexploded devices, i.e. excavation works in search of unexploded devices (included in *sub-element* 9.5.3: Other extraordinary site investigation works). 4 Site investigations, procured by *main contractor* as part of pre-construction services (included in *element* 12.2: Main contractor's pre-construction fees). 5 Work arising out of party wall awards/agreements (included in *sub-element* 8.8.1: Minor building works, as appropriate). 6 Intrusive investigations for toxic or hazardous materials, e.g. asbestos (included in *component* 12.3.3: Site investigation fees).

Component	Included	Unit	Excluded
	17 Sustainability consultant (to advise on renewable technologies and sustainability issues). 18 Archaeologist (e.g. to examine existing records and archaeological remains – desktop study). 19 BREEAM assessor. 20 Code for Sustainable Homes assessor. 21 Facilities manager (e.g. to advise on operational and maintenance matters). 22 Value engineer. 23 Building surveyor (i.e. to carry out structural/ dilapidations survey of adjoining buildings; and carry out condition surveys). 24 Unexploded devices consultant (e.g. to research and advise on possibility of unexploded bombs on site). 25 Photographer (i.e. to carry out a photographic survey of the site). 26 Specialist contractors/consultants (e.g. early advice on viability of ground source heating). 27 Other specialist consultants (to be stated).		
3 Site investigation fees	1 Site investigation. 2 Geotechnical investigation. 3 Trial pits. 4 Intrusive investigations for toxic or hazardous materials (e.g. type 3 survey for asbestos). 5 Other site investigations (to be stated).	sum	1 Removal of toxic or hazardous materials, e.g. asbestos (included in sub-element 9.1.1: Toxic or hazardous material removal).
4 Specialist support consultants' fees	1 Planning consultant (i.e. to advise on planning matters and facilitate planning process). 2 Political consultants (i.e. to assist with planning application). 3 Letting agents (e.g. advice on market needs, advice on design proposals and selling). 4 Legal advice – property (e.g. to advise on ownership of site, restrictive covenants, easements, boundaries, party wall agreements, highway agreements, local authority agreements and air rights).	%/sum	

Component	Included	Unit	Excluded
	5 Legal advice – construction (e.g. to advise on construction contracts, warranties, financial protection measures and the like).		
	6 Legal advice – environmental.		
	7 Tax specialist – (e.g. to advise on VAT, availability of capital tax allowances, tax relief in respect of land remediation and other specialist tax matters).		
	8 Grants advice (e.g. to advise on availability of grants for construction works).		
	9 Facilitator.		
	10 HIPS surveyor (e.g. to prepare Home Information Packs).		
	11 Other specialist support consultants (to be stated).		

Element 12.2: Main contractor's pre-construction fees

Component	Included	Unit	Excluded
1 Management and staff fees	Management and staff, such as:	man hours per week	
	1 Project director.		
	2 Project manager.		
	3 Construction manager.		
	4 Commercial manager.		
	5 Quantity surveyors.		
	6 Procurement manager.		
	7 Planning/programming manager and staff.		
	8 Design manager.		
	9 Temporary works design engineers.		
	10 Works package managers.		
	11 Building services engineering managers/co-ordinators.		
	12 Health and safety manager.		
	13 Secretary/administrative support.		
	14 Other pre-construction management and staff.		

Component	Included	Unit	Excluded
2 Specialist support services fees	1 Legal advice (i.e. solicitors). 2 Specialist subcontractor advice/participation. 3 Geotechnical investigations, procured by main contractor as part of pre-construction services. 4 Site investigations, procured by main contractor as part of pre-construction services. 5 Other pre-construction support services.	sum	
3 Temporary accommodation, services and facilities charges	1 Offices, including rental of temporary office space. 2 Service provider's charges for water, electricity and gas. 3 Rates. 4 Furniture and equipment, including workstations. 5 Office equipment, including photocopiers. 6 Telecommunications, including internet and intranet access. 7 IT systems, including hardware, printers, plotters and the like. 8 Office consumables. 9 Cleaning. 10 Other costs associated with the provision of pre-construction accommodation, services and facilities. 11 Reinstating accommodation to original condition on completion of pre-construction services.	per week	
4 Main contractor's overheads and profit	1 *Main contractor's* overheads and profit associated with pre-construction services.	%	

Element 12.3: Main contractor's design fees

Component	Included	Unit	Excluded
1 Main contractor's design consultants' fees **Note:** Where design liability is to be transferred to the *main contractor* (i.e. where a design and build or other *main contractor*-led design contract strategy is to be used) and all, or some, of the consultants within the *design team* are to be novated, the balance of the consultants' fees due after novation has occurred is to be transferred from *element* 12.1: Consultants' fees to *element* 12.3: Main contractor's design fees.	1 Architect. 2 Building services engineer(s). 3 Structural engineer. 4 Interior designer. 5 Landscape architect. 6 Infrastructure engineer. 7 Drainage engineer. 8 Other design consultants.	%/sum	

Group element 13: Other development/project costs

Group element 13 comprises the following elements:

13.1 Other development/project costs

Note: Where the unit of measurement for a *component* or a *sub-component* has been given as 'per week', a week shall mean a period of 7 calendar days irrespective of public holidays.

Element 13.1: Other development/project costs

Component	Included	Unit	Excluded
1 Land acquisition costs	1 Costs in connection with land acquisition.	sum	
2 *Employer finance costs*	1 Costs in connection with funding of building project.	sum	
3 Fees	1 Planning fees.	sum	1 Building control fees, where paid by the *main contractor* (included in *sub-element* 10.2.12: Fees and charges).
	2 Building control fees, where not paid by the *main contractor*.	sum	2 Oversailing fees, where paid by the *main contractor* (included in *sub-element* 10.2.12: Fees and charges).
	3 Oversailing fees, where not paid by the *main contractor*.	sum	3 Zurich and NHBC Buildmark registration fees or similar fees, where paid by the *main contractor* (included in *sub-element* 10.2.12: Fees and charges).
	4 Fees in connection with party wall awards.	sum	4 Considerate Constructors' Scheme fees (or alternative scheme operated by local authority). Paid by *main contractor* (included in *sub-element* 10.2.12: Fees and charges).
	5 Fees in connection with rights of light agreements.	sum	5 Other fees in connection with licences, permits and agreements, where paid by the *main contractor* (included in *sub-element* 10.2.12: Fees and charges).
	6 Zurich and NHBC Buildmark registration fees or similar fees, where not paid by the *main contractor*.	per unit	
	7 Fees in connection with other agreements between the *employer* and neighbours to facilitate the building project.	sum	
	8 Other fees in connection with licences, permits and agreements, where not paid by the *main contractor*.	sum	

Component	Included	Unit	Excluded
4 Charges	1 Adoption charges in connection with highways.	sum	
	2 Maintenance costs in connection with highways.	per week	
	3 Adoption charges in connection with services (e.g. sewers, water, electricity and gas).	sum	
	4 Maintenance costs in connection with services.	per week	
5 Planning contributions	1 Direct financial contributions in connection with planning consent (e.g. Section 106 and Section 278 contributions).	sum	1 Building works subject to a planning contribution which forms an integral part of the building project, included in the appropriate *group element, element or sub-element.*
	2 Environmental improvement works.	sum	
6 Insurances	1 Insurance for the works – existing buildings.	sum	1 Insurance for the works – new buildings, where insurance taken out by the *main contractor* (included in *sub-element* 10.2.14 Insurance, bonds, guarantees and warranties).
	2 Insurance for the works – new buildings, where insurance taken out by the *employer.*	sum	
	3 Other insurances in connection with the works.	sum	
	4 Insurance premium tax (IPT).	sum	
7 Archaeological works	1 Archaeological works financed by the *employer.*	sum	
8 Decanting and relocation costs	1 Temporary relocation costs.	sum	
	2 Fit-out of temporary accommodation.	sum	
	3 Rents and other running costs.	per week	
9 Fittings, furnishings and equipment	1 Fittings, furnishings and equipment which do not form part of a building contract.	sum	1 Fittings, furniture and equipment which form part of a building contract (included in *group element* 4: Fittings, furnishings and equipment).
10 Tenant's costs/contributions	1 Tenant's costs.	sum	
	2 Tenant's contributions.	sum	
11 Marketing costs	1 Launch event.	sum	
	2 Site based advertising (e.g. sales hoardings).	sum	
	3 Show unit/marketing suites (i.e. separate or within building to be built).	sum	
	4 Operating costs associated with show unit/marketing suites.	per week	
	5 Marketing literature.	sum	
12 Other *employer* costs	1 Other *employer* costs in connection with the building project (to be stated).	sum	

Group element 14: Risks

Group element 14 comprises the following elements:

14.1 Design development risks

14.2 Construction risks

14.3 *Employer* change risks

14.4 *Employer* other risks

Note: A list of typical risks under each of these headings is provided. The lists of risks provided are not meant to be definitive or exhaustive, but simply a guide. The lists can be used to prompt *project team* members.

Element 14.1: Design development risks

1 Inadequate or unclear project brief.
2 Unclear *design team* responsibilities.
3 Unrealistic design programme.
4 Ineffective quality control procedures.
5 Inadequate site investigation.
6 Planning constraints/requirements.
7 Soundness of design data.
8 Appropriateness of design (constructionability).
9 Degree of novelty (i.e. design novelty).
10 Ineffective design co-ordination.
11 Reliability of area schedules.
12 Reliability of estimating data:
 – changes in labour, materials, equipment and plant costs; and
 – inflation (i.e. differential inflation due to market factors and/or timing).
13 Use of provisional sums (i.e. do not give price certainty).

Element 14.2: Construction risks

1 Inadequate site investigation.
2 Archaeological remains.
3 Underground obstructions.
4 Contaminated ground.
5 Adjacent structures (i.e. requiring special precautions).
6 Geotechnical problems (e.g. mining and subsidence).
7 Ground water.
8 Asbestos and other hazardous materials.
9 Invasive plant growth.
10 Tree preservation orders.
11 Ecological issues (e.g. presence of endangered species).
12 Environmental impact.
13 Physical access to site (i.e. restrictions and limitations).
14 Existing occupancies/users.
15 Restricted working hours/routines.
16 Maintaining access.
17 Maintaining existing services.
18 Additional infrastructure.
19 Existing services (i.e. availability, capacity, condition and location).
20 Location of existing services.
21 Relocation of existing services.
22 Statutory undertakers (i.e. performance).
23 Uncertainty over the source and availability of materials.
24 Appropriateness of specifications.
25 Incomplete design.
26 Weather and seasonal implications.
27 Industrial relations.
28 Remote site.
29 Competence of contractor and subcontractors.
30 Health and safety.
31 Ineffective quality management procedures.
32 Phasing requirements (e.g. occupation and decanting).
33 Ineffective handover procedures.
34 Disputes and claims.

35 Effect of changes/variations on construction programme.
36 Cumulative effect of numerous changes/variations on construction programme.
37 Defects.
38 Accidents/injury.

Element 14.3: Employer change risks

1 Specific changes in requirements (i.e. in scope of works or project brief during design, pre-construction and construction stages).
2 Changes in quality (i.e. specification of materials and workmanship).
3 Changes in time.
4 *Employer* driven changes/variations introduced during the construction stage.
5 Effect on construction duration (i.e. impact on date for completion).
6 Cumulative effect of numerous changes.

Element 14.4: Employer other risks

1 Project brief:
 – End user requirements.
 – Inadequate or unclear project brief.
 – *Employer's* specific requirements (e.g. functional standards, site or establishment rules and regulations, and standing orders).
2 Timescales:
 – Unrealistic design and construction programmes.
 – Unrealistic tender period(s).
 – Insufficient time allowed for tender evaluation.
 – Contractual claims.
 – Effects of phased completion requirements (e.g. sectional completion).
 – Acceleration of construction works.
 – Effects of early handover requirements (e.g. requesting partial possession).
 – Postponement of pre-construction services or construction works.
 – Timescales for decision making.
3 Financial:
 – Availability of funds.
 – Unavailability of grants/grant refusal.
 – Cash flow effects on timing.
 – Existing liabilities (i.e. liquidated damages or premiums on other contracts due to late provision of accommodation).

- Changing inflation.
- Changing interest rates.
- Changing exchange rates.
- Changes in taxation (e.g. VAT).
- Unsuitable contract strategy.
- Incomplete design before construction commences.
- Unconventional contract strategy.
- Unconventional tender action.
- Amendments to standard contract conditions and/or supplementary contract conditions.
- Acceptance of use of provisional sums (i.e. do not give price certainty).
- Liquidation/insolvency of *main contractor*.
- Liquidation/insolvency of consultant.
- Delay in payment.

4 Management:
- Unclear project organisation and management.
- Competence of *project/design team*.
- Unclear definition of project/team responsibilities.
- Inadequate or no risk management strategy.
- Ineffective or no cost control procedures.
- Inadequate or no design review procedures.
- Ineffective or no procedures for procurement.
- Ineffective or no time control procedures.
- Ineffective change control procedures (for both pre-construction and construction stages of building project).
- Ineffective reporting systems.
- Phasing of decanting and occupation.

5 Third party:
- Requirements relating to planning (e.g. public enquiries, listed building consent and conservation area consent).
- Opposition by local councillor(s).
- Planning refusal.
- Legal agreements.
- Works arising out of party wall agreements.
- Requirements relating to existing rights of way, rights of light, way leaves and noise abatement.
- Requirements relating to listed buildings and/or conservation areas.
- Requirements relating to sites of scientific interest (SSI).

– Requirements relating to environmental impact assessments.
– Requirements relating to social matters (e.g. pressure groups and local protests).
– Public enquiries.

6 Other:

– Insistence on use of local work people.
– Availability of labour, materials and plant.
– Statutory requirements.
– Market conditions.
– Political change.
– Legislation.
– Force majeure.

Group element 15: Inflation

Group element 15 comprises the following elements:

15.1 Tender inflation

15.2 Construction inflation

Element	Included	Unit	Excluded
1 Tender inflation	1 Inflationary price increases during the period from the *estimate base date* to the date of tender return.	%	1 Unexpected price increases associated with particular materials or products or the impact of major projects sapping resources (home and abroad); particular specialist, works, trade, work package, and labour-only subcontractors; or other countries buying major quantities of raw materials (included in *element* 14.4: Employer's other risks).
2 Construction inflation	1 Inflationary price increases during the period from the date of tender return to the mid-point of the construction period.	%	2 Unexpected changes in market conditions (included in *element* 14.4: Employer's other risks).

Appendices

Appendix A: Core definition of gross internal area (GIA)

The definitions and diagrams in this appendix are reproduced from the *RICS Code of Measuring Practice* (6th edition).

Core definitions: gross internal area

2.0 Gross Internal Area (GIA)

Gross Internal Area is the area of a building measured to the internal face of the perimeter walls at each floor level (see note GIA 4).

Including

2.1 Areas occupied by internal walls and partitions

2.2 Columns, piers, chimney breasts, stairwells, lift-wells, other internal projections, vertical ducts, and the like

2.3 Atria and entrance halls, with clear height above, measured at base level only

2.4 Internal open-sided balconies, walkways, and the like

2.5 Structural, raked or stepped floors are to be treated as a level floor measured horizontally

2.6 Horizontal floors, with permanent access, below structural, raked or stepped floors

2.7 Corridors of a permanent essential nature (e.g. fire corridors, smoke lobbies)

2.8 Mezzanine floor areas with permanent access

2.9 Lift rooms, plant rooms, fuel stores, tank rooms which are housed in a covered structure of a permanent nature, whether or not above the main roof level

2.10 Service accommodation such as toilets, toilet lobbies, bathrooms, showers, changing rooms, cleaners' rooms, and the like

2.11 Projection rooms

2.12 Voids over stairwells and lift shafts on upper floors

2.13 Loading bays

2.14 Areas with a headroom of less than 1.5m (see APP 6)

2.15 Pavement vaults

2.16 Garages

2.17 Conservatories

Excluding

2.18 Perimeter wall thicknesses and external projections

2.19 External open-sided balconies, covered ways and fire escapes

2.20 Canopies

2.21 Voids over or under structural, raked or stepped floors

2.22 Greenhouses, garden stores, fuel stores, and the like in residential property

Applications
(when to use GIA)

Notes
(how to use GIA)

APP 4 **Building cost estimation** – GIA is a recognised method of measurement for calculating building costs

APP 5 **Estate agency and valuation** – GIA is a basis of measurement for the marketing and valuation of industrial buildings (including ancillary offices), warehouses, department stores, variety stores and food superstores. For the avoidance of doubt the basis of measurement should be stated

APP 6 **Rating** – GIA is the basis of measurement in England and Wales for the rating of industrial buildings, warehouses, retail warehouses, department stores, variety stores, food superstores and many specialist classes valued by reference to building cost (areas with a headroom of less than 1.5m being excluded except under stairs)

APP 7 **Property management** – GIA is a basis of measurement for the calculation of service charges for apportionment of occupiers' liabilities

APP 8 **New homes valuation** – a modified version of GIA is an accepted basis of measurement for the valuation and marketing of residential dwellings, particularly in new developments (see NSA on page 32)

GIA 1 **Diagrams** – diagrams C and D illustrate how to apply GIA

GIA 2 **Separate buildings** – GIA excludes the thickness of perimeter walls, but includes the thickness of all internal walls. Therefore, it is necessary to identify what constitutes a separate building

GIA 3 **Advice** – apart from the applications shown, GIA tends to have specialist valuation applications only. Valuers and surveyors who choose this definition for marketing purposes must have regard to the provisions of the *Property Misdescriptions Act* 1991 and *Property Misdescriptions (Specified Matters) Order* 1992 (see Introduction on page 1)

GIA 4 **Internal face** – means the brick/block work or plaster coat applied to the brick/block work, not the surface of internal linings installed by the occupier

GIA 5 **Lift rooms, etc.** – the items covered by 2.9 should be included if housed in a roofed structure having the appearance of permanence (e.g. made of brick or similar building material)

GIA 6 **Level changes** – the presence of steps or a change in floor levels is to be noted

GIA 7 **Voids** – attention is drawn to the exclusion of voids over atria at upper levels (see 2.3) and the inclusion of voids over stairs, etc. (see 2.12). Where an atrium-like space is formed to create an entrance feature and this also accommodates a staircase, this does not become a stairwell but remains an atrium measurable at base level only

Diagram C – Example of appropriate dimensions for GIA defined industrial/warehouse unit

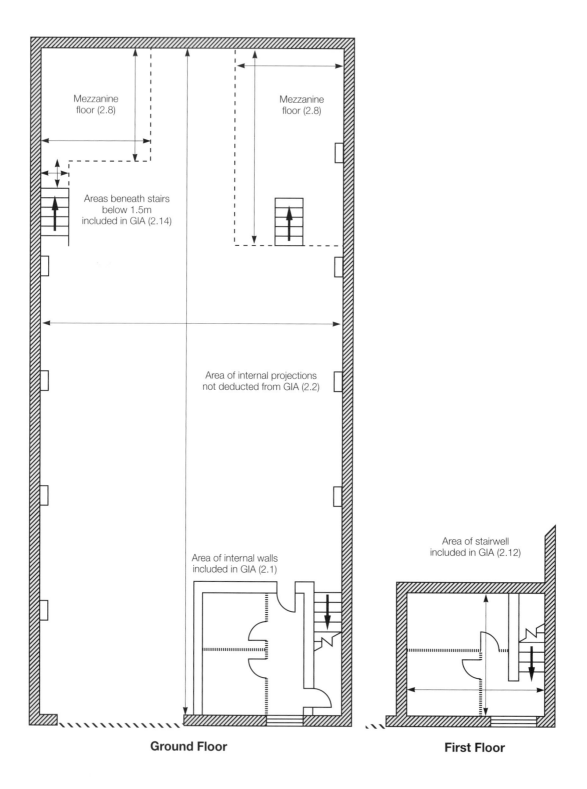

Mezzanine floor (2.8)

Mezzanine floor (2.8)

Areas beneath stairs below 1.5m included in GIA (2.14)

Area of internal projections not deducted from GIA (2.2)

Area of internal walls included in GIA (2.1)

Area of stairwell included in GIA (2.12)

Ground Floor

First Floor

Diagram D – Example of appropriate dimensions for GIA defined industrial/warehouse unit

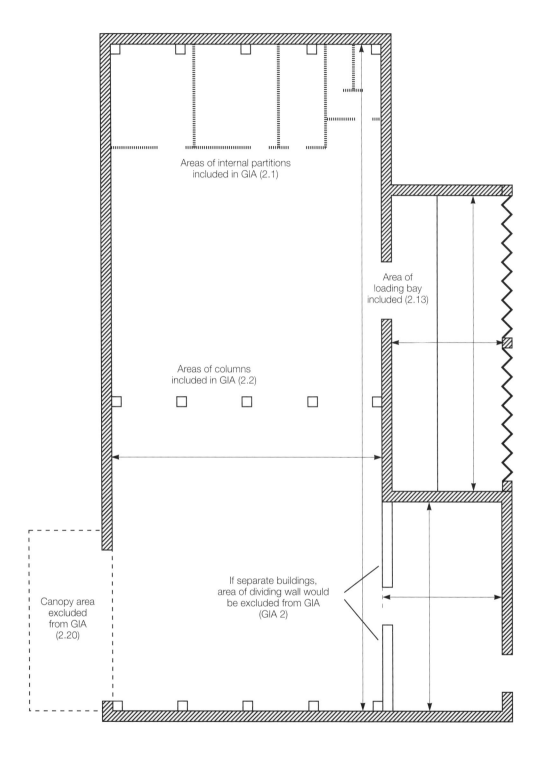

Areas of internal partitions included in GIA (2.1)

Area of loading bay included (2.13)

Areas of columns included in GIA (2.2)

If separate buildings, area of dividing wall would be excluded from GIA (GIA 2)

Canopy area excluded from GIA (2.20)

Diagram M – Example of appropriate dimensions for GIA floor area defined at each level – Leisure facilities

[Note: Numbers in brackets are cross references to the Core definitions: gross internal area.]

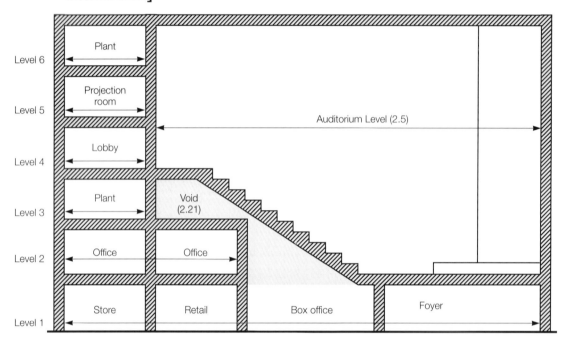

Building Section

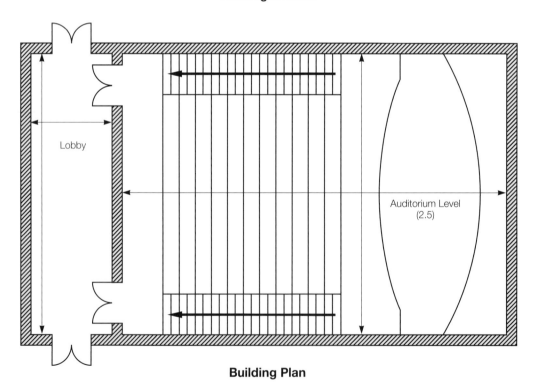

Building Plan

Appendix B: Commonly used functional units and functional units of measurement

Function	Functional unit of measurement
Car parking	
Car parking	per car parking space
Administrative facilities	
Offices	per m² of net internal area (NIA)
Commercial facilities	
Shops	per m² of *retail area* (m²)
Department stores	per m² of *retail area* (m²)
Shopping centres	per m² of *retail area* (m²)
Retail warehouses	per m² of *retail area* (m²)
Industrial facilities	
Factories	per m² of net internal area (NIA)
Warehouses/stores	per m² of net internal area (NIA)
Livestock buildings – farms (pig pens, milking parlours and the like)	per animal
Residential facilities	
Houses (private developer and affordable)	per house type (based on number of bedrooms)
Bungalows (private developer and affordable)	per bedroom
Apartments/flats (private developer and affordable)	per apartment/flat type (based on number of bedrooms)
Hotels/motels	per bedroom
Hotel furniture, fittings and equipment	per bedroom
Student accommodation	per bedroom
Youth hostels	per bedroom
Religious	
Churches, chapels, temples, mosques and the like	per pew or per seat
Education, scientific, information facilities	
Schools	per child or per student
Universities, colleges and the like	per student
Conference centres	number of places
Health and welfare facilities	
Hospitals	per bed space
Nursing homes	per bed space
Doctors' surgeries	per doctor consulting room
Dentists' surgeries	per dentist workspace
Protective facilities	
Fire stations	per fire tender space
Ambulance stations	per ambulance vehicle space
Law courts	per courtroom
Prisons	per cell
Recreational facilities	
Theatre	per seat

ORDER OF COST ESTIMATING AND ELEMENTAL COST PLANNING

Cinemas	per seat or per screen
Concert halls	per seat
Restaurants	per seat
Squash courts, tennis courts and the like	per court
Football stadia	per seat

Appendix C: Core definition of net internal area (NIA)

The definitions and diagrams in this appendix are reproduced from the *RICS Code of Measuring Practice* (6th edition).

Core definitions: net internal area

3.0 Net Internal Area (NIA)

Net Internal Area is the usable area within a building measured to the internal face of the perimeter walls at each floor level. (See note NIA 3)

Including		Excluding	
3.1	Atria with clear height above, measured at base level only (but see 3.11)	3.11	Those parts of entrance halls, atria, landings and balconies used in common (see 3.1 and 3.2)
3.2	Entrance halls (but see 3.11)	3.12	Toilets, toilet lobbies, bathrooms, cleaners' rooms, and the like
3.3	Notional lift lobbies and notional fire corridors	3.13	Lift rooms, plant rooms, tank rooms (other than those of a trade process nature), fuel stores, and the like
3.4	Kitchens	3.14	Stairwells, lift-wells and permanent lift lobbies
3.5	Built-in units, cupboards, and the like occupying usable areas	3.15(a)	Corridors and other circulation areas where used in common with other occupiers
3.6	Ramps, sloping areas and steps within usable areas	3.15(b)	Permanent circulation areas, corridors and thresholds/recesses associated with access, but not those parts that are usable areas
3.7	Areas occupied by ventilation/heating grilles	3.16	Areas under the control of service or other external authorities including meter cupboards and statutory service supply points
3.8	Areas occupied by skirting and perimeter trunking	3.17	Internal structural walls, walls enclosing excluded areas, columns, piers, chimney breasts, other projections, vertical ducts, walls separating tenancies and the like
3.9	Areas occupied by non-structural walls subdividing accommodation in sole occupancy	3.18(a)	The space occupied by permanent and continuous air-conditioning, heating or cooling apparatus, and ducting in so far as the space it occupies is rendered substantially unusable
3.10	Pavement vaults	3.18(b)	The space occupied by permanent, intermittent air-conditioning, heating or cooling apparatus protruding 0.25m or more into the usable area
		3.19	Areas with a headroom of less than 1.5m
		3.20	Areas rendered substantially unusable by virtue of having a dimension between opposite faces of less than 0.25m. See diagram E
		3.21	Vehicle parking areas (the number and type of spaces noted)

Applications

(when to use NIA)

Notes

(how to use NIA)

APP 9 **Estate agency and valuation** – NIA is the basis of measurement for the valuation and marketing of the following types of buildings:
- Shops and supermarkets;
- offices; and
- business use (except those in APP 5)

APP 10 **Rating** – NIA is the principal basis of measurement for rating of shops including supermarkets, offices, business use (except those in APP 6), and composite hereditaments

APP 11 **Property management** – NIA is a basis of measurement for the calculation of service charges for apportionment of occupiers' liability

NIA 1 **Usable area** – an area is usable if it can be used for any sensible purpose in connection with the purposes for which the premises are to be used

NIA 2 **Diagrams** – diagrams E, F, G, H, K, and L illustrate how to apply NIA

NIA 3 **Internal face** – means the brick/block work or plaster coat applied to the brick/block work, not the surface of internal linings installed by the occupier

NIA 4 **Full-height glazing** – where there is full-height glazing, measurements should be taken to the glazing unless elements of the window structure or design render the space substantially unusable.

NIA 5 **Advice** – when dealing with rent reviews or lease renewals, the exclusions are generally intended to relate to the premises as demised. Unless otherwise indicated by statutory provision or the terms of the lease, it will not normally be appropriate to exclude demised usable space which has been subsequently converted by a tenant to any of the exclusions listed

NIA 6 **Level changes** – the presence of steps or a change in floor levels is to be noted for valuation and marketing purposes

NIA 7 **Restricted headroom** – when marketing on an NIA basis it may be appropriate to identify floor areas below full height but above 1.5m

NIA 8 **Perimeter trunking** – when marketing on an NIA basis reference to the inclusion of perimeter trunking may be appropriate in order not to mislead

NIA 9 **Corridors** – whether or not a wall defining a corridor is structural or permanent (see 3.15 and 3.17), is a matter of fact. It depends upon the circumstances of the particular case. When marketing on an NIA basis reference to the inclusion of corridors may be appropriate

Diagram E – Example of appropriate dimensions for NIA floor area defined purpose designed offices

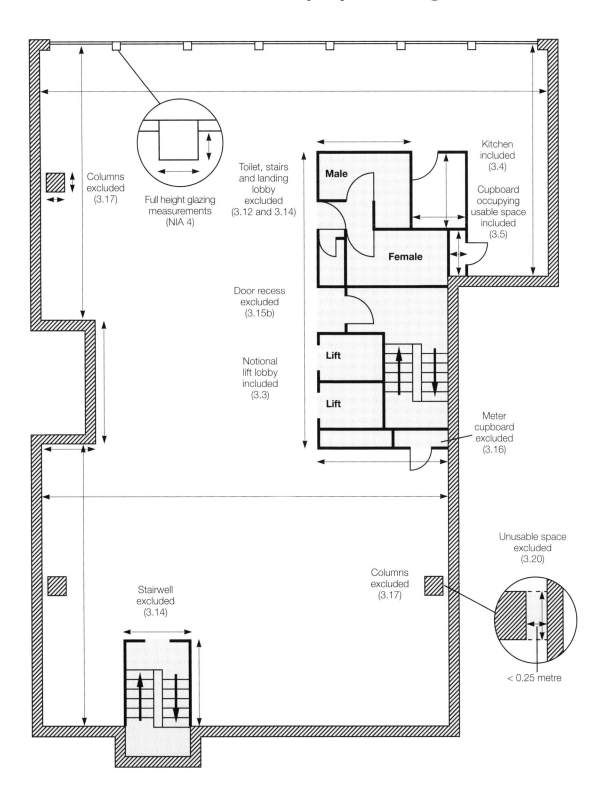

Diagram F – Example of appropriate dimensions for NIA floor area defined offices converted from dwelling house

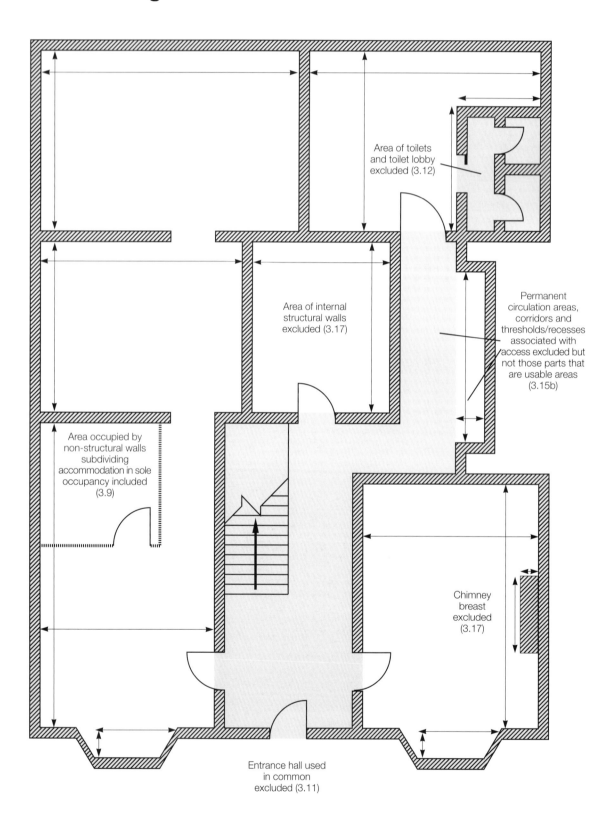

Area of toilets and toilet lobby excluded (3.12)

Permanent circulation areas, corridors and thresholds/recesses associated with access excluded but not those parts that are usable areas (3.15b)

Area of internal structural walls excluded (3.17)

Area occupied by non-structural walls subdividing accommodation in sole occupancy included (3.9)

Chimney breast excluded (3.17)

Entrance hall used in common excluded (3.11)

Diagram G – Example of appropriate dimensions for NIA floor areas defined offices (open plan) multiple occupation

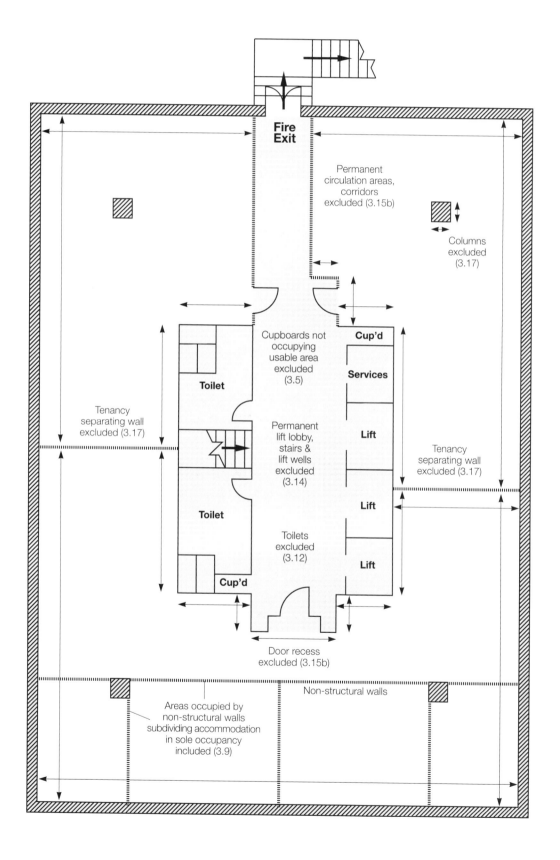

Diagram H – Net Internal Area (NIA) – Examples of appropriate points from which to measure in respect of various types of heating installations

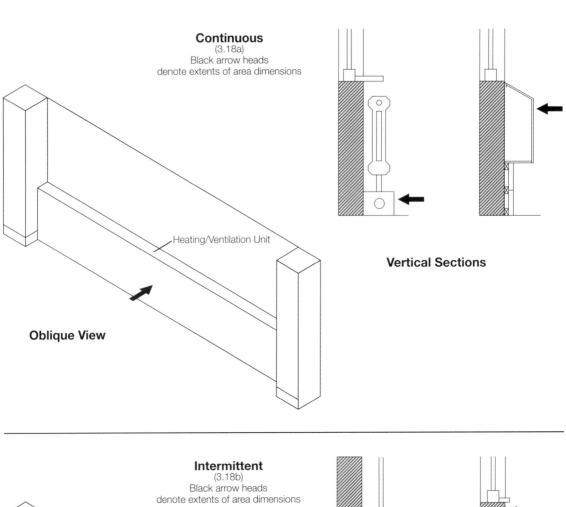

Continuous
(3.18a)
Black arrow heads
denote extents of area dimensions

Heating/Ventilation Unit

Vertical Sections

Oblique View

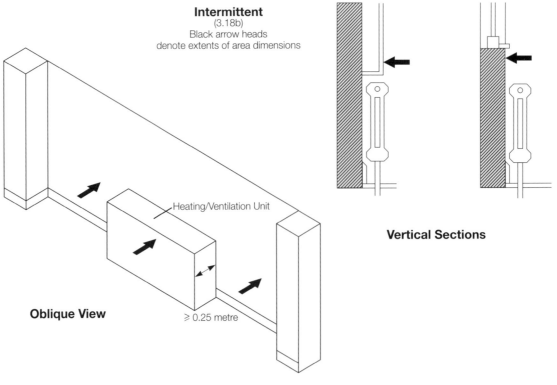

Intermittent
(3.18b)
Black arrow heads
denote extents of area dimensions

Heating/Ventilation Unit

Vertical Sections

Oblique View

≥ 0.25 metre

Appendix D: Special use definitions for shops

The definitions and diagrams in this appendix are reproduced from the *RICS Code of Measuring Practice* (6th edition).

Special use definitions: Shops

16.0 **Retail Area (RA)**

The retail area of the shop is the Net Internal Area (NIA)

Including		Excluding	
16.1	Storerooms and ancillary accommodation formed by non-structural partitions, the existence of which should be noted	16.3	Storerooms and ancillary accommodation formed by structural partitions
16.2	Recessed and arcaded areas of shops created by the location and design of the window display frontage	16.4	Display cabinets which should be identified separately

17.0 **Storage Area (StoA)**

The NIA of a shop which does not form part of the RA (see 16.0) and which is usable exclusively for storage purposes

18.0 **Ancillary Areas (AA)**

All NIA not included in RA and StoA but capable of beneficial use

19.0 **Gross Frontage (GF)**

The overall external measurement in a straight line across the front of the building, from the outside of external walls, or the centre line of party walls

20.0 **Net Frontage (NF)**

The overall external frontage on the shop line measured between the internal face of the external walls, or the internal face of support columns

Including		Excluding	
20.1	The display window frame and shop entrance	20.2	Recesses, doorways or access to other accommodation

21.0 **Shop Width (SW)**

Internal width between inside faces of external walls at front of shop or other point of reference

22.0 **Shop Depth (SD)**

Measurement from the notional display window to the rear of the retail area

Including	
22.1	The thickness of the display window (or any support structure)

23.0 **Built Depth (BD)**

Maximum external measurement from front to rear walls of a building at ground level

Applications
(when to use)

Notes
(how to use)

APP 19	**Estate agency and valuation** – RA is the basis of measurement for the valuation and marketing of shops and supermarkets	RA 1	**Diagrams** – diagrams E to H, K and L illustrate how to apply NIA; diagrams K and L are specific to shops
		RA 2	**Zoning** – the use of zones when assessing the values of shops is a valuation, not a measurement, technique. Consequently it is not part of this Code. Market custom shall prevail
		RA 3	**Display window** – location for the purpose of assessing GEA, GIA or NIA, in the case of shop property where the display window forms the non-structural 'fourth wall', its location should be assumed to be at the forward-most point at which a shop display window could be installed
		AA 1	**Ancillary areas** – include staff rooms, kitchens, training rooms, offices, and the like
		GF 1	**Return gross frontage** – to be measured in the same way as Gross Frontage
		NF 1	**Return net frontage** – to be measured in the same way as Net Frontage
		NF 2	**Display windows** – the existence and nature of display windows and integral shop fronts are to be noted
		SW 1	**Shop width** – if the shop width is not reasonably constant throughout the whole sales area, then this should be stated and additional measurements may need to be provided
		ShD1	**Notional display window** – the notional display window is to be assumed placed at the forward-most point at which a shop (see RA 3) display window could be installed
		ShD2	**Shop depth** – if the depth is not reasonably constant throughout the whole sales area, then this should be stated and additional measurements may need to be provided
		ShD3	**Building line** – the position of the building line is to be noted

EFFECTIVE FROM 1 MAY 2009

Diagram K – An example of **NIA** in practice in a retail context

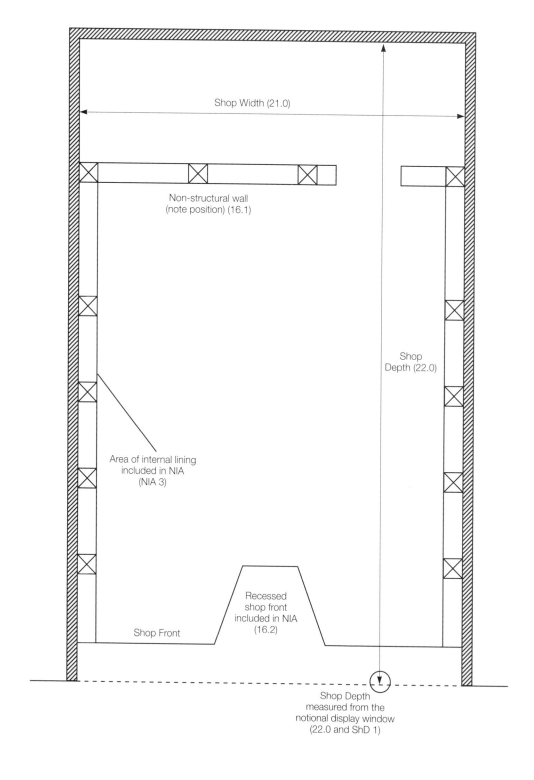

Shop Width (21.0)

Non-structural wall
(note position) (16.1)

Shop
Depth (22.0)

Area of internal lining
included in NIA
(NIA 3)

Recessed
shop front
included in NIA
(16.2)

Shop Front

Shop Depth
measured from the
notional display window
(22.0 and ShD 1)

Diagram L – An example of **NIA** in practice in a retail context

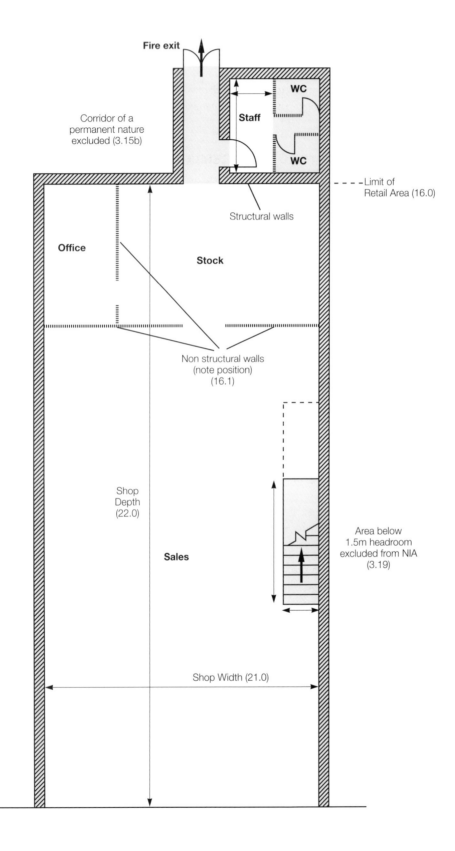

Appendix E: Measurement rules for elemental method of estimating

This appendix comprises the rules of measurement for *element unit quantities* (EUQs), which can be used to develop an *order of cost estimate* using the *elemental method* of estimating. The rules are tabulated.

Use of tabulated rules of measurement for elemental unit quantities (EUQs)

The table comprises the rules of measurement for *building works* (i.e. for *group elements* 1 to 9). The table is structured as follows:

- The first column lists the *group element*.
- The second column lists the *elements*.
- The third column lists the unit of measurement for *group elements* and *elements*, as appropriate.
- The fourth column contains the rules for measuring *element unit quantities* (EUQs) for *group elements* and *elements*, as appropriate.
- The last column contains further advice on measuring EUQs.
- Horizontal lines divide the tables to denote the end of a *group element* or *element*.
- The rules are written in the present tense.

Definitions of group elements and elements used in the elemental method of cost estimating

The definition of each *group element* and *element* used in the *elemental method* of cost estimating are the same as those defined for *elemental cost plans* in *Part 4: Tabulated rules of measurement for elemental cost planning*.

Rules of measurement for elemental unit quantities (EUQs)

If suitable information is available, then *element unit quantities* (EUQ) are measured for a *group element* or *element* in accordance with the rules and priced with suitable *element unit rates* (EUR) to ascertain the *cost target* for an *element*.

Where insufficient information is available for a particular *element*, the EUQ for that *element* is to be the *gross internal floor area* (GIFA or GIA).

Use of rules of measurement for elemental unit quantities (EUQs) for the preparation of cost analyses and benchmark analyses

The measurement rules for *element unit quantities* can also be used as a basis for measuring *element unit quantities* (EUQs) for the purpose of preparing cost analyses and benchmark analyses of building projects.

Rules of measurement for elemental method of estimating

Notes:

- Used to develop *order of cost estimate* using the *elemental method* of estimating.
- Where insufficient information is available for a particular *element*, the EUQ for that *element* is to be the *gross internal floor area* (GIFA or GIA).

Group element	Element	Unit	Measurement rules	Notes
1 Substructure		m²	1 The area measured is the area of the lowest floor measured to the internal face of the external perimeter walls. 2 The area of the lowest floor shall be measured in accordance with the rules of measurement for ascertaining the gross internal floor area (GIFA). 3 Areas of basements to be shown separately. 4 The area of basements shall be measured in accordance with the rules of measurement for ascertaining the GIFA.	
2 Superstructure	1 Frame	m²	1 The area measured is the area of the floors related to the frame. 2 The area of the frame shall be measured in accordance with the rules of measurement for ascertaining the gross internal floor area (GIFA).	
	2 Upper floors	m²	1 The area measured is the total area of upper floor(s). 2 The area of the upper floors shall be measured in accordance with the rules of measurement for ascertaining the gross internal floor area (GIFA). 3 Sloping surfaces such as galleries, tiered terraces and the like are to be measured flat on plan. 4 Areas for balconies, galleries, tiered terraces, service floors, walkways, internal bridges, external links, and roofs to internal buildings shall be shown separately.	Where balconies are included, the sum of the upper floors and lowest floor will exceed the GIFA.
	3 Roof	m²	1 The area measured is the area of the roof on plan. 2 The area measured is the area of the roof on plan measured to the inside face of the external walls.	
	4 Stairs and ramps	nr	1 Enumerate; giving total number of storey flights, i.e. the number of staircases or ramps multiplied by the number of floors served (excluding the lowest floor served in each case). 2 The total vertical rise of each staircase or ramp is to be stated, measured from top of structural floor level to top of structural floor level.	

Group element	Element	Unit	Measurement rules	Notes
	5 External walls	m²	The area measured is the area of the external wall, measured on the internal perimeter (i.e. the internal face) of the external wall. No deductions for windows or external doors.	1 It is unlikely that the thickness of external wall construction will be known the *RIBA Work Stages* A (Appraisal) and B (Design Brief) or *OGC Gateways* 1 (Business Justification) and 2 (Delivery Strategy). 2 Costs to be separately shown for each type of external wall system. 3 *Sub-element* includes costs in connection with forming openings for windows and external doors.
	6 Windows and external doors	m²	The area measured is the area of windows and external doors measured over frames.	Costs in connection with forming openings for windows and external doors to be included in *sub-element* 2.5: External walls.
	7 Internal walls and partitions	m²	The area measured is the area of internal walls and partitions, measured on the centre line of the internal wall or partition. No deduction is made for door openings, screens or the like.	Costs to be separately shown for each type of internal wall or partition.
	8 Internal doors	nr	Enumerate; giving total number of internal doors.	Irrespective of door type.
3 Internal finishes	1 Walls	m²	The area measured is the total area of wall finishes (i.e. the area of wall to which finishes are applied).	
	2 Floors	m²	The area measured is the total area of floor finishes (i.e. the area of floor to which finishes are applied).	
	3 Ceilings	m²	The area measured is the total area of ceiling finishes (i.e. the area of ceiling to which finishes are applied).	
4 Fittings, furnishings and equipment		m²	1 The area measured is the gross internal floor area (GIFA). 2 The area measured is measured in accordance with the rules of measurement for ascertaining the GIFA.	
5 Services	1 Sanitary appliances	nr	1 Enumerate; giving total number of appliances. 2 The total number of appliances enumerated is the total number of items listed below: (a) domestic sanitary appliances (nr) (b) specialist sanitary appliances (nr) (c) bathroom pods (nr) (d) toilet pods (nr) (e) shower room pods (nr).	1 Do not separately enumerate ancillary fittings/items. Costs of ancillary fittings/items to be included in unit cost for appliance. 2 Include the designed number of occupants for continuous urinals and the like. 3 Costs and measurements to be separately shown for: (a) domestic sanitary appliances (b) specialist sanitary appliances (c) bathroom pods (d) toilet pods (e) shower room pods.

Group element	Element	Unit	Measurement rules	Notes
	2 Services equipment	nr	1 Enumerate; giving total number of items. 2 The total number of items enumerated is the total number of items listed below: (a) commercial catering equipment (nr) (b) sinks supplied as an integral part of catering equipment (nr) (c) food storage equipment (nr) (d) specialist equipment (nr).	1 Do not separately enumerate ancillary fittings/items. Costs of ancillary fittings/items to be included in unit cost for item. 2 Costs and measurements to be separately shown for: (a) commercial catering equipment (b) sinks supplied as an integral part of catering equipment (c) food storage equipment (d) specialist equipment (e.g. dental chair and equipment in dental surgery).
	3 Disposal installations	nr	1 Enumerate; giving total number of above ground waste installations to sanitary appliances and services equipment, and entry chutes to refuse disposal installation. 2 The total number of items enumerated is the total number of items listed below: (a) waste points sanitary appliances (nr) (b) waste points to services equipment (nr) (c) waste points for laboratory and industrial liquid waste (nr) (d) entry points to rubbish chutes (nr) (e) entry points to chemical and industrial waste appliances (nr).	1 Do not separately enumerate ancillary fittings/items. Costs of ancillary fittings/items to be included in unit cost for item. 2 Costs and measurements to be separately shown for: (a) drainage to sanitary appliances (b) drainage to services equipment (e.g. sinks) (c) drainage for laboratory and industrial liquid waste (d) refuse disposal installations (e) chemical and industrial refuse disposal installations.
	4 Water installations	nr	1 Enumerate; giving total number of draw-off points. 2 The total number of draw-off points enumerated is the total number of items listed below: (a) mains supply draw-off points (nr) (b) cold water draw-off points (nr) (c) hot water draw-off points (nr) (d) steam and condensate draw-off points (nr).	Costs to be separately shown for each: (a) mains supply draw-off points (b) cold water draw-off points (c) hot water draw-off points (d) steam and condensate draw-off points.
	5 Heat source	nr	1 Enumerate; giving total number of heat sources. 2 Rating in kilowatts (kW) to be stated for each heat source.	Costs to be separately shown for each heat source.

Group element	Element	Unit	Measurement rules	Notes
	6 Space heating and air conditioning	m²	1 The area measured is the area serviced by the system. 2 The area serviced is measured in accordance with the rules of measurement for ascertaining the gross internal floor area (GIFA). 3 Where more than one system is employed, the area measured for each system is the area serviced by the system. Areas to be measured using the rules of measurement for ascertaining the GIFA.	Costs to be separately shown for each type of system.
	7 Ventilation systems			
	8 Electrical installations			
	9 Gas and other fuel installations			
	10 Lift and conveyor installations	nr	Enumerate; giving total number of lift and conveyor installations.	1 Costs to be separately shown for each type of lift and/or conveyor installation: (a) lifts (passenger, goods, fire fighting, etc); also state number of levels served (b) enclosed hoists; also state number of levels served (c) escalators; also state number of levels served (nr), rise (m) and length of travel (m) (d) moving pavements; also state length of travel (m) (e) powered stairlifts (f) conveyors (passenger or goods); also length of travel (m) (g) dock levellers and scissor lifts; also state total rise (m) and designed load (kN) (h) cranes and unenclosed hoists; also state total rise (m) and designed load (kN) (i) car lifts; also state number of levels served (j) car stacking systems; also state capacity (k) car/lorry turntables and the like (l) document handling systems (m) other lift and conveyor installations.
	11 Fire and lightning protection	m²	1 The area measured is the area serviced by the system. 2 The area serviced is measured in accordance with the rules of measurement for ascertaining the gross internal floor area (GIFA). 3 Where more than one system is employed, the area measured for each system is the area serviced by the system. Areas to be measured using the rules of measurement for ascertaining the GIFA.	Costs to be separately shown for each type of system.
	12 Communication, security and control systems			
	13 Specialist installations			

Group element	Element	Unit	Measurement rules	Notes
	14 Builders' work in connection with services	m²	1 The area measured is the gross internal floor area (GIFA). 2 The area measured is measured in accordance with the rules of measurement for ascertaining the GIFA.	Costs to be separately shown for each *element*.
	15 Testing and commissioning of services			
6 Complete buildings and building units	1 Prefabricated buildings	m²	1 The area measured is the gross internal floor area (GIFA) of the complete buildings or prefabricated room units. 2 The area measured is measured in accordance with the rules of measurement for ascertaining the GIFA.	Costs to be separately shown for each: (a) complete prefabricated building (b) type of prefabricated room unit (stating number of units).
7 Work to existing buildings	1 Minor demolition and alteration works	m²	1 The area measured is the gross internal floor area (GIFA) of the building(s) demolished or altered. 2 The area measured is measured in accordance with the rules of measurement for ascertaining the GIFA.	Costs to be separately shown for each building demolished or altered.
	2 Repairs to existing services			
	3 Damp-proof courses/fungus and beetle eradication	m²	1 The area measured is the gross internal floor area (GIFA) of the room(s) treated. 2 The area of the rooms treated is measured in accordance with the rules of measurement for ascertaining the GIFA.	
	4 Facade retention	m²	The area measured is the area of facade to be retained.	
	5 Cleaning existing surfaces	m²	The area measured is the surface area of the surface to be cleaned. No deduction for voids.	Costs to be separately shown for each type of surface.
	6 Renovation works	m²	The area measured is the area to be renovated.	Costs to be separately shown for each type of surface to be renovated.
8 External works	1 Site preparation works	m²	1 The area measured is the *site area* (SA). 2 The area measured is measured using the rules of measurement for ascertaining the SA.	Costs to be separately shown for each *element*.
	2 Roads, paths and pavings			
	3 Planting			
	4 Fencing, railings and walls			
	5 Site/street furniture and equipment			
	6 External drainage			
	7 External services			

Group element	Element	Unit	Measurement rules	Notes
	8 Minor building works and ancillary buildings	m²	1 The area measured is the gross internal floor area (GIFA) of the building(s). 2 The area measured is measured in accordance with the rules of measurement for ascertaining the GIFA.	Costs to be separately shown for each building.
9 Facilitating works	1 Toxic/hazardous material removal	m²	1 The area measured is the site area (SA), plus the footprint of all new buildings. 2 The area measured is measured using the rules of measurement for ascertaining the SA; plus the footprint area of all new buildings (i.e. the total area of the site).	Costs to be separately shown for each type of toxic/hazardous material to be removed.
	2 Major demolition works	m²	1 The area measured is the gross internal floor area (GIFA) of the building(s) demolished. 2 The area measured is measured in accordance with the rules of measurement for ascertaining the GIFA.	Costs to be separately shown for each building demolished.
	3 Specialist groundworks	m²	1 The area measured is the site area (SA), plus the footprint of all new buildings. 2 The area measured is measured using the rules of measurement for ascertaining the SA; plus the footprint area of all new buildings (i.e. the total area of the site).	Costs to be separately shown for each element.
	4 Temporary diversion works			
	5 Extraordinary site investigation works			

Appendix F: Logic and arrangement of levels 1 to 3 for elemental cost planning

LEVEL 1 Group element	LEVEL 2 Element	LEVEL 3 Sub-element
1 Substructure	1 Foundations	1 Standard foundations
		2 Piled foundations
		3 Underpinning
	2 Basement excavation	1 Basement excavation
	3 Basement retaining walls	1 Basement retaining walls
		2 Embedded basement retaining walls
	4 Ground floor construction	1 Ground floor slab/bed and suspended floor construction
2 Superstructure	1 Frame	1 Steel frames
		2 Space decks
		3 Concrete casings to steel frames
		4 Concrete frames
		5 Timber frames
		6 Specialist frames
	2 Upper floors	1 Concrete floors
		2 Precast/composite decking systems
		3 Timber floors
		4 Structural screeds
		5 Balconies
		6 Drainage to balconies
	3 Roof	1 Roof structure
		2 Roof coverings
		3 Glazed roofs
		4 Roof drainage
		5 Rooflights, skylights and openings
		6 Roof features
	4 Stairs and ramps	1 Stair/ramp structures
		2 Stair/ramp finishes
		3 Stair/ramp balustrades and handrails
		4 Ladders/chutes/slides
	5 External walls	1 External walls above ground floor level
		2 External enclosing walls below ground level
		3 Solar/rainscreen cladding
		4 External soffits
		5 Subsidiary walls, balustrades, handrails, railings and proprietary balconies
		6 Facade access/cleaning systems
	6 Windows and external doors	1 External windows
		2 External doors

APPENDIX F: LOGIC AND ARRANGEMENT OF LEVELS 1 TO 3 FOR ELEMENTAL COST PLANNING

LEVEL 1 Group element	LEVEL 2 Element	LEVEL 3 Sub-element
	7 Internal walls and partitions	1 Walls and partitions
		2 Balustrades and handrails
		3 Moveable room dividers
		4 Cubicles
	8 Internal doors	1 Internal doors
3 Internal finishes	1 Wall finishes	1 Finishes to walls
	2 Floor finishes	1 Finishes to floors
		2 Raised access floors
	3 Ceiling finishes	1 Finishes to ceilings
		2 False ceilings
		3 Demountable suspended ceilings
4 Fittings, furnishings and equipment	1 General fittings, furnishings and equipment	1 General fittings, furnishings and equipment
		2 Domestic kitchen fittings and equipment
		3 Signs/notices
		4 Works of art
		5 Equipment
	2 Special fittings, furnishings and equipment	1 Special purpose fittings, furnishings and equipment
	3 Internal planting	1 Internal planting
	4 Bird and vermin control	1 Bird and vermin control
5 Services	1 Sanitary appliances	1 Sanitary appliances
		2 Pods
		3 Sanitary fittings
	2 Services equipment	1 Services equipment
	3 Disposal installations	1 Foul drainage above ground
		2 Laboratory and industrial liquid waste drainage
		3 Refuse disposal
	4 Water installations	1 Mains water supply
		2 Cold water distribution
		3 Hot water distribution
		4 Local hot water distribution
		5 Steam and condensate distribution
	5 Heat source	1 Heat source
	6 Space heating and air conditioning	1 Central heating
		2 Local heating
		3 Central cooling
		4 Local cooling
		5 Central heating and cooling
		6 Local heating and cooling
		7 Central air conditioning
		8 Local air conditioning
	7 Ventilation systems	1 Central ventilation
		2 Local and special ventilation
		3 Smoke extract/control

LEVEL 1 Group element	LEVEL 2 Element	LEVEL 3 Sub-element
	8 Electrical installations	1 Electrical mains and sub-mains distribution
		2 Power installations
		3 Lighting installations
		4 Specialist lighting installations
		5 Local electricity generation systems
		6 Transformation devices
		7 Earthing and bonding systems
	9 Gas and other fuel installations	1 Gas distribution
		2 Fuel storage and piped distribution systems
	10 Lift and conveyor installations	1 Lifts
		2 Enclosed hoists
		3 Escalators
		4 Moving pavements
		5 Powered stairlifts
		6 Conveyors
		7 Dock levellers and scissor lifts
		8 Cranes and unenclosed hoists
		9 Car lifts, car stacking systems, turntables and the like
		10 Document handling systems
		11 Other lift and conveyor installations
	11 Fire and lightning protection	1 Fire fighting systems
		2 Lightning protection
	12 Communication, security and control systems	1 Communication systems
		2 Security systems
		3 Central control/building management systems
	13 Specialist installations	1 Specialist piped supply systems
		2 Radio and television studios
		3 Specialist refrigeration systems
		4 Water features
		5 Other specialist installations
	14 Builders' work in connection with services	1 General builders' work
	15 Testing and commissioning of services	1 Testing and commissioning of services
6 Complete buildings and building units	1 Prefabricated buildings	1 Complete buildings
		2 Building units
7 Work to existing buildings	1 Minor demolition works and alteration works	1 Minor demolition and alteration works
	2 Repairs to existing services	1 Existing services
	3 Damp-proof courses/fungus and beetle eradication	1 Damp-proof courses
		2 Fungus/beetle eradication
	4 Facade retention	1 Facade retention
	5 Cleaning existing surfaces	1 Cleaning existing surfaces
		2 Protective coatings to existing surfaces

LEVEL 1 Group element	LEVEL 2 Element	LEVEL 3 Sub-element
	6 Renovation works	1 Masonry repairs
		2 Concrete repairs
		3 Metal repairs
		4 Timber repairs
		5 Plastics repairs
8 External works	1 Site preparation works	1 Site clearance
		2 Preparatory groundworks
	2 Roads, paths and pavings	1 Roads, paths and pavings
		2 Special surfacings and pavings
	3 Planting	1 Seeding and turfing
		2 External planting
	4 Fencing, railings and walls	1 Fencing and railings
		2 Walls and screens
		3 Retaining walls
		4 Barriers and guardrails
	5 Site/street furniture and equipment	1 Site/street furniture and equipment
		2 Ornamental features
	6 External drainage	1 Surface water and foul water drainage
		2 Ancillary drainage systems
		3 External laboratory and industrial liquid waste drainage
		4 Land drainage
		5 Testing and commissioning of external drainage installations
	7 External services	1 Water mains supply
		2 Electricity mains supply
		3 External transformation devices
		4 Electricity distribution to external plant and equipment
		5 Gas mains supply
		6 Telecommunications and other communication system connections
		7 External fuel storage and piped distribution systems
		8 External security systems
		9 Site/street lighting systems
		10 Irrigation systems
		11 Local/district heating installations
		12 Builder's work in connection with external services
		13 Testing and commissioning of external services
	8 Minor building works and ancillary buildings	1 Minor building works
		2 Ancillary buildings and structures
		3 Underpinning to external site boundary walls
9 Facilitating works	1 Toxic/hazardous material removal	1 Toxic or hazardous material removal
		2 Contaminated land
		3 Eradication of plant growth
	2 Major demolition works	1 Demolition works
	3 Specialist groundworks	1 Site dewatering and pumping
		2 Soil stabilisation measures

ORDER OF COST ESTIMATING AND ELEMENTAL COST PLANNING

LEVEL 1 Group element	LEVEL 2 Element	LEVEL 3 Sub-element
		3 Ground gas venting measures
	4 Temporary diversion works	1 Temporary diversion works
	5 Extraordinary site investigation works	1 Archaeological investigation
		2 Reptile/wildlife mitigation measures
		3 Other extraordinary site investigation works
10 Main contractor's preliminaries	1 Employer's requirements	1 Site accommodation
		2 Site records
		3 Completion and post-completion requirements
	2 Main contractor's cost items	1 Management and staff
		2 Site establishment
		3 Temporary services
		4 Security
		5 Safety and environmental protection
		6 Control and protection
		7 Mechanical plant
		8 Temporary works
		9 Site records
		10 Completion and post-completion requirements
		11 Cleaning
		12 Fees and charges
		13 Site services
		14 Insurance, bonds, guarantees and warranties
11 Main contractor's overheads and profit	1 Main contractor's overheads	
	2 Main contractor's profit	
12 Project/design team fees	1 Consultants' fees	1 Project/design team consultants' fees
		2 Other consultants' fees
		3 Site investigation fees
		4 Specialist support consultants' fees
	2 Main contractor's pre-construction fees	1 Management and staff
		2 Specialist support services fees
		3 Temporary accommodation, services and facilities charges
		4 Main contractor's overheads and profit
	3 Main contractor's design fees	1 Main contractor's design consultants' fees
13 Other development/project costs	1 Other development/project costs	1 Land acquisition costs
		2 Employer finance costs
		3 Fees
		4 Charges
		5 Planning contributions
		6 Insurances
		7 Archaeological works
		8 Decanting and relocation
		9 Fittings, furnishing and equipment
		10 Tenant's costs/contributions
		11 Marketing costs

APPENDIX F: LOGIC AND ARRANGEMENT OF LEVELS 1 TO 3 FOR ELEMENTAL COST PLANNING

LEVEL 1 Group element	LEVEL 2 Element	LEVEL 3 Sub-element
		12 Other employer costs
14 Risk	1 Design development risks	
	2 Construction risks	
	3 Employer change risks	
	4 Employer other risks	
15 Inflation	1 Tender inflation	
	2 Construction inflation	

Appendix G: Information requirements for formal cost plans

This appendix comprises a list of the key information required to enable preparation of *formal cost plans*.

1 Formal Cost Plan 1

To enable preparation of Formal Cost Plan 1 (at *RIBA Work Stage* C: Concept or *OGC Gateway* 3A: Design Brief and Concept Approval), key information will be required as follows.

(a) **From the *employer***

 (i) Confirmation of the *cost limit* (i.e. the *authorised budget*). Where alternative cost options were reported to the *employer*, confirmation of the preferred design/development option and *cost limit* is required.

 (ii) Confirmation of the project/design brief, including statement of quality and 'fit-out' requirements.

 (iii) Confirmation of programme, including timetable of critical events (including timetable for design, construction start date, construction time, construction completion date and required occupation dates).

 (iv) Confirmation of requirements in respect of:

- procurement strategy, including phasing of construction works, temporary access requirements and the like;

- contract strategy;

- phasing, including requirements relating to decanting, temporary access and the like;

- facilitating works, including demolition, preparatory site works, and early infrastructure works (e.g. mains services connections and roadworks);

- treatment of *project/design team fees*;

- insurances;

- approach to dealing with *other development/project costs* (e.g. Section 106 contributions, party wall works and decanting costs);

- planning and Section 106 and 278 requirements required to be incorporated in the building design and/or *building works* contract(s);

- treatment of *employer's* risks;

- treatment of *inflation*;

- treatment of Value Added Tax (VAT); and

- other considerations (e.g. approach to dealing with capital allowances, land remediation allowances and grants).

 (v) Post-completion requirements.

 (vi) Authority to commence the next *RIBA Work Stage* or proceed to the next *OGC Gateway*.

(b) **From the architect**

 (i) Concept design drawings to a suitable scale, comprising:

- general arrangement plans (for all floors, including basement levels, and roofs);
- general elevations (with materials clearly annotated);
- general sections;
- external landscaping – general arrangement plan(s);
- plans of key building functions;
- detailed elevations showing construction of external walls, roofs, ground floor construction and upper floor construction;
- sketches showing key details/interfaces (e.g. interface between curtain walling system and structure, balconies and the like);
- concept design for rooms and common areas; and
- site constraints plan.

(ii)　Schedule of *gross external areas* (GEA), *gross internal floor areas* (GIFA), *net internal areas* (NIA – i.e. usable area for shops, supermarkets and offices) and *site area* (SA).

(iii)　Outline specification information, including:

- specification/design intent for all main *elements*;
- statement of required quality;
- outline specification for *components*, materials and finishes;
- acoustics/vibration requirements;
- outline performance criteria for main *element*;
- schedule of finishes; and
- details of alternative specifications.

(iv)　Room data sheets.

(v)　Schedules of key fittings, furnishings and equipment.

(vi)　Strategies, including:

- environmental/sustainability (in conjunction with the mechanical and electrical services engineer), including:
 - measures to achieve BREEAM or *Code for Sustainable Homes*;
 - Building Regulations requirements;
 - sustainability requirements and assumptions;
 - renewable energy requirements and assumptions;
 - employer's specific requirements;
- car parking, including motorcycles and bicycles;
- vertical movement (in conjunction with the mechanical and electrical services engineer);
- information technology (IT);
- fire;
- acoustics;
- security;
- DDA (Disability Discrimination Act);
- window cleaning;
- refuse/waste disposal;

- public art;

- conservation/listed buildings and the like (if applicable); and

- other important aspects of the building project.

 (vii) Reports, including:

- archaeological assessment/report (desktop study);

- measured survey (i.e. topographical survey).

 (viii) Phasing and outline construction methodology.

 (ix) Definition of 'fit-out'.

 (x) *Risk register/log.*

(c) **From the mechanical and electrical services engineer**

 (i) Concept design drawings to a suitable scale, comprising:

- general arrangement for each main system;

- schematic diagrams for each major system;

- plant room layouts, including roof plant layout;

- single line diagrams showing primary service routes; and

- typical layouts of landlord's areas, service areas and cores.

 (ii) Outline specification information, including:

- mechanical services;

- electrical services;

- transportation systems (e.g. lifts, hoists and escalators);

- protective installations;

- communication, security and control systems;

- special installations;

- plant/equipment schedule (for primary plant/equipment);

- approximate duties, output, and sizes of primary plant/equipment;

- schedule of cost significant builders' work in connection with mechanical and electrical engineering services installations/systems; and

- details of alternative specifications.

 (iii) Strategies, including:

- environmental/sustainability (in conjunction with the architect), including:

 – measures to achieve BREEAM or *Code for Sustainable Homes*;

 – Building Regulations requirements;

 – sustainability requirements and assumptions;

 – renewable energy requirements and assumptions;

 – employer's specific requirements.

- vertical movement (in conjunction with the architect); and

- removal/decommissioning of existing plant and or equipment.

 (iv) Reports, including:

- survey of underground services.

(v) Identification of requirements for any abnormal mechanical and electrical engineering services installations/systems.

(vi) Details of utilities services connections, including:

- connections;
- upgrading requirements; and
- diversions.

(vii) Methodology for facilitating works (i.e. early provision of mains services to site).

(viii) *Risk register/log.*

(d) **From the structural engineer**

(i) Reports based on desktop studies, including:

- environmental contamination (Phase 1 audit – i.e. to establish the nature of any subsurface contaminated soil and/or groundwater);
- geotechnical properties; and
- bombs.

(ii) Reports based on fieldwork, sampling and analysis (where commissioned by the *employer*), including:

- environmental contamination (Phase 2 audit): and
- geotechnical properties.

Note: Fieldwork comprises trial pits, auger holes, window samplers, boreholes, probing and the like.

(iii) Environmental risk assessment.

(iv) Advice on ground conditions.

(v) Concept design drawings to a suitable scale, comprising:

- general arrangement;
- frame configuration.
- layout of shear walls, core walls, columns and beams;
- sections;
- foundation layouts, including pile (and pile cap and ground beam) layouts;
- sections, showing ground slab construction, basement wall construction, pile caps construction and the like; and
- indicative drainage solution.

(vi) Formation and excavation levels.

(vii) Outline specification information, including:

- specification/design intent for all main *elements*;
- outline specification for *components* and materials;
- structural performance criteria (e.g. design loadings);
- pile sizes, including indicative lengths;
- statement on strategy for integration of mechanical and electrical engineering services with structural components; and
- details of alternative specifications.

(viii) Estimates of reinforcement content for all reinforced concrete components.

(ix) Mass of steelwork in steel framed structures.

(x) Methodologies for:

 - facilitating works, including demolition, preparatory site works, and early infrastructure works (e.g. roadworks and drainage);

 - temporary works;

 - alterations; and

 - drainage (indicative solution).

(xi) *Risk register/log.*

2 Formal Cost Plan 2

To enable preparation of Formal Cost Plan 2 (at *RIBA Work Stage* D: Design Development or *OGC Gateway* 3B: Detailed Design Approval), key information will be required as follows.

(a) **From the *employer***

 (i) Confirmation that Formal Cost Plan 1 prepared at *RIBA Work Stage* C: Concept, or *OGC Gateway* 3A: Design Brief and Concept Approval, is acceptable.

 (ii) Confirmation of any preferred alternatives given in cost report for Cost Plan 1.

 (iii) Confirmation of the project/design brief, including statement of quality and 'fit-out' requirements.

 (iv) Confirmation of programme, including timetable of critical events (including timetable for design, construction start date, construction time, construction completion date and required occupation dates).

 (v) Confirmation of requirements in respect of:

 - procurement strategy, including phasing of construction works, temporary access requirements and the like;

 - contract strategy;

 - phasing, including requirements relating to decanting, temporary access and the like;

 - facilitating works, including demolition, preparatory site works, and early infrastructure works (e.g. mains services connections and roadworks);

 - treatment of *project/design team fees*;

 - insurances;

 - approach to dealing with *other development/project costs* (e.g. Section 106 contributions, party wall works and decanting costs);

 - planning and Section 106 and 278 requirements required to be incorporated in the building design and/or *building works* contract(s);

 - treatment of *employer's* risks;

 - treatment of *inflation*;

 - treatment of Value Added Tax (VAT); and

 - other considerations (e.g. approach to dealing with capital allowances, land remediation allowances and grants).

 (vi) Post-completion requirements.

 (vii) Acceptance of any other matters within the cost report for Cost Plan 1.

 (viii) Authority to commence the next *RIBA Work Stage* or proceed to the next *OGC Gateway*.

(b) **From the architect**

 (i) Detailed design drawings to a suitable scale, comprising:

- general arrangement plans (for all floors, including basement levels, and roofs);
- general elevations (with materials clearly annotated);
- general sections;
- external landscaping – general arrangement plan(s);
- plans of key building functions;
- detailed elevations;
- detailed sections, showing construction of external walls, roofs, ground floor construction and upper floor construction;
- drawings showing key details/interfaces (e.g. interface between curtain walling system and structure, balconies and the like);
- detailed floor plans, showing the layout of rooms and common areas.

 (ii) Updated site constraints plan.

 (iii) Schedule of *gross external areas* (GEA), *gross internal floor areas* (GIFA), *net internal areas* (NIA – i.e. usable area for shops, supermarkets and offices) and *site area* (SA).

 (iv) Updated outline specification information, including:

- specification/design intent for all main *elements*;
- statement of required quality;
- outline specification for *components*, materials and finishes;
- acoustics/vibration requirements;
- outline performance criteria for main *element*;
- schedule of finishes; and
- details of alternative specifications.

 (v) Updated room data sheets.

 (vi) Updated schedules of key fittings, furnishings and equipment.

 (vii) Updated strategies, including:

- environmental/sustainability (in conjunction with the mechanical and electrical services engineer), including:
 - measures to achieve BREEAM or *Code for Sustainable Homes*;
 - Building Regulations requirements;
 - sustainability requirements and assumptions;
 - renewable energy requirements and assumptions;
 - employer's specific requirements;
- car parking, including motorcycles and bicycles;
- vertical movement (in conjunction with the mechanical and electrical services engineer);
- information technology (IT);
- fire;
- acoustics;
- security;

- DDA (Disability Discrimination Act);
- window cleaning;
- refuse/waste disposal;
- public art;
- conservation/listed buildings and the like (if applicable); and
- other important aspects of the building project.

(viii) Updated reports, including:

- archaeological assessment/report (desktop study); and
- measured survey (i.e. topographical survey).

(ix) Updated phasing and outline construction methodology.

(x) Updated *risk register/log*.

(c) **From the mechanical and electrical services engineer**

(i) Detailed design drawings to a suitable scale, comprising:

- general arrangement for each main system;
- schematic diagrams for each major system;
- plant room layouts, including roof plant layout;
- single line diagrams showing primary service routes; and
- typical layouts of landlord's areas, service areas and cores.

(ii) Updated outline specification information, including:

- mechanical services;
- electrical services;
- transportation systems (e.g. lifts, hoists and escalators);
- protective installations;
- communication, security and control systems;
- specialist installations;
- plant/equipment schedule (for primary plant/equipment);
- approximate duties, output, and sizes of primary plant/equipment; and
- schedule of cost significant builders' work in connection with mechanical and electrical engineering services installations/systems.

(iii) Updated strategies, including:

- environmental/sustainability (in conjunction with the architect), including:
 - measures to achieve BREEAM or *Code for Sustainable Homes*;
 - Building Regulations requirements;
 - sustainability requirements and assumptions;
 - renewable energy requirements and assumptions;
 - employer's specific requirements;
- vertical movement (in conjunction with the architect); and
- removal/decommissioning of existing plant and or equipment.

(iv) Identification of requirements for any abnormal mechanical and electrical engineering services installations/systems.

(v) Details of utilities services connections, including:

- connections;

- upgrading requirements;

- diversions; and

- quotations from statutory undertakers.

(vi) Updated methodology for facilitating works (i.e. early provision of mains services to site).

(vii) Updated *risk register/log*.

(d) **From the structural engineer**

(i) Reports based on fieldwork, sampling and analysis (where commissioned by the *employer*), including:

- environmental contamination (Phase 2 audit).

- geotechnical properties.

Note: Fieldwork comprises trial pits, auger holes, window samplers, boreholes, probing and the like.

(ii) Environmental risk assessment.

(iii) Updated advice on ground conditions.

(iv) Detailed design drawings to a suitable scale, comprising:

- general arrangement;

- layout of shear walls, core walls, columns and beams;

- frame configuration.

- foundation layouts, including pile (and pile cap and ground beam) layouts;

- sections, showing ground slab construction, basement wall construction, pile caps construction and the like; and

- indicative drainage solution.

(v) Formation and excavation levels.

(vi) Updated outline specification information, including:

- specification/design intent for all main *elements*;

- outline specification for *components* and materials;

- structural performance criteria (e.g. design loadings);

- pile sizes, including indicative lengths;

- statement on strategy for integration of mechanical and electrical engineering services with structural components;

- details of alternative specifications.

(vii) Updated estimates of reinforcement content for all reinforced concrete components.

(viii) Mass of steelwork in steel framed structures.

(ix) Updated methodologies for:

- facilitating works, including demolition, preparatory site works, and early infrastructure works (e.g. roadworks and drainage);

- temporary works;

- alterations; and

- drainage (indicative solution).

(x) *Risk register/log.*

(e) **From the specialist consultants**

(i) Design development drawings.

(ii) Outline specification information.

3 Formal Cost Plan 3

To enable preparation of Formal Cost Plan 3 (at *RIBA Work Stages* E: Technical Design and F: Production Information and *OGC Gateway* 3B: Detailed Design Approval), key information will be required as follows.

(a) **From the *employer***

(i) Confirmation that Formal Cost Plan 2 prepared at *RIBA Work Stage* D: Design Development, or *OGC Gateway* 3B: Detailed Design Approval, is acceptable.

(ii) Confirmation of any preferred alternatives given in cost report for Cost Plan 2.

(iii) Confirmation of the project/design brief, including statement of quality and 'fit-out' requirements.

(iv) Confirmation of programme, including timetable of critical events (including timetable for design, construction start date, construction time, construction completion date and required occupation dates).

(v) Confirmation of requirements in respect of:

- procurement strategy, including phasing of construction works, temporary access requirements and the like;

- contract strategy;

- phasing, including requirements relating to decanting, temporary access and the like;

- facilitating works, including demolition, preparatory site works, and early infrastructure works (e.g. mains services connections and roadworks);

- treatment of *project/design team fees.*

- insurances.

- approach to dealing with *other development/project costs* (e.g. Section 106 contributions, party wall works and decanting costs);

- planning and Section 106 and 278 requirements required to be incorporated in the building design and/or *building works* contract(s);

- treatment of *employer's* risks;

- treatment of *inflation;*

- treatment of Value Added Tax (VAT); and

- other considerations (e.g. approach to dealing with capital allowances, land remediation allowances and grants).

(vi) Post-completion requirements.

(vii) Acceptance of any other matters within the cost report for Cost Plan 2.

(viii) Authority to commence the next *RIBA Work Stage* or proceed to the next *OGC Gateway.*

(b) **From the architect**

(i) Final design drawings to a suitable scale, including:

- final plans/layouts;

- elevations;

- sections;
- location drawings;
- assembly drawings; and
- component drawings.

(ii) Updated site constraints plan.

(iii) Schedule of *gross external areas* (GEA), *gross internal floor areas* (GIFA), *net internal areas* (NIA – i.e. usable area for shops, supermarkets and offices) and *site area* (SA).

(iv) Final specification information, including:

- specification/design for all main *elements*;
- statement of required quality;
- final specification for *components*, materials and finishes;
- acoustics/vibration requirements;
- final performance criteria for main *element*;
- schedule of finishes; and
- details of alternative specifications.

(v) Final room data sheets.

(vi) Final schedules of key fittings, furnishings and equipment.

(vii) Final strategies, including:

- environmental/sustainability (in conjunction with the mechanical and electrical services engineer), including:
 - measures to achieve BREEAM or *Code for Sustainable Homes*;
 - Building Regulations requirements;
 - sustainability requirements and assumptions;
 - renewable energy requirements and assumptions;
 - employer's specific requirements;
- car parking, including motorcycles and bicycles;
- vertical movement (in conjunction with the mechanical and electrical services engineer);
- information technology (IT);
- fire;
- acoustics;
- security;
- DDA (Disability Discrimination Act);
- window cleaning;
- refuse/waste disposal;
- public art;
- conservation/listed buildings and the like (if applicable); and
- other important aspects of the building project.

(viii) Updated reports, including:

- archaeological assessment/report (desktop study); and
- measured survey (i.e. topographical survey).

 (ix) Final phasing and outline construction methodology.

 (x) Updated *risk register/log.*

(c) **From the mechanical and electrical services engineer**

 (i) Detailed design drawings to a suitable scale.

 (ii) Final specification information, including:

- mechanical services;
- electrical services;
- transportation systems (e.g. lifts, hoists and escalators);
- protective installations;
- communication, security and control systems;
- specialist installations;
- plant/equipment schedule (for primary plant/equipment);
- duties, output, and sizes of primary plant/equipment; and
- schedule of cost significant builders' work in connection with mechanical and electrical engineering services installations/systems.

 (iii) Final strategies, including:

- environmental/sustainability (in conjunction with the architect), including:
 - measures to achieve BREEAM or *Code for Sustainable Homes*;
 - Building Regulations requirements;
 - sustainability requirements and assumptions;
 - renewable energy requirements and assumptions;
 - employer's specific requirements;
- vertical movement (in conjunction with the architect); and
- removal/decommissioning of existing plant and or equipment.

 (iv) Details of utilities services connections, including:

- connections;
- upgrading requirements;
- diversions; and
- quotation from statutory undertakers.

 (v) Final methodology for facilitating works (i.e. early provision of mains services to site).

 (vi) Updated *risk register/log.*

(d) **From the structural engineer**

 (i) Reports based on fieldwork, sampling and analysis (where commissioned by the *employer*), including:

- environmental contamination (Phase 2 audit); and
- geotechnical properties.

 Note: Fieldwork comprises trial pits, auger holes, window samplers, boreholes, probing and the like.

 (ii) Updated environmental risk assessment.

 (iii) Updated advice on ground conditions.

 (iv) Final design drawings to a suitable scale, including:

- general arrangement;

- layout of shear walls, core walls, columns and beams;

- frame configuration;

- foundation layouts, including pile (and pile cap and ground beam) layouts;

- sections, showing ground slab construction, basement wall construction, pile caps construction and the like; and

- final drainage solution.

(v) Formation and excavation levels.

(vi) Final specification information, including:

- specification/design for all main *elements*;

- final specification for *components* and materials;

- structural performance criteria (e.g. design loadings);

- pile sizes, including indicative lengths; and

- statement on strategy for integration of mechanical and electrical engineering services with structural components.

(vii) Updated estimates of reinforcement content for all reinforced concrete components.

(viii) Mass of steelwork in steel framed structures.

(ix) Final methodologies for:

- facilitating works, including demolition, preparatory site works, and early infrastructure works (e.g. roadworks and drainage);

- temporary works;

- alterations; and

- drainage.

(x) Updated *risk register/log*.

(e) **From the specialist consultants**

(i) Final design drawings to a suitable scale.

(ii) Final specification information.

Appendix H: Template for elemental cost plan (based on level 1 codes)

Cost plan no. Project title:

COST CENTRE	GROUP ELEMENT/ELEMENT	COST/M² OF GIFA	TOTAL COST OF ELEMENT (TARGET COST)
		£	£
	BUILDING WORKS		
1	Substructure		
2	Superstructure		
3	Internal finishes		
4	Fittings, furnishings and equipment		
5	Services		
6	Complete buildings and building units		
7	Work to existing buildings		
8	External works		
9	Facilitating works		
	SUB-TOTAL: BUILDING WORKS		
10	Main contractor's preliminaries		
	SUB-TOTAL: BUILDING WORKS (including main contractor's preliminaries)		
11	Main contractor's overheads and profit		
	TOTAL: BUILDING WORKS ESTIMATE (A)		
	PROJECT/DESIGN TEAM FEES AND OTHER DEVELOPMENT/PROJECT		
12	Project/design team fees		
13	Other development/project costs		
	TOTAL: PROJECT/DESIGN TEAM FEES AND OTHER DEVELOPMENT/PROJECT COSTS ESTIMATE (B)		
	BASE COST ESTIMATE (C) [C = A + B]		
14	TOTAL: RISK ALLOWANCE ESTIMATE (D)		
	COST LIMIT (excluding inflation) (E) [E = C + D]		
15	INFLATION		
15.1	Tender inflation		
15.2	Construction inflation		
	TOTAL: INFLATION ALLOWANCE (F)		
	COST LIMIT (excluding VAT assessment) (G) [G = E + F]		
16	VAT ASSESSMENT		excluded (See Note)

1. **Base date of cost plan:**

2. **All transfers are to be to/from the risk allowance cost centres and balanced by an equal but opposite adjustment to the risk allowance cost centres.**

APPENDIX H: TEMPLATE FOR ELEMENTAL COST PLAN (BASED ON LEVEL 1 CODES)

Note: Value Added Tax (VAT) in relation to buildings is a complex area. Therefore, it is recommended that VAT be excluded from *order of cost estimates*. It is recommended that specialist advice is sought on VAT matters to ensure that the correct rates are applied to the various aspects of a building project.

Appendix I: Template for elemental cost plan (based on level 2 codes)

Cost plan no.

Project title:

COST CENTRE	GROUP ELEMENT/ELEMENT	COST/M² OF GIFA	TOTAL COST OF ELEMENT (TARGET COST)
		£	£
	BUILDING WORKS		
1	Substructure		
1.1	Foundations		
1.2	Basement excavation		
1.3	Basement retaining walls		
1.4	Ground floor construction		
2	Superstructure		
2.1	Frame		
2.2	Upper floors		
2.3	Roof		
2.4	Stairs and ramps		
2.5	External walls		
2.6	Windows and external doors		
2.7	Internal walls and partitions		
2.8	Internal doors		
3	Internal finishes		
3.1	Wall finishes		
3.2	Floor finishes		
3.3	Ceiling finishes		
4	Fittings, furnishings and equipment		
4.1	General fittings, furnishings and equipment		
4.2	Special fittings, furnishings and equipment		
4.3	Internal planting		
4.4	Bird and vermin control		
5	Services		
5.1	Sanitary appliances		
5.2	Services equipment		
5.3	Disposal installations		
5.4	Water installations		
5.5	Heat source		
5.6	Space heating and air conditioning		
5.7	Ventilation systems		
5.8	Electrical installations		
5.9	Gas and other fuel installations		
5.10	Lift and conveyor installations		

5.11	Fire and lightning protection		
5.12	Communication, security and control systems		
5.13	Specialist installations		
5.14	Builders' work in connection with services		
5.15	Testing and commissioning of services		
6	**Complete buildings and building units**		
6.1	Prefabricated buildings		
7	**Work to existing buildings**		
7.1	Minor demolition works and alteration works		
7.2	Repairs to existing services		
7.3	Damp-proof courses/fungus and beetle eradication		
7.4	Facade retention		
7.5	Cleaning existing surfaces		
7.6	Renovation works		
8	**External works**		
8.1	Site preparation works		
8.2	Roads, paths and pavings		
8.3	Planting		
8.4	Fencing, railings and walls		
8.5	Site/street furniture and equipment		
8.6	External drainage		
8.7	External services		
8.8	Minor building works and ancillary buildings		
9	**Facilitating works**		
9.1	Toxic/hazardous material removal		
9.2	Major demolition works		
9.3	Specialist groundworks		
9.4	Temporary diversion works		
9.5	Extraordinary site investigation works		
	SUB-TOTAL: BUILDING WORKS		
10	**Main contractor's preliminaries**		
10.1	Employer's requirements		
10.2	Main contractor's cost items		
	SUB-TOTAL: BUILDING WORKS (including main contractor's preliminaries)		
11	**Main contractor's overheads and profit**		
11.1	Main contractor's overheads		
11.2	Main contractor's profit		
	TOTAL: BUILDING WORKS ESTIMATE (A)		
	PROJECT/DESIGN TEAM FEES AND OTHER DEVELOPMENT/PROJECT		
12	**Project/design team fees**		
12.1	Consultants' fees		
12.2	Main contractor's pre-construction fees		
12.3	Main contractor's design fees		
13	**Other development/project costs**		
	TOTAL: PROJECT/DESIGN TEAM FEES AND OTHER DEVELOPMENT/PROJECT COSTS ESTIMATE (B)		

	BASE COST ESTIMATE (C) [C = A + B]		
14	Risks		
14.1	Design development risks		
14.2	Construction risks		
14.3	Employer change risks		
14.4	Employer other risks		
	TOTAL: RISK ALLOWANCE ESTIMATE (D)		
	COST LIMIT (excluding inflation) (E) [E = C + D]		
15	Inflation		
15.1	Tender inflation		
15.2	Construction inflation		
	TOTAL: INFLATION ALLOWANCE (F)		
	COST LIMIT (excluding VAT assessment) (G) [G = E + F]		
16	VAT ASSESSMENT		excluded [See Note]

1. Base date of cost plan:

2. All transfers are to be to/from the risk allowance cost centres and balanced by an equal but opposite adjustment to the risk allowance cost centres.

Note: Value Added Tax (VAT) in relation to buildings is a complex area. Therefore, it is recommended that VAT be excluded from *order of cost estimates*. It is recommended that specialist advice is sought on VAT matters to ensure that the correct rates are applied to the various aspects of a building project.

Bibliography

Published by the Office of Government Commerce, ITIL, 2007:

- OGC Gateway™ Process *Review 0: Strategic assessment*

- OGC Gateway™ Process *Review 1: Business justification*

- OGC Gateway™ Process *Review 2: Delivery strategy*

- OGC Gateway™ Process *Review 3: Investment decision*

- OGC Gateway™ Process *Review 4: Readiness for service*

- OGC Gateway™ Process *Review 5: Operational review and benefits realisation*

Royal Institute of British Architects, *RIBA Outline Plan of Work 2007* (amended November 2008), RIBA, 2008

Royal Institution of Chartered Surveyors, *Code of Measuring Practice: A Guide for Property Professionals* (6th edition), RICS, 2007

Royal Institution of Chartered Surveyors, *Cost Management in Engineering Construction Projects*, RICS, Surveyors Holdings Limited, London, 1992

Index

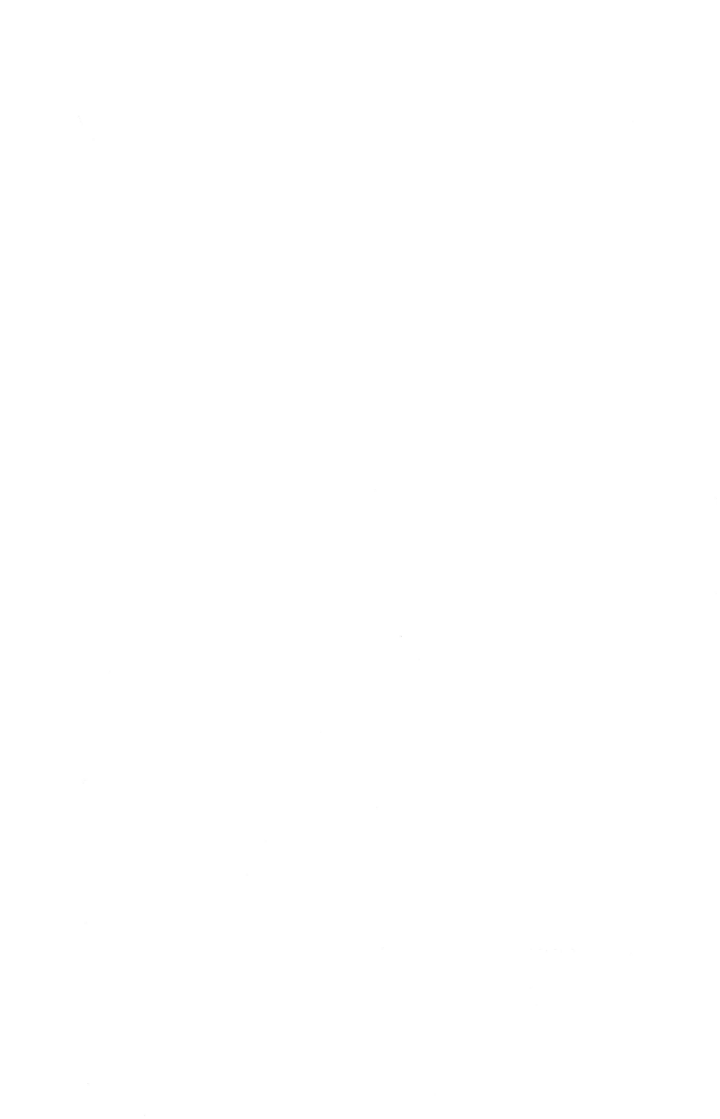